THE PATH WAS STEEP

The Path Was Steep

A Memoir of Appalachian Coal Camps During the Great Depression

SUZANNE PICKETT

FOREWORD BY NORMAN MCMILLAN

NEWSOUTH BOOKS
Montgomery

PUBLISHED IN COOPERATION WITH
THE CAHABA TRACE COMMISSION

NewSouth Books
105 S. Court Street
Montgomery, AL 36104

This work is based on true incidents from the author's life. Some people and some
situations have been fictionalized to protect the identities of individuals
or their family members.

Portions of this title were previously published by Black Belt Press
as *Hot Dogs for Thanksgiving*, with the ISBN 1-881320-76-6.

Library of Congress Cataloging-in-Publication Data

Pickett, Suzanne.
The path was steep : a memoir of Appalachian coal camps during
the Great Depression / Suzanne Pickett.
pages cm

ISBN 978-1-58838-261-0 (paperback) — ISBN 978-1-60306-334-0 (ebook)

1. Pickett, Suzanne—Homes and haunts. 2. Appalachian Region, Southern—Social
life and customs—20th century. 3. Appalachian Mountains—Biography.
4. Appalachian Mountains—History, Local. 5. Authors—United States—
Biography. 6. Coal miners—United States—Biography. 7. Coal mines and
mining—Appalachian Region, Southern—History—20th century.
8. Depressions—1929. I. Title.
F217.A65P535 2013
974'.041—dc23

2013034242

Design by Randall Williams
Printed in the United States of America

Published in cooperation with
The Cahaba Trace Commission
13728 Montevallo Rd, Brierfield, AL 35035

In Loving Memory of David Pickett

(1907–1990)

Sue Pickett's Appalachian World

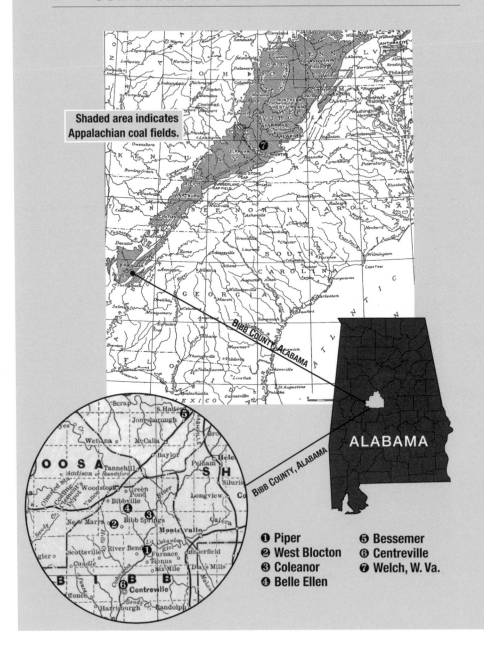

Shaded area indicates Appalachian coal fields.

BIBB COUNTY, ALABAMA

ALABAMA

BIBB COUNTY, ALABAMA

❶ Piper
❷ West Blocton
❸ Coleanor
❹ Belle Ellen
❺ Bessemer
❻ Centreville
❼ Welch, W. Va.

Contents

Foreword

NORMAN McMILLAN

The title of Suzanne Pickett's evocative and gracefully written memoir, *The Path Was Steep*, foreshadows the two primary motifs of her book, motion and struggle. Wife of an ambitious and restless coal miner, Sue, as she was commonly called, recreates the challenges and the rewards of life in the coalfields of Alabama and West Virginia during the years of the Great Depression of the 1930s. Despite the many hardships her family faced, Pickett's great sense of self-worth, her estimable creative powers, her boundless curiosity, and her impressive energy enable her to rise above circumstances that might have broken a weaker spirit. Moreover, Pickett places the events of her own life in a national context. Through reading Sue's memoir, for example, we can clearly see the circumstances that led to the often-violent conflicts between labor and management that were so widespread during this period.

The lives of the Pickett family seem to be defined by motion. In search of employment, Sue's husband David—like so many of his contemporaries—hitches a ride in an empty freight train boxcar to leave Alabama in search of employment in Michigan and Kentucky and then in West Virginia, where he finally finds work in the coal mines. Sue and her young daughters, Sharon and Davene, then journey by train to join him.

Once the family is settled in West Virginia, they manage to acquire a 1926 Studebaker, which becomes like a fifth member of the family, earn-

ing the name of Thunderbolt because of the loud sounds of its protest-
ing engine. David loves speed, careening around dangerous curves on a
mountain road in West Virginia called the Jumps. As Sue peers beyond
the precipices, she can see below the broken carcasses of automobiles
that have slid off the highway, and she fears that her family may end up
with the same fate. But such fears are always trumped by the desire or
need to go somewhere.

NOTHING SEEMED TO REDUCE the Pickett family to idleness and despair,
no matter what difficulties they encountered, and the difficulties were
numerous during those Depression years. First, there was the constant
struggle to provide for the basic necessities of life. In 2013, very few
people are still alive who can remember firsthand the extent of misery
and deprivation during the 1930s, and reading about the period in school
textbooks doesn't fully convey how many were suffering or how badly.
Consider, for example, that at the lowest point of the Great Recession
that began in 2007, some 8 to 9 percent of U.S. workers were officially
unemployed. But in 1931, when David Pickett was roaming in a desperate
search for work, some 25 to 30 percent of the U.S. labor force was simply
unable to find a job of any kind. And in those years before the New Deal
reforms of the Franklin D. Roosevelt administration—backed by coal
miners' labor unions—there was no safety net. No Social Security for
the aged, no food stamps for the hungry, no Medicare or Medicaid for
the sick, no energy assistance for those without heat.

We can well imagine David's sense of relief when he finally found work
as a coal miner in West Virginia. Even then, there was no guarantee of
how many shifts he might be given. Then there was the constant danger

*Norman McMillan retired as a professor of English at the University of
Montevallo. He is the author of* Distant Son: An Alabama Boyhood.

in the mines. Deaths in U.S. coal mines numbered more than a thousand a year in the early part of the twentieth century. Thousands of other miners were seriously maimed in accidents each year; Sue considered David lucky in that he merely broke his foot in a mine accident. "Black lung" was not well understood until years after the period about which Sue Pickett writes, but that disease, too, caused by constantly breathing in the fine coal dust which filled the underground mine shafts, crippled and reduced the quality of lives of many longtime miners.

Nonetheless, the uppermost concern for the Pickett family was that David find employment. The pay he received was barely a living wage, but somehow the family made do. Sue even earned $1.50 a week writing for the *Daily News* in Welch, West Virginia, crafting poems from the dreary headlines of the day. But the Picketts were much better off than their family and friends back in Alabama. In fact, quite a number of Alabamians came to West Virginia to stay with them while looking for work, often unsuccessfully. Nobody was turned away.

Another struggle the Picketts faced was being confined to cramped quarters. Throughout the memoir, we repeatedly have the sense of far too many people crowded into far too little space. Thunderbolt, designed for five passengers, amazingly transported fourteen family members on a trip of 140 miles. Plus there was the matter of privacy and modesty in the overpacked houses of that day. Sue, for instance, became adept at changing her clothes under the bedcovers while a room was crowded with people.

Both in West Virginia and Alabama, the Picketts frequently struggled with the elements. Inadequate heating and cooling as well as insufficient clothing and cover were a constant challenge. One freezing night they arrived unannounced at Sue's father's house to find all sleeping spaces taken. Sue and David managed to squeeze their girls into beds with others and then took themselves to a cotton storage room to spend the night covered over by mounds of cotton.

As tough and resourceful as Sue and David were, they could only make it with the help of others. Sue's brother-in-law, George, told them, "As long as I've got a biscuit, you won't starve," and that seemed to be the attitude of most of Sue and David's family and friends.

Despite this mutual support, mineworkers and their families were, for the most part, no match for oppressive mine owners. By 1933, the ever-restless David had learned that jobs were again becoming available in the coalfields of Alabama, which were an integral part of the iron and steel production that had contributed to the industrialization of Birmingham. So the Picketts moved back to Bibb County and settled in the company town of Piper, established in 1901 by the Little Cahaba Coal Company and named for industrialist Henry F. DeBardeleben's partner, Oliver Hazzard Perry Piper.

Democrat Franklin Roosevelt was elected in 1932, and in 1933–34 his policies began to restore hope and bring some relief to the desperate. Still, the weak economy suppressed the wages of even those fortunate workers who had jobs. Sue tells of a group of miners who went to their bosses and pled for higher wages because their children were starving. The owners refused, one suggesting that the children could eat mussels from the mountain streams and hickory nuts from the trees of the forests. Sue's resentment of this callousness is palpable, and she sympathizes with the coal miners as they take drastic steps to achieve better wages and work conditions.

In 1933, a series of coal strikes were called by the Congress of Industrial Organizations, of which the United Mine Workers Association—led by John L. Lewis—was a part. Previous strikes by miners in Alabama had been suppressed by the private security forces of the industrialists with the backing of state government, and in 1933 Alabama Governor Benjamin Meek Miller called out the National Guard to put down the strikes.

But by the spring of 1934, some 90 percent of Alabama coal miners were unionized and their collective strength was too great to be denied.

Those miners were, of course, both white and black. While Sue does not dwell at length on the issue of race, she is writing about a period in Alabama and Southern history in which race loomed large in both law and culture. David Pickett began working in the mines in 1926, and it was not until 1928 that Alabama's brutal convict leasing system was abolished; 90 percent of the convicts sentenced to what amounted to a second form of slavery in the state's coal mines were African American. The first few decades of the twentieth century were also the peak period for lynchings in Alabama, and the rigid system of Jim Crow segregation governed every interaction between blacks and whites. Sue does describe, if briefly, a moving incident in West Virginia in which her Alabama racial acculturation collided headlong with her inherent sense of human decency and the guilt she felt from that incident. How many thousands of white Southerners must she have spoken for in the few paragraphs she wrote about that encounter? On their trips back and forth between West Virginia and Alabama, Sue and David would also have passed near Scottsboro, Alabama, and Chattanooga, Tennessee, where the 1931 "Scottsboro Boys" events unfolded. Some of the cross-racial organizing around that famous case took place within the labor movement, which was gathering force after the election of FDR in 1932 and factored into the coal miners' strikes. Sue describes these strikes in some detail.

Sue describes a thousand miners—of both races—from the Cahaba coalfields arming themselves and surrounding a building in Coleanor where the owners and their armed guards were discussing how to break the current strike. This event in March of 1934 ended without bloodshed, due largely to the positive influence of the union leaders. The owners surrendered and agreed to negotiate. David, armed with his own weapon, participated in this event, and Sue respected him for it.

After the Depression, things generally got better for the Picketts, as they did for families across America, due in large part to FDR's reforms. David became superintendent of the No. 9 mine in West Blocton, Alabama, and he moved his family into the spacious superintendent's house. When he took a job in another mine, his successor chose not to live in that house, and David was able to buy it, much to Sue's delight. The Picketts spent their last years there, and Sue resumed a journalistic career begun back in West Virginia. For a number of years she wrote a column for the *Centreville Press*. Typically, she began by describing the beauties of nature, recording rapturously the first jonquils of the season or the first blooming of the dogwoods. She then wrote of family and friends, and she often ended with religious musings and exhortations.

I discovered Sue Pickett from these articles, and she was in her eighties when I first met her. Friends from West Blocton took my wife and me to visit her at the superintendent's house. It remains a memorable experience. Dressed in white slacks and a white blouse, a beautiful lady with white hair piled on her head invited us into her living room. I have always heard of understated elegance, but I saw it that day in that room, with its few well-chosen decorations. While we were there, she brought out a large box containing manuscripts, correspondence regarding her writing, and newspaper clippings. She showed us a letter from a magazine editor accepting a short story and complimenting her on her writing.

Later on, when I read *The Path Was Steep*, my mind went back to that day, as the same pride, love of beauty, and kindness I witnessed then are present on every page of the memoir. The book gives us not only a window into a significant era in our nation's history, but a fine example of a life well-lived.

The Path Was Steep

*An * in the text indicates terms perhaps not familiar to contemporary readers. A list of definitions will be found on the last page.*

You Could Almost Smell the Depression

S mall heat devils shimmered all down the road. Corn, stripped of
its fodder, hung limp on the dusty stalks, the ears few and smaller
than average. Cows lay under trees in brown pastures. Only the
small bitterweed flourished and blossomed along the roadside, the yellow
flowers dirty, as gold all too often is dirty, though no one that I knew had
even a nodding acquaintance with gold.

We didn't blame God, of course. He was far above and beyond blame,
but Hoover was different—almost two years now since the October crash,
and the president had not stood in the breach.

The Depression stretched across the world, but I was not too concerned
with that. My own small part of the world had crashed about me, and I
was forced to leave home, relatives, and friends. Yet these same friends and
kinfolk thought me extremely lucky. David had a job. When he wrote that
he'd made $14.50 his first shift, the news, like wildfire, spread to Birming-
ham, all through Jefferson County, and on to Bibb and Shelby counties.

The fact that he'd only worked eighteen hours as machine-helper was
almost as fantastic. In Alabama mines, men begged for ten-hour shifts at
two dollars a day.

David's last letter had enclosed a money order, and now the babies
and I were leaving for West Virginia. Alabama's heat devils were beautiful
to me, and the parched fields and the dirty gold of the bitterweeds. My

heart was as bitter as the small blossoms we passed on our way down the lane to the highway.

Papa's old Ford was still able to navigate, so he'd offered to drive us to Birmingham. Dust fogged behind us and put another coat of dirt on the bitter gold. The car growled sluggishly for half a mile, sputtered as we turned onto the Dixie Bee Line Highway, clanked ominously, and then died.

Papa adjusted things, climbed out, and turned the crank. Nothing. He pushed his hat to the back of his head, scratched a minute, and then lifted the hood of the car. The motor hadn't fallen to the road, but it might as well have for all the life that it showed.

"I'll push; you steer," Papa said and spat tobacco juice at a dusty pine. We rolled down a slight hill. No sign of life from the motor.

"Never make it to Birmingham." He mopped his brow.

"I want to see my daddy," Sharon wept. "I want to show him my new shoes."

Davene, almost fifteen months old, had preened over a new dress. Now she looked at her three-and-a-half-year-old sister and began to wail in sympathy.

Papa kissed the girls. "I'll stop the next car." He'd never learned to be afraid of anyone.

As if on signal, a gaudy, roaring rainbow turned a curve and shuttled towards us. Papa's long arm reached out, and his confident thumb waved southward. The rainbow, a Stutz Bearcat, 1919 vintage, stopped. Its yellow body, purple hood, and green, red, black, and blue fenders dazzled us.

"Trouble?" An incredibly tall, thin man unlimbered himself from the car. He had a turkey-red neck, bright blue eyes, thick shoulder-length pinkish hair, tobacco-stained pinkish mustache, and thick bushy eyebrows. Dressed in blue overalls, white shirt, and green tie, he was as brilliantly colored as his Stutz. He loped to the Ford and peered under the hood.

"Let me see them babies," a warm, feminine voice said. Eyes adjusted to gaudy colors, I blinked at a drab, smallish woman. Hair, skin, and dress were mild shades of tan. The little thing hopped to the earth and grabbed Davene. For both, it was love at first sight. The woman crooned a minute, then raised beautiful, dark eyes. "Me and the old man never had any children." She put a twig of a finger in one of Davene's curls, then touched Sharon's cheek. "Oh, what a love you are!" she said.

Sharon, used to the back seat since Davene arrived, flashed worshipful eyes.

"Me and the old man just sort of baby each other," the woman smiled, and her small, weathered face grew beautiful.

The man found time to look at her. His face softened; the moment seemed almost holy. Then he bent over the Ford again. "All shot to hell," he said.

Papa flinched.

"Griff don't mean no harm," the woman said. "He's a good Christian man."

"Christian, hell!" Griff exploded. "The old woman has her way, she'll take me to heaven on her coattails. But a wicked old devil like me won't never make it," he grinned.

His wife closed her eyes, and her lips moved.

"Prayin' again," Griff said. "That's the prayinest woman this side of paradise."

Papa's smile was broad and happy. A woman who prayed was to be trusted. "Sue here," he flourished his hand. "My daughter, Mrs. Pickett, has to catch a bus in Birmingham." He scratched his head confidently. "You going that far?"

"If we wasn't, we'd make the trip just to hold these babies," the woman said.

"Old woman! You tryin' to boss me!" Griff bellowed.

"If you don't want to take her . . ." Papa's hands wavered in their confident flourishing, and his Mosley pride reared.

"Don't git on yo hoss," Griff said. "Just ain't going to let that woman boss me."

"Griff's powerful independent," the woman's eyes sparkled, and her face showed her pride.

"I'll pay you, of course." Papa reached for his worn, leather purse. Bless him! I knew he scarcely had a dollar.

"Talk about pay and nobody rides," Griff settled the matter. "Old woman, put them younguns in the car."

Serenely, Papa dropped some coins back in his purse. The man was good. All men were good. His faith in humanity was restored.

"Can I hold the little one?" Mrs. Griff asked.

"Oh, yes." I looked at the Stutz doubtfully. It was heaped with bottles, brushes, boxes, and buckets of paint.

"Pile the satchels on top, old man," Mrs. Griff said. He stiffened, saw Papa's trusting face, and meekly piled the satchels.

"Now, now, you be good." Papa blew his nose.

"Papa—" I choked and kissed his cheek. My hands clung to his for a minute; then I climbed into the Stutz. It roared, and we were off, whirling past the dusty fields and parched gardens that were suddenly so beautiful to my heartsick eyes.

OUR JOURNEY WILL NOT be forgotten. People on porches, in yards, and in gardens stared at us as we bolted along. Davene babbled happily. Sharon crooned a song about Daddy and new shoes. Mrs. Griff hugged Davene hungrily—too hungrily, I thought. My faith was not as strong as Papa's. No children were as beautiful as my two girls. Who wouldn't covet them?

"Whoah! There's a dollar!" Griff slid the car to a stop. Would he rob a man in broad daylight?

"Sure we got time?" Mrs. Griff asked.

"Shut up, old woman!" Griff descended from the Stutz. Two strides took him to an ancient, rusty car parked at a service station. A small, white-haired man dressed in white shirt, pressed pants, and red suspenders leaned against the car. "Paint your fenders, mister?" Griff asked. "Paint one free just to show how it looks."

"But—"

"What color you like?" Griff busied himself with buckets and brush.

"Blue," the man admitted. "But—"

"Blue it is," Griff said and began to smear on blue paint. His speed was incredible. "As I said, paint one free. Others just a dollar. Look better?" He stepped aside to admire his handiwork.

"Maybe," Red Suspenders grudged.

"Want I should paint the others?"

"What else can I do?" The suspenders matched the man's temper. A good thing Papa wasn't there; the man's profanity would have crushed him. Curses spouting from his lips, he opened a worn purse so like Papa's I had to remind myself of the smallness of my own purse, and that little girls must have food on our trip, or I would have offered to pay for the fenders.

Gnarled fingers hovered over the purse; then it opened, and I saw it didn't resemble Papa's at all. It was stuffed with bills and silver. Fingers caressed each coin, then slowly counted out a quarter, five dimes, four nickels and five pennies.

His artwork accomplished, Griff started to board the Stutz. Then another car stopped. A man stepped out and walked over to admire the blue fenders.

"Paint yours for a dollar," Griff offered. "Paint the first one free. What color you like?"

"Well, green, but—"

"Green it is." The owner of the blue fenders grinned as Griff began to smear on green paint.

"Griff's sure smart," Mrs. Griff beamed. "Mixes his own paint. Don't hardly cost nothing. We been to Florida and all over. Got some put away for a rainy day, too." She shifted Davene to a more comfortable position.

Two more cars stopped.

I suffered.

But the painting went swiftly. Then Griff took out a heavy gold watch, glanced at it, stored buckets and brushes, and we roared towards Birmingham.

"You brought me good luck, little girl. Like to have you with us all the time," Griff said.

"He never could resist a pretty face," Mrs. Griff said and sat very straight. "But he knows I'd put rat poison in his coffee if he went too far."

"She'd do it, too," he boasted. "Prayin' all the time."

WE REACHED THE BUS station with ten minutes to spare. You could almost smell the Depression in Birmingham. Certainly, you noticed the freshness of the air, the lack of smoke from steel mills. People walked more slowly. There was the very feel of despair. No brisk, beautifully dressed people like those who five years ago walked joyously these same streets. (I was one who walked with that joy, my feet scarcely touching the sidewalks.)

Griff helped me with bags and boxes. "How much do I owe you?" I felt pride-bound to ask.

"Not a red cent," Mrs. Griff said and buried her nose in Davene's curls.

"Old woman—" Griff began. I opened my purse. "None of that," he shouted. "Old woman got rare pleasure from holdin' them younguns."

Her eyes were serene "Like I said, Griff's got the heart of a Christian."

I bought my ticket, and the bus was ready. "Take good care of them younguns," Mrs. Griff said.

My feet were heavy as I climbed the steps. My lungs filled hungrily with Alabama air. It isn't fair, I thought bitterly. What have I done? I may never see Alabama again.

With my blood and heart and mind, with my very breath, I wanted to see David, to have him hold me and promise, "Everything will be all right." But I wanted it here in Alabama, back in Piper, our small coal-mining hometown, and not five hundred miles away in a strange West Virginia town.

What October Would Bring

Papa had once been a coal miner, and as a child I had learned the snobbishness of those whose fathers earned their living working on the earth's surface. We were low-class, ignorant, dirty to them. In those days of rare indoor plumbing, miners must have been the cleanest of all people. Others took baths Saturday night, if that often, but miners, of necessity, tubbed themselves daily.

We knew that we were not dirty, and we didn't think of ourselves as being in the lower stratum. We read our Bible, the King James Version, and understood that naked we came into this world and naked we shall leave it. The rich man's son appeared red and squalling out of his mother's womb; so also came the coal miner's son, a little stronger perhaps—his father was muscled and tough. But all were brought forth equally, in pain. We were Americans, freeborn, and we didn't know there were any little people.

Living with constant danger, our men were fearless. In the darkness beneath the earth's surface, they knew a brotherhood that none else could know. Black men and white rode the trip into the mine. Down there, at least, the color of one's skin was not important. Even farmers did not understand the earth so well, nor love it more. A miner knew its very belly: the dank smell of underground; water dripping from hidden streams in the rock; total, utter darkness. He knew the power of sheer weight that

made itself known in crackings and groanings in the roof, usually just before timbers on the longwall* began to splinter.

He knew the god of fire that hid in the bowels of the earth, that could, of itself, explode into blinding light and power and death as gases ignited. He was aware of the colorless, odorless carbon monoxide that could bring death on silent feet. Ignoring this, miners enjoyed the godlike feeling that came as they mastered the underground. My husband, David, was a timberman for a time. There were no steel bolts then to hold the roof. A score of timbercutters worked endlessly in the woodlands surrounding the mines to keep a supply of timbers on hand.

The roof was uneven, pockmarked with holes and sharp rocks. The life of all depended on holding that roof on the longwall, and the timberman, with a helper, never had time to rest. He dragged heavy timbers to a dangerous place, set them, and drove capboards* to fit under the roof, even as the top began to settle and sometimes crushed oak or pine. As the weight above splintered timbers, he set others quickly to save his own life and the lives of the men who worked on the wall, or face, cutting and loading coal.

They sang as they worked, joked and laughed when there was breath for laughter, fighting the dark overhead that grudged the taking of its black veins of coal. A carbide lamp with hooks that fitted onto a cap fought the chaos of darkness. Each man knew that an unexpected flow of gas from a newly opened pocket could ignite from a lamp, and perhaps an explosion would crash through the mine with vivid light, tumbling rocks, then death and darkness.

DAVID AND I MET in the summer of 1926; we were married October 5th. The war to end all wars had been fought and won. The future stretched ahead, a golden haze. David worked at the By-Product Plant of Woodward Iron, in Dolomite, and I was a long-distance telephone operator in the

Birmingham office. "Dave has a wandering mind," his mother told me shortly after we married. He proved it. The Woodward job paid $4.40 a day. David was offered work in the Belle Ellen mine at five dollars a day. So it was back to the mining camps for both of us.

There must have been half a hundred mines within a radius of fifty miles of Birmingham. Nowhere else in America, perhaps in the world, were all the ingredients for making quality steel in such close proximity. Iron ore, coal, dolomite*—everything was at hand. Woodward, Republic Steel, T.C.I. (Tennessee Coal and Iron, a subsidiary of U.S. Steel) gulped millions of tons of coal.

The pay at Belle Ellen didn't pan out. David may have had a wandering mind, but never, for one moment of his life, was he lazy. After finding and quitting three more unsatisfactory jobs, he began work January 6, 1927, for the Little Cahaba Coal Company at Piper, forty miles south of Birmingham.

I was dreadfully homesick for all of a month. When we went to Bessemer and I heard the screech of streetcar wheels, I wept so hard that a strange woman glared at David. "You ought to be ashamed of yourself!" She shook a finger at him. His face was so amazed that I began to laugh, and my homesickness died. The magic of Piper captured all of my heart. I have never since loved a place so well.

The Cahaba River had cut a deep gorge across Bibb County. The river banks and the hills were covered with trees, mountain laurel, honeysuckle, violets, ferns—a wild beauty that caught at your heart, and forever after you were not quite so happy in another place.

On a series of rolling hills far above the Cahaba, shaded by giant oaks, Piper was cool and lovely in summer, and winter did not seem so cold as in places on the lower hills of Bibb. In spring the hills were covered with small blue daisies. There was a special light there, too, and the air was so pure that you had a constant sense of well-being.

The houses in Piper were scarcely worth mentioning. The ancient red and green that had once stained them now blended into muted colors. Plumbing consisted of a lone hydrant on the back porch. Three large, high-ceilinged rooms was the usual size. You were lucky to get a four-room house and smart if you stretched canvas on the back porch to make extra sleeping room.

In our small house, we had food, shelter, clothes, and an ocean tide of love. Sharon Sue, the most beautiful baby in the world (she resembled her father, his gold hair, blue eyes—his were blue-gray—perfect skin), was born fourteen and a half months after we married.

And there were friends in Piper. Real friends. In happy times or troubled times, you could count on them. Most people belonged to the Baptist or the Methodist church, and very large crowds attended the services.

HOOVER WAS ELECTED PRESIDENT in 1928. There would be two cars in every garage, two chickens in every pot. David was so sure of this that he came home one afternoon to announce that we were leaving for Detroit, and we left the next day, in June 1929.

Homesick for my loved friends and the Piper hills, I wept at night. But I'd learn to like it. Detroit offered a million opportunities. No one dreamed what October would bring. But some of the plants did not wait for October. Budd Wheel, where David worked, began to lay off men. Thousands, jobless, knew distress, but David and I packed our few belongings and caught a bus to Alabama.

Mr. Randle, the superintendent at Piper, was glad to give David work. People still speak of David as the most beautiful man they ever saw, with the most beautiful speaking and singing voice. He had a special electric charge, lightning-streaked eyes, Greek-god features, but he also had something else. "Mrs. Pickett," Mr. Randle told me, "Dave is the best damn worker I ever saw, and he has the worst damn temper." I knew. I certainly knew.

The temper meant talent, a determination to succeed. Finally, with God's help, the temper was almost conquered.

Piper coal was the best coal in the state, and work was steady that winter. We bought furniture, rented another three-room house. There was the living blaze of autumn, smoke from chimneys, friends. Dreams? Mine were here, but all across America, dreams became nightmares. Winter passed. Davene was born in June 1930, another beautiful blend, and the Depression swooped down on America as a giant bat swoops for its prey.

America reeled under its impact. Coal mining, a sleeping giant, suffered through hard times, then roused, walked, and grew until in full strength, the men—400,000 of them—at one word from their leader could bring to a dead stop the war effort of America—if they so desired. One shake of John L. Lewis's eyebrows, and kings and presidents listened. Lewis, the greatest of the labor leaders, had worked in the mine himself. He knew the danger, sweat, exhaustion, the griefs, heartaches, and joys of the men. He spoke for them, and they trusted him utterly.

The twin villages of Piper and Coleanor, and their sister town of Belle Ellen across the Cahaba River, began the movement that spread through Bibb County, Alabama, and the South to join their northern brothers. Then, united, coal miners fought until the nation recognized their power and acknowledged their rights as human beings.

Late in 1933, Jim Ledford and Bryant Berry began a list that grew until every man in Coleanor and Piper (except the officials) had signed. The men had organized the once-dead (in the South) United Mine Workers of America.

On a wild night in March 1934, an armed mob gathered at Coleanor, ready to fight and, if necessary, die for the rights to which they had newly awakened. Men raced from Belle Ellen; some, too-hurried to take the long ride by car, swam the Cahaba River to reach Coleanor, just over the hill.

One black man wept as he ran, afraid that someone else would kill Mike Self, whom he believed it was his right to kill.

Legends had grown and multiplied about Mike Self. Half of them may have been true. Self was company deputy at Acmar—shack rouster, a deputy was called. His duties included rousing a late sleeper from his bed and forcing him to work. Another was ejecting families from company houses if, having been discharged, they refused to move.

Mine owners, too, fought for their lives during the Depression. Living over the mountain* in Birmingham, as a rule—with Cadillacs, jewels, furs, and trips to Europe as an accepted way of life—they were scarcely aware from the top of the turbulent base of the pyramid that held them aloft. The owners hired general managers. Next came the superintendents, then mine foremen, or wall bosses. The latter were part of the workers and sympathized with them.

Wounds received during the Depression festered. Bitterness grew, and finally the day of reckoning came. Coleanor, Piper, and Belle Ellen had come out on strike. Word came that Mike Self and deputies had been hired to guard the men who would be brought in to break the strike. Miners across the Cahaba field gathered with one objective: to fight, to kill! kill! kill! if necessary.

But I am getting far ahead of my story.

≡≡ 3 ≡

As Long as I've Got a Biscuit,
You Won't Starve

Ｔhe Wall Street crash had come unexpectedly to a prosperous, joy-mad America. This was followed by the burning summer of 1930, with drought and parched fields. The topsoil of many farms blew away in the Dust Bowl. Former millionaires, not knowing how to face life penniless, jumped from skyscrapers. Work across America slowed; wages plummeted. Few were able to buy cars. Plants in Detroit closed or operated two and three days weekly. With the production of cars dropping, steel companies suffered. Men in the giant mills were laid off indefinitely. These unemployed men could not buy other products, and plant after plant suspended operations.

The drought summer of '30 was followed by a warm and gentle winter. How lovely the Piper hills and soft air were, but worry kept us from enjoying the beautiful weather. Coal miners ardently wished for cold weather. When frost hardened the earth, people managed to buy coal. But on mild days they burned sticks, chips, cardboard boxes, even newspapers, if one was lucky enough to subscribe to a paper.

Six days a week was the rule at Piper. Now, towards spring, a day's work depended on the morning train. We listened agonizingly for the shrill whistle and the clonk of couplings, as a loaded car was hitched onto the train and an empty car left behind.

One April afternoon, I took Sharon, now three, and ten-month-old Davene into the garden to survey prospects for spring planting. Davene found a chicken dropping and tasted it experimentally. I grabbed for it, expecting her to wrestle for her find, but she threw it to the earth and cried, "Daddy!"

Black with coal dust, David stood in the kitchen door.

"Watch the baby while Daddy bathes," I told Sharon, and put Davene back on the porch. It was very low; a fall wouldn't have hurt her, but Sharon was better than a watchdog. She loved her baby sister and had never heard of "sibling rivalry." If Davene crawled near the edge of the porch, Sharon pulled her to safety.

In the kitchen, I looked at the cornbread and stirred the butterbeans. The cornbread was crisp and brown. I pulled it from the oven and emptied the beans into a blue bowl.

David took the kettle from the stove, poured boiling water into a large zinc tub, and cooled the water with two buckets from the back-porch hydrant. Then he undressed and hung his black work clothes, stiff with dirt and sweat, on a nail behind the stove. "I'm leaving Piper," he said. On his knees beside the tub, he washed his face, head, and shoulders; dried them; then stepped into the tub. Muscles rippled with every movement: timber-setting, coal-shoveling muscles.

I'd expected this, yet was not prepared. We knew that things were bad. Women fought hunger and despair with soap and water. Clothes might be worn thin and patched, but they were clean, starched, and ironed. The men, scarcely able to feed their families, had grown careless. A week's growth of beard grizzled many chins as they gathered daily at the commissary. "There ain't no work anywhere," they'd say.

Rumors of jobs in Kentucky and West Virginia drifted into town. Other rumors told of long lines of men waiting in every place to find jobs. A man would take work at half the usual pay.

Slavery? In free America? Yet he must feed his family.

Now I was silent as the fair wind stilled, and the birds stopped their singing. The only sound was the slosh of water as David soaped and rinsed. Black streaks ran down his sides and into the tub. Black drops spattered the old tow sack* I'd spread around the tub. Blackness hid the late sunlight and the sky, and pulled a curtain across my heart. But what could I say? It was David's job to earn a living. He was not equipped to sit and starve. Jaunty and confident, he was sure that a good job, somewhere, had his name on it.

"Times are bad everywhere," I said. "Maybe they will get better."

"Not in Piper. Work always slows in summer."

Nothing could stop his leaving. Desolately, I packed clothes and personal belongings. The furniture, bought on payment after a summer in Detroit, went back to the store. My father lived on a farm, and there was always plenty of food there. Tears dimmed my eyes as I held Davene and took a last look at green hills. Sharon's fair head leaned against me. I stooped to kiss her. Would we ever see these hills again?

My sister Thelma and her husband, George Johnson, managed a form of survival on the small wages he earned at Woodward Iron. A neighbor took us to Dolomite, where they lived. The neighbor was one of the rare greedy ones. In Piper, we helped one another, but not this man. Dolomite was not even a block out of his way to Fairfield, but he charged five of David's lonely dollars to let us ride.

He knew we had a small sum from the sale of a few things—bedding, etc.—at half their value. But few were like him. Near hunger brought out the best in others. They were willing to share to the very last.

Bag and baggage, what little we had, we arrived in Dolomite unexpectedly, just before noon. If Thelma and George felt consternation, they didn't show it. George grinned, his black eyes alight. Jean, almost three, and Ailene, seven, grabbed the girls. Thelma kissed us all, then started over. Who wouldn't? With David there to kiss?

"I wrote to Papa. He's coming for us," I offered, as if giving a present.

"You are going to stay with us," George stated.

"Dinner is almost ready," Thelma said.

She had made a dress for a neighbor, who returned the favor by bringing a sack full of cabbage. George, unable to buy shells for his gun, set out homemade traps for birds and rabbits. Six birds, little more than thumb-size, added flavor to a bowl of dumplings. The cabbage, steaming hot dripping with salt, pepper, and a touch of sugar added; light, fluffy biscuits; and gravy, rich with canned milk, made you doubt that there was hunger in the world.

Food! It became more and more important. Not something you took for granted, but worthy of genuine thanksgiving.

Papa rattled up in his old rusty Ford a few minutes before dinner. He was so vividly alive. After the assassination of each of the Kennedys, people would say, "He can't be dead! He was so alive!" A few, rare people have this quality. Papa had it to a great degree. He registered, cast a long shadow. My father, Lee Mosley, had stubby-lashed gray eyes, a patrician arched nose, and straight black hair. Very thin and pine-tree straight, he was still a handsome man—so virile that less than a year after my mother died, he had married a young, pretty wife.

Papa had never been neutral about anything. His religion came first, then politics, farming, weather, this Depression. He was interested in every subject and deeply involved in it. Earth, water, skies, animals, people— people most of all. Like Will Rogers, Papa never saw a man he didn't like.

This day he offered thanks for the food. Flourishing his knife and fork, illustrating his remarks with his hands, eyes alight, Papa ate, talked, and, as always, managed to quote a few scriptures.

Then it was time to go. George and Thelma came with us to the car. I was quiet, quelled. This wasn't happening. We were just visiting. Only little jabs of pain struck through my middle and called me a liar.

I clung to David's arm, walked beside Thelma, sniffed the nearby gases of the Woodward plant.

"Things are bad everywhere, son," Papa waved his hands downwards to illustrate his remarks.

"I'll find work," David said confidently. He rolled a Bugler cigarette, careful not to spill a grain of the precious tobacco. Finding a match, he lifted his leg to tighten his pants, and scratched. The thin material held, and the match ignited. "Someday," I predicted silently, "he'll bust his britches."

"Do you need any money?"

"No, sir," David lied.

"I could let you have a dollar or so."

"Honest," (how often people use this expression when about to tell a whopper) "I don't need a thing." David smoked a few draws and handed the cigarette to George.

"If you can't find a job," George inhaled, then returned the cigarette, "come on home. As long as I've got a biscuit, you won't starve."

"I'll remember that," David laughed, as if at a joke. He and George smoked the cigarette alternately, holding it at the last between thumb and forefinger.

"Well, I have to plant some corn," Papa said.

I kept a smile on my carefully painted lips and blinked to save my mascara. But the smile ached in my throat. Sharon was too young for bravery. She clung to David's legs and wept.

"Daddy will send for you soon," he stooped to kiss her.

But I mustn't cry, though I wanted to scream, "Don't leave!" I knew his mode of travel. A freight train. I knew the danger. Lose your grip as you caught the train, and you would be crushed beneath the wheels. A "hobo" must spot an empty boxcar, swing onto it, and climb into an open door.

Guards searched the cars. If caught, a man was thrown into jail for several weeks. How the bright plumes of David's pride would be soiled in

jail! If not caught, how would he eat? This, too, I knew. I could almost see him. His face would be shaved and clean; he'd manage that at a creek or someplace. His teeth would be brushed, and his hair, combed slick with water but drying, would be a tumble of bright gold curls. His long lashes would droop over his gray eyes to hide the deep hurt to his pride, but his smile would be wide, showing his unbelievably white teeth as he said, worn hat in hand, "Lady, do you have some work that I can do?"

No woman could resist that voice and that smile; this, too, I knew. He would eat, but at what cost to his pride.

"You write soon," I whispered.

His face was white, but he smiled; he even swaggered a little; then his shoulders drooped. He didn't slump; he'd not let himself do that. His smile was crooked. "Don't worry, I'll send for you soon."

Papa coddled the motor of the old Ford. It sputtered, heaved, then racketed forward. Davene, happy to be riding, didn't even look back, but Sharon wept desolately, voicing my own thoughts: "Will we ever see Daddy again?"

Despite All, Well-fed and Loved

As we rode towards the small town of Morris, we were strangely quiet. Usually, with two Mosleys together, you had a conversation. Frequently a heated conversation. "Papa," I said finally, with the pride bred in people in that era. We didn't want to be beholden to anyone. We wanted the best things in life, but only if we earned them. We knew God's law "In the sweat of thy face shalt thou eat bread" and didn't want relatives, friends, or a benign government in Washington to heap unearned benefits on us. So now I said, "I'll be lots of trouble and expense, Papa. I'll help with the farm work."

His face reddened. He turned to speak; then he took my left hand in his, lapped his thumb and forefinger around the wrist, and said, "You—a farmhand?"

I looked at the wrist angrily. At that time, I was quite thin and practically boneless. Nature had given me very small hands. They were David's special pride, but I looked at them in anger now. Of what earthly use were they?

"I'm stronger than I look," I said.

"You've never been strong."

"But I will help . . ."

"The boys can help all that I need," Papa settled the matter. His heart as big and broad as the fields through which we passed, Papa understood all that I felt and thought. He had been close to my position all too re-

cently. He'd worked in the mine for years; then at the beginning of the Depression, his section at Majestic mine closed. He was out of work, past fifty, with a wife and six children to support. Providentially, Mildred, his wife, had an income of $28.75 a month, insurance from a brother who had been killed in the war. Papa rented forty acres of land near Morris. His credit was good for a mule, a cow, and a few farming tools. Rent was three bales of cotton a year.

We left the Dixie Bee Line Highway and turned into a lane that led to the farmhouse. It was unpainted, age-silvered, with a front and back porch, and an open hall separating the rooms. There were two large front rooms, each with a rock fireplace. One room had a bed in each of three corners, a table, chairs, and an old phonograph. The other had two beds, a dresser, a wardrobe, a rocker, and a trunk whose flat surface served as a chair.

A small room was at the back of one bedroom and a kitchen behind the other. The kitchen was furnished with a Hoover cabinet in desperate need of paint, a cook table, and a shelf for water buckets and washpan. Big tin cans on the floor held sugar, meal, flour, and lard; they left room for the large dining table in winter.

A dog-run with a homemade bench and a few cowhide-bottomed chairs served as sitting room in summer, and we used the back porch for dining.

Here a long plank table was matched by benches at either side. Extra chairs seated as many as could crowd around the table. Water buckets, washpans, tubs of pepper, and flowers lined wide shelves. A gourd dipper added unbelievable sweetness to the water. Used to my own private glass, it was a few days before I could relish this, but "beggars can't be choosers," and I soon drank from the gourd as lustily as anyone.

A day or so later I set out sweet potato plants. Possibly I hoed a little, but other than that, I was practically useless. Miss Mildred did the cooking. I gathered vegetables and washed dishes. The children wore feedsack

shorts and were bathed daily in a zinc tub under the pear tree. There was little washing and less ironing.

Three times a day the table was loaded with food. Around the table crowded the lively children, dogs, cats, chickens, and a swarm of happy flies. I soon grew used to noise, crowding, and insects, and all summer I kept a peach tree switch handy, waving uselessly against the flies. Miss Mildred was very kind. Not once did she ever make us feel unwelcome.

The railroad was only a mile away. At night, when I heard the lonesome wail of the train, I wept, thinking of David stealing a dangerous ride, and I wept for myself and the children. A few tears now and then spilled for others, but, selfishly, I had very few for any but my own woes.

A card finally came from David. He had gone to Detroit. The breadlines were staggering—no chance to earn a living in Detroit. He was leaving for Kentucky.

Papa, up before dawn, worked tirelessly; then after lunch he propped a chair upside-down against the wall in the cool breeze of the dog-run*, his head on a pillow that fitted onto the rungs of the chair. He would read his Bible and then take a short nap before returning to his plowing.

After dinner dishes were washed, I often sat in the hall, or lay on an old quilt while the children played, or took a nap.

Papa looked up from his Bible one day. "Sue, this will pass. You have to stay here until David can send for you. Why not make the best of it?"

"Papa—" A long look passed between us. "I will try." He returned to his Bible reading. My eyes dropped to his hands: long, thin, muscled, aging, the very veins showing his mortality. A lump came into my throat, and my eyes dropped to my own small, white hands. Every finger and joint was shaped exactly like his. I had Mama's big, dark eyes, but I realized suddenly that perhaps every wrinkle in my brain came from Papa—he understood me so well.

THERE WAS ACTUALLY A great deal to enjoy. Mosley aunts, uncles, and cousins lived on nearby farms. My sister Maurine and her husband, Ezra Armour, owned a country store at Haig, six miles away. With five children, Maurine needed help, so our youngest sister, Lucile, had moved in to sew, sweep, clean house, and take a chief part in all the events of the community.

Our brother Clarence had been working in Tampa when the Depression hit, and he returned home. With a limp from polio and a hand that wouldn't always obey him, Clarence was lucky that Ezra found work for him in the store. A large group of young people were in the area, and they had hilarious times together. Pat Buttram was one of this group. Later, Pat became known as "the boy from Winston County" on national radio. Still later, as a famous movie star, he provided the humor in Gene Autry movies.

The children enjoyed every minute on the farm. There were downy chickens just hatched, a hen bringing in a new brood every few days. There were kittens, dogs, flowers blooming, and gardens. Fruit would soon ripen. I became happy by day in the peace of summer on a farm, only at night letting my tears wet my pillow.

Davene learned to walk, the others cheering her on. Sharon, her blue eyes filled with love, seemed to think that she had done something wonderful the first time Davene walked the length of the hallway.

Miss Mildred's check came, and Papa asked if I'd like to go to Birmingham with him to buy a month's groceries: half a barrel of flour, 160 pounds of sugar, and coffee, soap, soda, etc. Our brief shopping ended, we drove out to see Thelma and George.

Sharon and Jean ran out to play, but soon came in crying. Jane Grant, carrying her small black dog, was with them. He had bitten Jean's leg and Sharon's hand.

"He is old," Jane explained. "He doesn't like children."

"Is he sick?" I asked. We knew little of rabies then.

"Just bad-tempered." Jane cuddled the dog, put her cheek against his

silky coat. He whined and hid his face against her arm. My small fear died.

Back at Papa's, we sank into the same routine. Day after day I trudged to the mailbox and returned with no mail from David.

Lucile invited me to the movies. She and John Suddeth, one of her current boyfriends, would be glad to have me along. Miss Mildred, happy that someone had a chance at some fun, offered to keep the girls.

I didn't have as much fun as I'd hoped. I felt guilty and uneasy. Was David having fun? Did the girls miss me? When we reached home, a car was parked at the front. I said my hurried thanks and went inside. Thelma and George were there. "Lucile would have waited . . ." I began, but Thelma burst into sobs. "Oh, Sue!" she wept.

George put his arm around me.

"Now, now, don't scare her," Papa said.

An avalanche of ice crashed about me, putting fear in my chest, numbing my hands and feet. "David's been killed!" I thought it would be a scream, but it was only a dry whisper.

"No, not that bad." Thelma kissed me, and her tears wet my cheek.

I leaned against the doorframe, and my eyes focused on Jane Grant. The avalanche of fear took another direction, and the ice still crushed me.

"Sue—" Jane began to sob. "Our dog had rabies—two children—two little children." She reached her hand towards me, pleading. "Sue, they died."

As the earth shook, I turned, put my face against the solid doorframe, and clung for a minute.

"Sue—" Papa's hand was on my shoulder.

"I don't want you!" I told him savagely, as if he had just given me a mortal wound. "I want Sharon!" Then I kissed his cheek. "Papa, you start praying." I headed towards the bedroom, then turned. "When did he bite the ones who . . ." But I couldn't say the word.

"Two weeks ago. But on the face. It is much quicker there."

"Thelma!" I put my arm around her, finding comfort that Jean's bite was on her leg.

"We started Jean's shots this afternoon," she tried to smile. "And we brought two treatments for Sharon. Dr. McInery has ordered more; we'll bring it tomorrow."

"Sharon will be all right." Papa blew his nose. "God will take care of her."

But I scarcely heard. I was standing beside Sharon, looking at her. She was too beautiful and too good. Her lashes were black and very long against her pink cheeks. Her soft, gold hair waved against her forehead. She opened her eyes. "Mother, you all right?" she asked. Her eyes were too big and too blue, clear, shining . . .

"Yes," I swallowed. "Yes, darling."

Vaguely, I knew that Thelma and those with her had gone. I kissed Sharon, blew out the light, then fell on my knees beside the bed. "God!" I tried to pray, but no words came. "Oh, God!"

Most of the night I spent on my knees. "I don't know where David is," I explained once. Later, words spilled from me. "God, I'll promise anything. Don't let her die! Please, God!"

Up very early the next morning, I built a fire in the stove and started breakfast. Papa chopped cotton from six until seven. The doctor's office opened at eight. Papa would drive us each day for fourteen days. His confidence in humanity was so great it never occurred to him that the doctor might charge for giving the shots. Papa was a former employee of the company, out of work through no fault of his own.

I carried both bottles of vaccine and explained what had happened. "I'll be all right," Sharon smiled. "Mother kissed my hand."

The doctor must have seen the stark fear in my eyes. "The incubation period is rarely less than three weeks," he said as he swabbed cotton on Sharon's belly.

"But two children died after two weeks."

"If the bite was deep, near the brain, even vaccine might not help," he said. "But on the hand," he picked up Sharon's soft hand. "Don't be afraid," he smiled.

"I haven't any money," I said. "But I'll pay as soon . . ."

"There is no charge for rabies treatment," he smiled; then he frowned. "You kissed her hand? Better take the shots yourself. If you had a scratch on your lips, or a bad tooth . . ."

I certainly had a bad tooth. It didn't occur to me that if any of the rabies germs had entered, they would be near my brain. Anyhow, I'd used up my quota of fear.

Each day for fourteen days, Papa left his work in the fields to drive us to Majestic. Miss Mildred, God bless her, kept Davene gladly, and had lunch ready for us when we returned. I worried about the expense and the time from Papa's work. After each trip, I was too exhausted, mentally and physically, to help in the fields.

"Has to be done," Papa waved time and expense away. "I love Sharon, too." His eyes moistened.

Sharon's belly was polka-dotted with needles, but she didn't cry once, just kept her eyes trustingly on my face.

There were no polka-dots on my belly. My modesty would be unbelievable today. But then, some women died because of false modesty that kept them from having medical examinations. In Afghanistan, where women wore veils, when a man who was not a relative saw a woman's face, he either married her or he died. Things weren't that bad in our area. As "flappers," my generation had brought naked arms into view, and legs, too, and some even wore low-backed dresses. Not many though, for a woman's body from neck to knee was almost sacred. Even bathing, we wore a suit with a skirt longer than miniskirts today, and the neck was respectably high. The doctor must have shook with silent laughter, but he made no

comment when, instead of my belly, I presented my arms for the shots. They became pretty sore, and I could do less work than usual.

Poor Sharon! Not only did she suffer from a sore belly, but never was a child watched so carefully. Miss Mildred and I thought a person "going mad" would have a rabid fit if she even saw water.

We kept the windlass* pretty busy as we drew water from the well, and we almost drowned Sharon. Obediently, she tried to drink the glasses of water we gave her. Sometimes she puffed and sighed. "I can hear it slosh around in my stomach," she told me once. After that, I slacked off a little on the water bit. At least, I tried to slack. Yet, I'd start up suddenly, call her, and offer another drink. Drought or no drought, this was a deadly emergency.

MINUTES BECAME HOURS, THEN days. The vaccine was completed and Sharon pronounced out of danger. Now I could worry about something else. There was still no news from David. A little green monster perched on my shoulder and whispered, "David is a very good-looking man. Besides, who wants to be tied down with family in these times?"

"David has written to me," I argued. "The letter has been lost." And I ran all the way to the mailbox. My faith, I was convinced, had produced the two letters that were there. One had been mailed in Kentucky, the other in West Virginia. The date on the Kentucky letter was two weeks older than the other, so I read it first. "I'm asking my boarding mistress to mail this for me," he had written. "There is a freight train out tonight, I'm catching it for W. Va. Will write as soon as I locate a job." I cried a little, sent fiery darts towards the landlady in Kentucky for her delay in mailing the letter, and then I forgave her—she had mailed it finally.

The Kentucky job had been impossible, the pay scarcely enough for board. Working conditions were almost unbearable; houses were small shacks on mountainsides, far from civilization. Reports from West Virginia were encouraging. He had decided to try there.

David wrapped fifty cents in paper and enclosed it. "I'd send more," he wrote, "but there just wasn't anything left after I paid my board bill."

He must be almost hopeless, I thought, weeping. Leaving again penniless—he should have kept the fifty cents. His clothes growing thin, he was catching still another freight train, hunting work when millions were jobless and tracking from place to place, looking for nonexistent work.

Then I read the West Virginia letter. He boasted a little. How could he help it after so many disappointments? One hundred men had applied for work the day he was there, and he alone was hired. Surely they were seasoned, robust miners. David was almost twenty-four. With his fair skin and bright curls, he looked all of nineteen. Besides his youthful look, he was handicapped with that almost perfect face.

But there was an intensity about David, a determination, an unquestioning belief in himself. "If Dave needed a job and walked down the streets of a strange town," Clarence used to say, "some man would walk up and offer him work."

I spared a few minutes to think of the line of despairing men who were not hired. I could almost see their gaunt, hopeless faces. They were growing familiar everywhere. Kimberly Mine had closed. Papa set aside a small field of okra. Anyone in need, black or white, was free to come and cut okra. Before summer was over, every day you could see two or three busy with knives, gathering supper.

I read David's letter again. Penniless, he had found work, but special clothes were required. The company deputy had guaranteed his bill at the commissary. He'd even borrowed a stamp to mail this letter.

His second letter told of the $14.80 shift, and, as mentioned, word spread through three counties. I'd hardly arrived in West Virginia when a trickle of visitors, still hearing of that shift, came to look for work. As the Depression grew worse, the trickle became a steady stream.

That long, hard shift was beginner's luck. The regular machine-helper

came back to work the next day, and David began to dig coal. He seldom made less than eight dollars a day. This would have been riches in Piper, as the mine worked six days a week. But his board was $1.25 a day. His bill at the store would be collected before he could draw a pay. But just as soon as possible, he'd send for us.

THE SUMMER WAS HALF gone: full of laughter, tears, heat, and happy children who played all day long. Very pretty children. Miss Mildred had blue eyes, dark curly hair, and dark skin. Colleen had her great blue eyes, curls, and the Mosley fair skin. Daphne, too, and Royce and J. D. had inherited curls.

Meals were heaped up on the table, vegetables mostly. Eggs were legal tender, exchanged for necessities when the check gave out. I lived in a half-vacuum. Sometimes at night, I felt trapped and guilty. By day I felt better. Millions were in far worse state. We were not hungry. My children were well-fed and loved. Miss Mildred's heart was big enough to love all the children in the world, so it was very easy for her to love step-grandchildren. The girls had all the milk they could drink. Davene, seated, would pull herself by her feet (before she walked), and say "bilk, bilk, bilk" when she saw the full milk bucket. Miss Mildred always gave her a glassful.

Oh, things were going well for us! Sharon had escaped a horrible death. No need to feel guilty. We hadn't done anything to bring this on ourselves. Look at the Chicago gangsters: soaked in blood, doing every evil under the sun, and living in fabulous prosperity. Surely they couldn't be happy. Money could not buy happiness.

We, the poor, knew far more happiness. We could sleep at night with no black deeds on our conscience. Besides, when things looked blackest, there was always David's job.

And soon I was to have work also.

5

The Community Barber

My stepbrothers Grayson and Lee were as far apart as East and West. Grayson, the older, was bossed outrageously by Lee, a changeling, made up of quicksilver sweetness, meanness, and mischief. Lee's charm clutched at your heart in the same moment you wondered why someone didn't beat the daylights out of him.

A great romance had budded at the farm when the children and I arrived. Through the summer it sprang into full and glorious bloom. Lee, desperately in love with my cousin Pearl, babbled to anyone who would listen. At age twelve, his was a pure and noble love. To show his devotion, he stole eggs to buy candy for Pearl, and like a man, he spoke for her. Papa's brother, Uncle Lish, his hazel eyes twinkling, listened and then discussed the matter of support.

"We mean to wait until we are sixteen," Lee said bravely. He had blond curls, fair skin with pale freckles, and a dimpled chin that definitely proved the saying "Dimple in the chin, a devil within." His wide blue eyes between thick gold lashes had such a look of innocence that he escaped the consequences of his mischief again and again.

He had a Tom Sawyer personality and would have liked a tough, manly exterior. Each morning he plastered his curls flat, but they soon sprang erect. If he had possessed sufficient funds, Lee, I am sure, would have bought hair-straightener. Not only was his hair incurably curly but it

grew prolifically. Haircuts were twenty-five cents each. Men could scarcely afford a haircut in those days.

Lee worked a deal with the barber, and one day he approached me with barber scissors. "Sue," he smiled. "Will you cut my hair?" I had never been proof against his charm, so we set up shop under the pear tree. I took the scissors, snipped the air a few times, then aimed at Lee's curls. Soon I was snapping away like a turtle. His hair was much shorter, but I frowned. "Your neck is fuzzy," I said.

Grayson had watched happily as I cut away at the pale gold field of hair. "I'll get Papa's razor," he offered, and ran to the house.

Expertly, I swathed lather on Lee's neck. Then, like a baseball player making false moves, I twisted and flourished my razor. I'd watched often enough to know how to use a straight razor. You must approach at a certain angle and scrape away. Either Lee's good angel watched over him, or I was more expert than I thought. I took a trial run down his neck, and the fuzz miraculously disappeared.

Grayson had brought the razor strop. Pride now bouncing off my hands—my no-longer-useless hands—I sharpened up my weapon and started on the bowed, sacrificial neck again.

Lee had never been a coward. Now love added to his bravery. He didn't flinch as I scraped around his ears, at fuzzy temples and the back of his neck. At last, hair shorn and ears still attached to his head, Lee rose, felt around his neck, and—eyes bright with gratitude—thanked me.

"Would you cut my hair?" Grayson asked, as always ready to follow Lee into any danger.

Sure of my skill now, I began work on Grayson's equally thick mop of brown hair. Papa, coming to the house for a drink of water, saw me flourish the razor over Grayson's bowed neck.

"Sue!" He started to run. "You be careful!"

For his benefit, I did an expert turn around Grayson's left ear. Papa

stopped; his waving hands stilled, and he sat down under the pear tree until my second haircut was finished.

"I didn't know you could cut hair," Papa said.

"I didn't either," I boasted a little. "Easiest thing I ever did." It wasn't necessary to tell the state of my knees, which had begun to tremble the moment the razor was in my hand. Only now that the haircuts were actually over did they seem to have strength to hold me erect.

Word of my skill soon spread, and I became the community barber. Uncle Lish, who lived the second farm away; my cousin Rob on the next farm; Forrest, whose land lay at the back of the pasture (Papa rented his farm from Forrest); and his sons Earl, Ed, and Junior—all Mosleys, close kin, soon came to sit under the pear tree for weekly haircuts.

It would have been an insult to them, to me, and to kinship to offer pay for my services. Didn't they share fruits and vegetables with us if they had any we didn't have? And didn't the fact that I was of use make the long summer days pass more pleasantly?

The boys dug washer holes and set up stakes for pitching horseshoes under the pear trees. My tomboy childhood returned, and soon no one could beat me at those games. I became so expert at mumblety-peg (knife-throwing at porch planks) that I must have been county champion if we'd held a tournament.

THE DEPRESSION WAS NOT so hard on farmers as on wage earners. Farmers had never been wealthy, but they did not fear hunger, which daily became a great national scourge. Strange tales began to circulate. Society demanded stern Victorian morals, so we were shocked at the tale of a young, pretty mother of three children. She had gone to the road, stopped a bread truck, and offered to sell herself for a few loaves of bread.

Gossips, eager to find fault, said, "She just wanted an excuse to have an affair with the man."

"No," a person who knew her well said. "She is a virtuous woman, but her children were starving."

I'd look at the wide fields, hear the cackle of hens, the lowing of cattle with full udders. I'd gather baskets of vegetables from the field and be humbly grateful that Papa lived on a farm. And yet, Miss Mildred's check would go only so far. Even on a farm, many things had to be bought: kerosene for the lamps, sugar, coffee, chewing tobacco. Papa grew thrifty with the latter. He would bite off a chunk of his favorite, Brown Mule, savor the first chewing, and then cache it on one of the logs at the old barn.

There was aspirin, too. Papa suffered from headaches; Miss Mildred was bothered with her teeth. The children must have clothes and shoes for winter, and school books and paper and pencils. Such were not furnished then.

I yearned to share the expense. David sent an occasional dollar, most of which I used on paper, envelopes, and stamps. In summer, work grew slack, even in West Virginia. The company was still collecting on his debt. Board must be paid weekly; there was carbide, Prince Albert, and his own paper and stamps. He had left home almost ragged. "If you don't buy at least one outfit, I'll buy them myself and mail them to you when you send money," I wrote.

His next letter apologized, but yes, he really did need clothes. The company put them on his bill. But he was saving dimes and had a matchbox almost full. His debts would soon be paid, and he was sure to send for us by the last of August.

So I gathered vegetables, pitched horseshoes, took all the children swimming in a creek behind Uncle Lish's place, made some feedsack dresses for Aunt Stella's girls, wielded my scissors, and wondered what I could do to earn a few pennies.

Davene, a little spitfire, was petted and spoiled by all. Sharon, sweet and gentle, sang by the hour, played with the others, and longed for new

shoes. Each night she ended her prayers, "And please let Daddy make some money and buy me some new shoes."

Often, she slipped into the house to put on her tight, scuffed patent-leather slippers. Her plump feet were her greatest pride. "My feet are like Daddy's," she'd boast. "And he's got the biggest feet in the world." Poor Davene and I had bony AAA feet that demanded expensive shoes.

The summer before, farms had started blowing away in the Dust Bowl in the West. Drought again threatened. I'd find Papa under an apple tree or among the corn rows on his knees. When rains came just before the crop died, my own prayers would be more fervent that night.

No one could grow peas like Papa. He firmly believed in planting by the Zodiac signs. His peas grew low and bushy, with ripening fruit as thick as porcupine quills. His corn was low, also, with big fat ears if there was sufficient rain. Okra, tomatoes: everything was prolific. "Papa," I said one afternoon as I walked with him through the fields. There were bushels of ripening peas, low on the vines among the corn rows. "We could sell these at Majestic."

"You know I don't have time to peddle." His face was tired, but his eyes alight as always at the sight of corn and peas, and cotton across the road. He was never as happy as when walking through his fields.

"I do," I said.

"You? A peddler?" He knew my pride, inherited from him. "Anyhow, you can't drive."

"Lee can."

"He's wild as a buck!" Papa spread his hands in emphasis.

"I'll watch him." The thought never occurred to either of us that it was against the law for Lee to drive.

And so I made a job for myself. Just after breakfast three mornings a week, Lee, Grayson, and I shuttled off in the Model T Ford. Lee, exuberant, desired speed. I threatened to tell Papa. He was not afraid. Finally, I

turned off the ignition key. To start the motor, he had to get outside, go to the front, and turn a crank. After a few times of this, Lee settled down to erratic but reasonably safe driving.

We stopped at my sister Maurine's for a few minutes' visit with her and Lucile, then on to the dying coal-mining town of Majestic. As men and women came out to see what we offered, I felt a mingling of guilt and helpfulness. They could scarcely afford the small price that we charged, yet each could have planted a garden for himself.

We accepted company scrip and often, I knew, the ten or twenty cents handed to us was the last that person had for that day. We sold peas for ten cents a gallon and heaped the bucket high. Big melons went for fifteen cents, smaller ones for five and ten cents. They were always ripe. Papa could walk through a field, look at a melon, and tell the state of ripeness. Tomatoes and okra were plentiful; beans, too—bearing more the more we gathered. Papa didn't sell his corn. That was kept for bread and food for the animals.

That first day we bought a tank of gasoline, a new broom, ten pounds of sugar, and a box of cocoa. The monthly hundred pounds of sugar had gone into apple and peach pies, preserves and jellies. Miss Mildred had begun to crave chocolate cake. We also bought thread, aspirin, coffee, and a plug of Brown Mule tobacco.

The children were chocolate-smeared and happy as we rose from the table that night. "Yes, I'm pregnant again," Miss Mildred admitted as she gorged on chocolate cake. "And," her blue eyes were grave, "I won't live through it this time."

"Of course you will," I promised, not knowing how near I came to being wrong.

THE LAST OF AUGUST, I walked to the mail box. Papa's old straw hat came to my eyebrows. Pride hadn't vanished in this Depression. I tended my

baby-white skin as if it were some rare jewel. I'd not go to David toughened by sun and as freckled as a guinea egg.

I was tired and discouraged. Bad news came with each passing day. America had reached the depth of suffering, we'd think, when news of more cutbacks and fewer jobs would come. Mines, plants, and factories were limping along, trying desperately to keep from closing down entirely.

I was so discouraged that I didn't actually believe David's letter held a money order until I read the amount three times, heard myself crying, and saw the dust flying under my feet as I raced towards the house.

6

The Value of Papa's Teaching

The next morning we started off in the old Ford, passed the dusty bitterweeds, and turned onto the highway, where the motor failed. The incredible Griff and Mrs. Griff rescued us, and the girls and I were safely on a bus and headed for Welch, West Virginia. As we rode the long miles that took us to David, I was in my usual state of shock. I knew this was happening but just didn't believe it. Tomorrow I would wake and go peddling again.

Night came; the children slept on empty seats. I slept, too. During the night, the driver woke us. We stumbled from the bus, collected baggage, and piled onto cold, hard benches to sleep through a two-hour stopover at Bristol, Tennessee. Another driver shook us awake; we staggered onto his bus and slept again.

A rainy, gray dawn awakened me. I had a crick in my neck and a dry, brassy taste in my mouth. When the bus stopped for a thirty-minute rest, I smeared tired faces, brushed my teeth and then the girls', and found a place to eat.

Food and fresh air revived us. The children stared out the window as we drove through Virginia. Sacred Virginia, home of Washington, Jackson, and Lee. Virginia hills were neat, round, and green, with cattle grazing placidly, as if men had never died there, as if a cause had not been lost.

My great-grandfather Canada had died of wounds received in that

war. My grandfather Mosley, wounded at Atlanta, kept the bullet that wounded him. General Pickett was a relative of David's. So, even in my state of shock, something vibrated in my heart at seeing Virginia for the first time.

Then we were in Bluefield, and Virginia hills turned into West Virginia mountains, incredibly high and higher. Rain slanted past a window now. "Slippery when wet," a sign stated, and below at a vast distance lay relics of cars to prove the statement. I kept the bus on the road by sheer will power. No fiendish road, however wet, could stop us now that we were so close to David.

My neck acquired another crick as I gazed at the mountains. Straight up they went, like trees. Sharon, after a nap, stood on her knees at the window. A black thundercloud of a mountain towered over the bus.

"Mother, what is that?" she asked.

"Just a mountain, darling."

"I want to go home," she wept. "I am afraid of that mountain."

They were so awesome that Davene sat for thirty minutes wide awake, stilled, just looking. A record for her.

THE RAIN ENDED, AND the sun shone between the peaks, then hid itself behind the hills long before the day ended. We climbed to the roof of the world; then we zoomed down, down, down into a densely settled valley. Surely this was Switzerland—but it was the town of Welch. Mists hung in the hills that hovered menacingly overhead. Hemlocks, apple trees, and tangled vines hid rocks and boulders.

The bus drove into the station and stopped, and there he stood! Like a rock, like Gibraltar. His white teeth gleamed in a wide smile. The mists had tumbled his curls into a bright gold mass on his forehead.

"I see my daddy!" Sharon screamed. "Look, Daddy, I've got some new shoes!"

He was up the steps and had caught us all in his arms. "Daddy, Daddy, Daddy," Sharon wept, forgetting her shoes.

In the taxi, Davene clung to me and looked at David suspiciously. She hadn't seen him since she was nine months old. But halfway to the boarding house (he had arranged for us to stay there a few days), Davene peered at him again, then flung her arms around him. "Daddy!" she shouted.

Then David and I were both crying.

THE BOARDING HOUSE STOOD on an almost perpendicular hill. The back porch was jammed against the hill, but a long flight of steps had to be mounted before we stood on the front porch.

"Dave, come on in the kitchen," someone called.

We went through the house, depositing our things in our room. The house had seven big rooms. Each bedroom held two beds, and each bed held two men at night. In emergencies, cots were crowded into the rooms. David was in such high favor that we had a whole room to ourselves.

A long plank table, a big coal stove, and a pine sideboard furnished the dining room. The kitchen held a giant cookstove, and before the stove was a short, plump woman with very blue eyes, pink cheeks covered with yellow down, and a fine, gold mustache on her upper lip.

"Mrs. Cranford," David smiled, "this is Sue, and these are the girls."

Mrs. Cranford was drying an iron skillet. "How are you?" She slapped the skillet on the stove, put thick rashers of fat pork into it, and began to peel boiled sweet potatoes. "Dave told us all about you. These are my 'jewels.'" She waved a knife at the girls who came in and out of the kitchen carrying dishes, setting the table, helping with potatoes, turning the meat, and stirring various pots that boiled on the stove.

The meat was browned. Halved potatoes dumped into the fat browned quickly, were forked onto a platter, and sprinkled with salt and sugar.

Sixteen men were seated at the table. The "jewels" waiting on the table inspected me freely.

"The one who looks like me is Ruby," Mrs. Cranford said, pouring coffee. Ruby handed cream and sugar down the table. Thinner than her mother, curved generously, Ruby had brown hair, pink cheeks, bright blue eyes, and a hint of her future mustache.

"Ruby is going to marry one day, if she can find a man with enough money to take her from the coal mines. Jade now—"

"Mama," it must have been Jade who cut in, "do you have to talk so much?"

"Jade," Mrs. Cranford ignored her, "has been married four times. You was married to all of them, wasn't you, Jade?"

"Nobody's business if I wasn't," Jade said. She had a small waist, too much bosom, flaming red hair, white skin, and eyes that exactly matched her name.

"Your man wasn't so crazy for you," the jade eyes looked down at me through lowered lids, "I'd a taken him away from you."

"Better women than you have tried." I matched swords with her. Surprisingly, she smiled.

Opal, the next daughter, was short and plump in exciting places. Opal had dark skin, bold black eyes under heavy black brows, and blue-black hair.

"Opal takes after her paw," Mrs. Cranford said. "I loved the sonofabitch, but he's dead now," matter of factly.

I choked on a bite of potato.

A boarder, coming in late, hit Opal on a tempting spot. Eyes flashing, she returned the blow. Laughing, he pulled her hair. She grabbed a knife from the table, and he fled to the kitchen.

"She'll marry him one day," Mrs. Cranford said, pouring David a second cup of coffee. "This is Pearl, my baby," she introduced the last of her "jewels." "Pearl is the sweetest."

Pearl's name was as fitting as Jade's. She had pale silk hair, dark gold lashes and brows, wide blue eyes, and skin the palest shade of pink—translucent, almost. Pearl, about ten, I guessed, ate with the boarders.

"You're pretty," she smiled at me.

"Thank you," I glowed, happy for a kind word.

Talk cascading from her lips, Mrs. Cranford had ushered us through supper. She was in the kitchen now.

"If you like that type," Jade grinned, clearly conscious of her own superiority.

The girls, now joined by the boarders, began to discuss me as freely as they had inspected me.

"She's prettier than you," Pearl told Jade.

"Think so, Dave?" Jade asked.

"My hair is blacker than hers," Opal patted her own black mane.

"Hers has got a little red in it where the light shines on it," one of the men grinned at Jade.

"She's mighty skinny," Ruby said, her non-skinny bust and hips very prominent as she walked around the table.

"A mite skinny," one of the men agreed.

Industriously, I chased peas with a fork. My hands shook, and the peas eluded me. David looked at my hands.

"Skinny legs," Jade said.

"Don't you have no sun in Alabamy?" one of the men asked.

"Of course," I looked at him in surprise.

"Yore skin don't look like the sun ever touched it."

"Oh, I wear a hat to keep from freckling," I explained.

"Good thing the girls take after their daddy," Jade said. She was standing behind David. Suddenly, she rumpled his hair.

His face had been red. Now it whitened. "Will-you-get your big hands off me!" he said.

Rising from the table, he grabbed Davene. "Let's go, Sue," he said.

Jade howled with laughter. "Don't worry, Dave," she said. "I like big, dark, ugly men. I was just trying to make her jealous."

"Jade, behave yourself!" Mrs. Cranford came into the room.

"You're mean!" Pearl said. "You're the meanest woman in the world!"

"Pays to be mean, baby," Jade stooped to hug her. "I got four husbands that way."

"You didn't keep them," Ruby said.

"You never managed to get even one."

"Mama, if she don't leave here, I will!" Ruby began to cry.

"Jade, I'll thrash the hide off your back if you cause any more trouble," Mrs. Cranford said and went to get a pot of fresh coffee.

"All right, Mama." Jade was surprisingly meek.

"I'M LEAVING THIS PLACE tonight!" David said as soon as we were in our room.

"You've stayed two months," I begged. The bus hadn't been conducive to rest and after thirty-six hours, I thought I'd die if I had to take another step.

"They never acted this way before."

Davene was asleep, her head rolling on his shoulder. Sharon leaned against me, whimpering. "I'm tired, Mother."

"Of course you are tired," David said, and putting Davene on the bed, he began to undress Sharon.

Too exhausted to worry and too tired to be more than numb at seeing David again, I was asleep as soon as my head touched the pillow. I don't think I moved all night.

The next day was Saturday, and there was no work. David left early to look for a house in Welch. "I've never been so dirty," I told Mrs. Cranford. There hadn't been bathing facilities last night, but exhaustion had made this unimportant.

"Plenty of hot water," Mrs. Cranford said. Pearl brought a big round tub. "I'll mind the children while you bathe," she offered.

I was scrubbing briskly when the door opened. "Don't come in here!" I shouted, and grabbed a towel. Mama had certainly instilled modesty into us. Not one of her daughters would let anyone—not anyone—see her nude.

"Aw, what's eatin' you?" Jade came in and sat on the bed. "Think you've got more than other women?"

I huddled in the tub. The towel was entirely too small.

"Well, if you don't beat the devil," Jade said. "I bet Dave don't even get a look at you. You're pretty tough, in spite of what I said last night."

"Thank you," I chattered. September mornings were cold in the mountains.

"Say," she pushed her hands through her bright hair and held it high. "Me and you could be friends, maybe."

"Of course." Tears filled my eyes at this offer of friendship, and I tried to stop chattering.

"Aw, kid," she laughed and rose. "They come ignorant from Alabama, don't they?" Her eyes were strange, hungry, full of need, as if she asked for help. Maybe we could have been friends.

Thirty minutes later, as Jade helped me carry out my bath water, David came in. "Get your things," he said to me. "We are leaving here."

"TAKIN' HER AWAY FROM US, Dave?" Jade asked as we started to leave. Her eyes were bright green, then smoky, with a tormented look. "Maybe it's the best thing you ever done."

A month later, I went to see her in the hospital. Two men, fighting over her, had killed each other. A wild bullet had hit Jade in the stomach. "Well, kid," she smiled; then her lips twisted in pain. "Looks like my time has come."

"Jade, no!" I began to cry. The very earth would be diminished with so much beauty underground.

"Hang onto that man, kid." Her voice was a whisper. "I woulda took him if I could."

She died two days later. I thought of Jade often. Beauty, vitality, honesty, goodness, evil. Jade had lost her way somewhere and had not been able to find it again. Dimly, I saw the value of Papa's teaching—one man, one wife until death do us part. If Jade had settled down with that first husband of hers, she'd be alive today.

"I didn't want life on those terms." Her bright face looked at me for a minute, then dimmed. Well—she had chosen, and now all of that beauty was underground.

A New Hope

Our rooms were an upstairs apartment in Welch. Mr. Peraldo, our landlord, had brooding, Roman eyes, black hair streaked with white, and a habitual look of worry on his face. He was manager of foreign affairs at the local bank, taught school at night (six languages) to immigrants, and owned a rock quarry. Yet the Depression had hit him also, and he rented part of his home. We had the upstairs; rent was $28 a month. The Carters rented the first basement. The house was built on such a steep hill that the second basement, where Mr. Peraldo's father lived, had back windows high off the ground. The Peraldos' front porch was level with the street.

Mrs. Peraldo was the granddaughter of a countess and aristocratically beautiful. I had read that the old Roman aristocracy was the oldest and the most snobbish in the world, but she was always lovely to us. The Carters, in the first basement, were another Depression-hurt, proud family—Virginia proud, landed gentry. Jeff Carter had not been trained for work in a coal mine. He should have been riding to hounds, but this black Depression was certainly a leveler. David and I, used to comparative poverty, weren't as hurt, as unable to cope, as some.

After I had washed my clothes (in the bathtub, and never mind my aching back), I'd take the girls out with me, bundled in their warmest attire. When the clothes were popping in the wind that swooshed down the

mountains, I'd sit on a rock and watch the children at play. Sometimes we'd climb to the rock quarry at the top of the street. Slabs of granite brooded into the sky, and men clung to sheer walls, using chisels, hammers, and saws. Could one of the Italian workers be another Michelangelo?

The clean sheets of granite were awesomely beautiful. Hobart Street ended suddenly at the edge of the sky, and a rugged, narrow path wound around boulders and craggy rocks, down, down, and down: the shortest way to Hemphill, where David worked. He was on the night shift now, machine-helper, and he walked this unbelievable path to and from work. I took it once and was in bed half a day as the result. David worked long hours and climbed this trail to earn enough for rent, food, and necessary clothing. Sometimes unnecessary—when he worked an extra shift, he would spend extravagantly on a dress for me.

Letters from Piper brought distressing news. Hunger was a stark fact at times. Piper friends hungry? I wept at the news.

ONE COLD DAY AS the girls and I came in from hanging out clothes, Mrs. Peraldo, in her doorway, smiled at me. "It is so cold outside." She looked at the girls. Their cheeks were pomegranate red. Yellow silk curls, under blue tams, clung to their shoulders, and their noses were pink.

"Blizzard cold," I agreed. And the glow of my own red nose was clearly visible in the wall mirror.

"Won't you come in for a minute?"

Fabulous wool sweaters, socks, and bouclé knit dresses were piled high in an open steamer trunk. "See what my sister have sent me," she smiled. "What am I do with all of this? And she sends all of the time. Zhorze Jr. and Henry can never wear out so much, nor can I."

Her sister, she explained, owned a chain of knitting mills in Italy. "I do not have the room," she tried again. "The boys grow so fast that I have to store their small things. Would you mind—" she paused. "We are like

the sisters, you know. Such good friends—if you have the room, Sharon
and Davene can have of the socks and of the sweaters—"

My first instinct was to freeze. We were not beggars. Accept charity?
Wear castoff clothing? Not on your life! But she was so kind, so warm—my
heart spilled over with gratitude. "We'd love to have the things," I smiled.

She was almost pathetically grateful, and her eyes misted with tears
when I accepted a dreadfully expensive, brand-new, white bouclé knit suit
and a dress. After that, the girls and I wore imported clothes, such as I
had scarcely ever seen. The socks and sweaters really came in handy in the
cold. Snow fell again and again, and the mountain air was bitter at times.

THE GIRLS SPENT MUCH of their time at our back window and stared far
below where a street with ant-sized people (it seemed) ran through the
gorge that gave access to Welch. Great mountains loomed all around;
Welch filled the valley, and homes climbed the hills. Once Mrs. Peraldo
showed me a picture of their summer home in Switzerland, and I thought
it a picture of Welch. A street ran the length of Welch, and far, far below
our house, a fire burned constantly. Natural gas coming from an aperture
fed it. A man came daily to burn trash over the flame. Sharon, watching,
began to picture evil things about the fire. "Mother, is it the Devil?" she
whispered once. "I am afraid of him."

"Darling, he's just a man," I kissed her. "Let's go and see him." Hun-
dreds of wooden steps led to the far street below. At the bottom, Sharon
clung to me, trembling. But Davene ran to the man. "Hello, Mr. Devil,"
she laughed. "I am not afraid of you."

"Sister!" Sharon's love was greater than her fear, and she ran to stand
before Davene. "Don't you hurt my sister!" she screamed.

The man wore a red stocking cap pushed back from tight, black curls.
His cheeks were red, and white teeth gleamed between red lips. "Little
girl, I won't hurt you," he smiled.

"Why, Mother, he is just a man." Color came back to Sharon's cheeks.

"You scare the little girl?" he stopped laughing.

"I never scare my children," I said quickly. "But someone did," grimly. "We live up there," I pointed to our high window.

"George tell me about you." He lifted Sharon. "You like to burn trash?" he asked, handing her a paper.

"Davene!" I caught her as she ran towards the blaze.

"Mickelli is your good friend," he told the girls.

After that, they watched happily as he burned papers. "Mickelli is good; he keeps our streets clean," Sharon told Davene.

"I am going to marry Mickelli," Davene announced.

I SOON BECAME ACQUAINTED with the Carters. He and David were friends now and walked the trail to Hemphill to work together. His educated, Virginia accent was new but intriguing. "Ooot and aboot," he said for "out and about," and "hoose" for "house."

Mrs. Carter, with laughing dark eyes and dark hair, was very pretty, and large with child. Their daughter Mary, about seven, was sweet, shy, and soft-voiced. She had blond hair, pale skin, and blue eyes. A polio victim, she used crutches, but you soon forgot them. Sharon and Davene worshipped her.

Mary told stories of the three bears and Red Riding Hood, two of their favorites since babyhood. She said "woodchoppers" where we said "woodcutters."

"They chopped the wolf," Davene said one day.

"Yes."

"They chopped off his hands."

"They did that."

"And he couldn't pat a cake," she said, happily.

You're a bloodthirsty little thing, I thought.

"They killed him," she said.

"The wolf is dead."

"And he can't hurt the little baby."

"You darling," I hugged her. She wasn't bloodthirsty. She was concerned for Mary's expected baby brother—whom, I began to think in panic a few nights later, I'd have to deliver.

Christmas passed and New Year's 1932 arrived. The Depression held America in a remorseless grip. But a small thunder began to be heard—a new hope. Who regarded the fact that he was crippled? Franklin Delano Roosevelt, governor of New York, grew and grew on the horizon.

President Hoover was blamed for everything from the war between China and Japan to the Dust Bowl. Confidence in America was gone; the birth rate plummeted.

But one birth was of great interest to me. I visited the basement apartment often. Now that the son—it would be a boy—was due, Mr. Carter decreed that he must be born in the hospital.

Mrs. Carter, mindful of the present financial conditions, disagreed. "I'll have my baby at home," she told me. "I want you to be with me."

"No! I'd be scared to death!"

"You've had two babies."

Two, yes, and unbearable agony with Sharon, born at home, weight ten pounds, a breech presentation, a country doctor—but this experience did not qualify me as a midwife.

"I'm in labor," Mrs. Carter announced one night after the men had left for work. Her smile stopped suddenly, and her face reddened.

"I'll call a taxi!" I babbled.

"Jeff has a friend who will take us if I go to the hospital."

"Us?"

"But I'm going to have my baby at home. You'll help me." Her face reddened again.

"Let me call that friend," I grasped the table for support.

"It will—cost so much."

"I have to put the children to bed," I told her.

"Don't leave me. Please!"

"I'll be right back," I promised, and grabbed the girls by their hands. We stopped at Mrs. Peraldo's door; I knocked and explained about the baby. "We'll need to use your telephone."

"She can't have the bebe at home!" Mrs. Peraldo chattered. "You call that friend."

"I will," fervently. "Will you listen for the girls?" Our bedroom was directly over hers.

"Oh, I listen! You hurry now!"

Upstairs, I undressed the girls and put them to bed. For the next two hours, I wore out the stair treads running upstairs and down to the basement. Each time Mrs. Peraldo put her head out the door to ask about progress.

"I'm keeping you awake," I apologized.

"With a bebe coming, you think I sleep?" she asked. "But if I do, I leave the door unlocked for you. Just come on in."

Mrs. Carter's pains were five minutes apart now. "Where is that man's telephone number?" I almost hissed at her.

"If we—go—to the hospital—Mary will be—" Her face purpled.

"She can stay with the girls." I grabbed the sleeping Mary and hurried upstairs. I must have built some pretty good leg muscles that night.

Sharon and Davene never woke. I put their little friend in bed beside them, then ran downstairs. "Now," I said, firmly. "It is time to go."

"But think of the money!" she wailed.

"This is no time to think!" I wanted to slap her. "You've got to do something!" Tears suddenly rolled down my cheeks.

"My grip is packed," she tried to smile.

A sigh that came all the way from my toenails surged through me. "Give me that telephone number!"

As I took it, she bent double. Her face was a vivid plum color.

"I can't deliver a baby," I wept.

"Hurry," she gasped. "Hurry!"

I hurtled outside, around, and pounded on Mrs. Peraldo's door. She had gone to bed at last, but the light was on and the door unlocked. I called the operator, and after several years, it seemed, the telephone began to ring.

It rang and rang.

"Oh," I wept into the phone. "The baby may be arriving this minute. Mrs. Carter is all alone." I started to hang up and dash downstairs to help.

Then, "Hello?" a feminine voice said.

"Is Mister—" I didn't even know the man's name "—is your husband at home?" I asked.

"Who is this?"

"I am calling for Mrs. Carter," I stuttered. "The baby—"

"John!" the woman shrieked. "Mrs. Carter needs you!"

"Hurry!" I shouted, slammed the receiver on the hook, and started for the door.

"The bebe has arrive?" Mrs. Peraldo stood in her bedroom door.

"Any minute, listen for the girls!" I raced downstairs, collected the suitcase, took Mrs. Carter's arm, and we stumbled outside. Business of purple, agonized face again. "Lord," I whimpered. "You know I can't deliver a baby."

Car lights approached and stopped.

"Hurry!" I snarled, shoving my patient into the car. "Hurry!" The hospital was only a mile away. We turned hairpin curves on two wheels and made it.

A nurse rushed my patient to the delivery room. I answered questions, signed papers, then followed another nurse to the maternity ward, the suitcase slugging against my leg.

Another nurse met us. "The baby is here," she laughed. "A boy."

We'd been in the hospital exactly eight minutes. Of course I didn't really need ammonia. The nurse just thought I did.

Mother and son were doing fine, but yours truly wasn't so chipper. I weaved down the hall and into the lobby. A strange man waited to take me home. I marched out of the hospital, down the steps, and to the car. Opening the rear door, I stepped in and sat down.

Neither of us spoke. Possibly, he thought of his wife at home. I had another worry—how would David react to my ride at 2 A.M. with a total stranger? We made it home in record time. "Thank you," I said and streaked into the house.

Up the stairs I raced, looked at the girls, turned back the covers to put my head against their chests. They lived! Alone at night, they had survived.

I dipped to my knees. "Thank you," I whispered, found a vacant spot at the foot of the bed, lay down fully clothed, and fell asleep.

But this earth-shattering event didn't change the facts of the Depression. The story of David's $14.80 shift was still circulating back home. The Peraldos must have thought we meant to keep a boarding house, so many came to visit. The old leather sofa in the living room, which made an extra bed, was rarely empty.

My brother Clarence and my cousin Wilburn Clark had visited for three weeks. David's company, Kingston Pocahontas, with an unexpected order, was hiring men, so they tried coal mining. They kept us laughing with their fantastic tales and jokes.

Wilburn had black eyes, deep dimples in cheek and chin, and fantastic charm. He was full of tales about himself, such as the time he had been too familiar with a señorita across the Rio Grande; and the Mexicans, with fixed bayonets, compelled him to swim for his life while American soldiers on the opposite bank of the river cheered him as he swam.

Wilburn's work shoes were too small, so he changed shoes with Clarence, who had the narrow Mosley feet. The next morning both limped up the trail on injured feet. Each had preferred working barefoot on jagged rocks and coal to the agony of wearing shoes that, Clarence vowed, had been designed as instruments of torture.

Two mornings later, Wilburn came home missing a finger. There was difficulty about compensation. He was accused of deliberately chopping off the finger. They even said that he had made two efforts. Far too many men were now missing fingers or toes. The compensation would feed them and their families for weeks.

But the company had to pay. Wilburn chose a cash deal, for less money, and it was back to Alabama for him and Clarence.

Work had practically stopped at Woodward Iron, so George came up for a month. Johnny Appleseed had passed that way once, and there was always a plentiful supply of apples, which sold at fifty cents a bushel. George and David lugged home a bushel every day or so.

We ate apple pie, fried apples, applesauce, baked apples, jelly, and preserves. In between times, the girls ran about with apples in their hands. None of us needed a doctor all winter. We didn't charge any of these visitors board, and somehow David and I managed the rent and our food, with even an extra at times.

George had never been out of Alabama before. He missed Thelma and the girls, Ailene and Jean, very much. With his first month's pay (two weeks were held back at first), it was back to Alabama for another homing pigeon.

Now a trickle of visitors that became a steady stream began to arrive by freight train, or they had hitchhiked across the country. These tired, hungry men stayed a night or so; then, with no work available, they would drift on to another town. I imagine, till this day, when they think of West Virginia, they also think of apples.

THE GIRLS SLEPT WITH me nights when David worked. With our many visitors, they had to sleep on pallets on the floor, made by shoving chair cushions together.

To amuse myself, I had begun to write the daily news in rhyme and read it to the girls. Junior and Henry often came up to listen. Mr. Peraldo once listened at the top of the stairs. "Could I talk to you?" He appeared suddenly at the door. "How long does it take you to write those?"

"Oh, ten or fifteen minutes."

"Could you do them every day?"

"Easily."

"Mind if I keep those you have?"

The next afternoon Mrs. Peraldo called me. "Zhorze," she said, then smiled. "I mean—George tell me you should see his friend, Mr. Kaiser, the newspaper man, tomorrow."

"I showed him your rhymes," Mr. Peraldo stood behind her. "He thinks he can use them as a special feature in the paper."

Brash and ignorant, I went to the office of the Welch *Daily News* the next morning, too ignorant to realize that no unknown, especially with no experience as a writer, who has taken no courses and has only a high school education, lands a job as front page, feature writer for a daily newspaper.

I didn't even know what to say. I think I muttered once, "It has been said that I have a brain; if so, I want to use it."

Mr. Kaiser was very kind. I learned that he also had daily papers in North and South Carolina. "I like the rhymes very much," he said. "I'd love to have them, but I am ashamed to offer you what I can pay. I'm the only man in Welch who has not laid off any employees, but if you'd like to do the feature—"

As easy as that. A newspaper job, and featured on the front page beside Will Rogers. Pay? One dollar and fifty cents a week. And the heady excitement of recognition. A girl at the ten-cent store was as excited as if

I were a personage when she cashed my pay check. "I keep a scrapbook of your poems," she said breathlessly.

The superintendent of education owned a shoe store. When I presented my weekly check, he looked, shook hands with me, and called his wife from the back to introduce us. "We are so proud to have someone like you in Welch," he said.

The local high school, when studying poets, included my rhymes in their study.

Talent there must have been, a small amount, but it was wasted on such a stupid person as I. With such beginner's luck, I might have been a successful, widely-known writer in a few years. But my big talent was supposed to be painting and drawing, next music, then singing, and even acting, so writing was just an accidental hobby. It was years before the urge to write became so strong that I was compelled to try my hand once more.

Then I had heady fame in Welch. We lived in a nice apartment and had good clothes when millions were jobless across America. I knew how fortunate we were, yet I was practically dying of homesickness. The big problem was getting back home to Piper.

In the meantime, I did the best that I could with my rhymes and tried to be a good wife and mother. David—bless him!—never complained because I didn't have any talent for housekeeping.

The girls loved story hour, and nightly I read to them, or told stories of Washington, Lee, St. Valentine, etc. Sharon and Davene were deeply interested in hearing about the one who was "first in war, first in peace, and first in the hearts of his countrymen." I showed them Washington's birthday, February 22, on the calendar, and both girls marked the date.

On February 23, a visitor arrived from Piper: McClaine Jones, David's former wall boss*.

"Do you know who this is?" I asked Sharon, thinking she might remember Mac.

"I know," Davene said.

"Who is it, darling?"

"George Washington," she said triumphantly.

Mac—an experienced fire boss, wall boss, and machine man—landed a job, and the sofa was occupied again on weekends. David and Mac both worked night shift. David caught every extra shift he could, and he and his buddy worked long hours, cutting coal. Each place they cut added to their income.

Times grew steadily worse. Men were laid off. Work dropped to two and three days weekly. My check helped with the grocery bill and bought a few toys for the girls. We didn't charge Mac for board; his family at home was in desperate need of far too many things.

8

We Never Knew Our Cruelty

One morning David and Mac panted up the hill and came in exhausted, as usual. An extra ring of white was around David's lips. "Well," he announced grimly, "we are moving." He put his lunch bucket on the table and went to brush his teeth.

"That Dave." Mac sat in one of the leather chairs. "Made of steel. Just sails up that hill." His face was tired, his fingers clumsy as he rolled a cigarette.

Davene climbed the chair and perched on his knee. Sharon lay on her stomach behind the sofa and looked at shoes in a Sears Roebuck catalogue.

"He's too tired to hold you," I reached for Davene. My knees felt weak. Fear tied a knot in my chest. Papa would take us in again, but what about David? There was no work anywhere, especially at home. Mentally, I counted the money in my purse. With David's pay—thank goodness they held back two weeks—there might be enough for current bills and bus fare home.

"Were you laid off, too?" I spared a moment to pity Mac.

"Laid off?" He licked his cigarette, struck a match, then let the flame burn as he stared at me.

"What gave you that idea?" David came in and kissed me, his breath smelling of toothpaste. "Nobody's laid off," he said. "We're just moving to Hemphill."

Relief fought with anger as I began to argue. We didn't have any furniture; I'd have to quit my job . . .

David frowned as he rolled a cigarette. "The company has a new rule. All employees have to live at Hemphill."

I went to the bedroom and began to comb my hair in anger. This was the living end! Desolate, black Hemphill. Small houses perched on stilts that leaned precariously against a rocky hillside. "No baths," I said as David followed me. "No hot water. Those houses don't have anything!"

"Piper houses don't, either."

"But that is home!"

"I'd do better if I could." For a minute his jauntiness was gone, and he wore the typical lost, Depression look.

"Oh, David!" I resented the Depression bitterly. Resented Mac in the next room. We didn't have any privacy, yet I didn't want him to leave; someone else would show up, and you couldn't turn hopeless men out to starve. "Maybe, soon—" I kissed him and smiled. The Roosevelt rumble was growing stronger. This was March 1932. In November—we hoped.

"What about your work?" Mrs. Peraldo asked, helping me pack. "Mr. Kaiser likes your verses."

Oh, I would miss the work! Printer's ink had smudged my fingers. Hard to recover from that disease. When I reached the office each morning, some of the news had been typed for me. Other news I'd gather, listening in on the leased wire in Mr. Kaiser's office. Most of the important people dropped by sooner or later. Mr. Kaiser would introduce them to me. One of the most famous men in Welch was Lawyer Cartwright, a black man. He was extremely brilliant and quite wealthy.

I'd heard of him. Heard the tale of when he was traveling with a friend, by train into Virginia. At the state line, Mr. Cartwright was separated from his white friend and told to go to the cars at the back of the train.

The friend protested, "But you don't know who this man is!"

"Whoever he is," the conductor is reported to have said, "he is just a damn black nigger in Virginia." Oh, we have paid for such as this! We

have paid in full. I write this with a sort of horror. Were we ever really like that in the South? Oh, yes, we were, and never knew how cruel this was.

It has been many years since I heard that story, but I think I bled a little. At least, I hope that I bled.

Though born and reared in Alabama, I knew far less prejudice than the average person. Papa and Mama were almost totally without it. They loved everyone too much to hate because of color.

But living when and where we did, a certain way of life was absorbed by all. There was an old but true saying, "The North loves the black race and hates the individual. The South hates the race but loves the individual."

We had always lived near blacks. I played with the small children of Mary, who came to wash for us, and I loved them. There was always laughter and friendliness, but there was a definite, accepted line between black and white over which no one crossed.

I had never heard a white person address a black as "Mr.," "Miss," or "Mrs." It was always "Sam" or "Mary." But a black must always use a title when addressing a white person, even the children. It would have been a dangerous thing to leave this off.

We were not intentionally cruel. Some, the lower class who could not earn respect from their own color, were belligerent and cruelly demanding of respect from blacks. But the better class of whites had only contempt for such people, and the blacks had a saying, "I'd rather be a nigger than poor white trash."

Most of us just lived in and perpetuated the way of life to which we had been born. Our fathers or grandfathers had fought in the war, had been slave owners, and we had a warm, paternal feeling for blacks.

We loved them with our guilt. We loved them achingly, tenderly, pityingly. A black man could always come to his "white folks" for food, clothes, or any other need, and he knew he would get it. "My white folks will take care of me," many boasted.

And this was true. For in our hearts, we had not really freed them. We were possessive and lovingly paternal. (I hurt now as I tell this, but it was true then.) They were children, we thought, unable to govern themselves. We accepted their failings, what we judged their lower moral standards. We accepted them (as children), loved them, cared for them when needed, but—they had a certain, definite "place," and we were determined that they keep that place. How could we have been so blind? So cruel, yet unconscious of this cruelty?

Not once in my life had I met a "Negro" as a social equal.

One day in his office, Mr. Kaiser rose when a well-dressed black man entered, and shook his hand. As was his custom, he turned to me. "Mrs. Pickett," he began; then his face changed. The realization that I was from Alabama must have struck him. He faltered; then he turned, offered a chair to his visitor, and they began to talk.

All of my background held me silent, cold. Today I would smile, offer my hand, and say, "How do you do? I am so glad to meet you." But then I sat miserably at my desk, aware of what had almost happened, aware perhaps that both Mr. Kaiser and his friend were uncomfortable, and all I could do was scribble away at my rhymes as news came in over the leased wire. I am sorry and ashamed now. But that was all I could do then. I knew that the visitor was the renowned Lawyer Cartwright.

Other than this episode, all of my work had been pure joy. I loved to watch the Linotype as it set hot lead. I loved being part of the paper and being treated as a very special part.

"I hate to lose the feature," Mr. Kaiser said when I told him that I must quit. "Perhaps you could do a review of the news and mail it to me."

But I couldn't do it. The spontaneity was gone.

Yet in Hemphill things were not so bad as expected, at least on first appearance. David had rented a large house on a level swatch of ground,

with flowers and shrubbery. The house had a wide front porch (although I was never able to use it) and six big rooms. No bath, of course, but at least it wasn't perched on a hillside, shuddering in the wind that came down from the mountains.

Our neighbors, Bill and Cynthia Sperry, were made to order for us. Young, friendly, they lived next door in a big brick house. Bill's people owned the land at Hemphill, including mineral rights, and the brick home. He had a monthly income from coal which the Pocahontas company mined. Not enough for trips to Europe—other relatives shared in this income—but there was sufficient for food and clothes.

I could always sort of hypnotize babies, and their baby Gwendolyn, age six months, fell asleep the first time I rocked her. In no time, the Sperrys were our best friends.

Our friendship suffered precariously one night about midnight. We sat in our bedroom playing set-back. The babies were asleep long ago. All was silence. No cars passed; no dogs barked. There was one of those heavy silences which sometimes creep into a place. We played silently, raking in the cards we had won.

"Won't I kill you, Cynthy?" David asked all at once.

"Yeth, you will," I answered promptly.

Cynthia turned white. Bill jumped to his feet, ready to do battle. David and I glanced at them in surprise; then I whooped with laughter. "Cynthia thinks we are going to murder her," I gasped. David was laughing, too. Seeing it was some kind of joke, though it must have seemed a strange one to them, they gave us time to explain. David had a relative, quite a character. Now that man bossed his wife, who happened to be named Cynthia. She was literally afraid of him, with just cause. She was also slightly tongue-tied.

He'd come home roaring drunk and shout, "Won't I kill you, Cynthy!" And she'd scuttle out of harm's way as she answered, "Yeth, you will."

This was a standing joke with us. David shouted the words at me, and automatically I gave the answer.

The next afternoon Cynthia came in laughing. "I am so mad at David I could kill him!"

"Why?"

"Every time Bill comes in, he shouts, 'Won't I kill you, Cynthy?' And like a fool I say, 'Yeth, you will' before I think."

CYNTHIA USED THE KITCHEN door, for as large as the house was, there was one slight handicap. The former tenants refused to move although they were far behind with their rent. They had crowded into the nicest, largest rooms at the front and barred the door to us. Our only access was through our kitchen.

"They told me the house would be empty," David apologized. "The sheriff will put them out if I ask."

"We couldn't do that. Where would they go?"

So we accepted the small back rooms and shared the one windswept toilet with the strangers, our guests. Grimly, they squatted in the front rooms of the house on which we paid the $17.50 a month rent. "Furriners come in here," I heard the man say through thin walls, and was sure that I heard the chambering of a shell in a shotgun, "take our jobs and take our homes."

When I met him in the back yard, he stalked past me. Sometimes he aimed and spat tobacco juice near my feet. His wife, a tall, thin woman, peered suspiciously at me, but sniffed and turned her head if I spoke. I felt like a criminal and tiptoed about my work fearfully. We were uncomfortable, distressingly uncomfortable.

Mrs. Peraldo and Mrs. Hunt, another darling friend, walked from Welch and surprised me one day. I was never the best housekeeper, and this was one of my worst days. The men off to work, the girls had to be fed

and dressed, and there was the inconvenience of our one entrance at the back. No chance to keep even one front room in decent order and ready for company. Besides, we had bought only the necessary furniture: beds, a few tables and chairs, a dresser, a coal stove for cooking. Exhausted after handling water and scrubbing black clothes for the men, I'd lain down to take a nap with the girls before taking time to clean up. I really loved these friends. They were cultured and interesting, and I specially loved Mrs. Peraldo. She had been so very good to me. But my embarrassment over the condition of the house may have made my welcome seem a little strained.

Cynthia didn't seem to notice my housekeeping (or lack of it). And she spent much time with me. She and Bill, David and I had long talks. They had read my rhymes in the paper, and hearing that I didn't have a typewriter, they gave me my first one: a deluxe, portable Underwood that Bill had used for only three weeks in school. It was, incidentally, the best typewriter I ever owned. I used it for nineteen years, then gave it to our little grandson. They really made typewriters in those days.

Mac went to an occasional movie and wrote letters home. In lieu of board, he'd sometimes buy something special to eat. On the afternoon of March 31, he came in with steaks, canned tomatoes, and a box of cayenne pepper.

I buttered the steaks, broiled them, and poured the tomatoes over them. Taking some out for the children, I dusted the rest heavily with hot pepper. Twenty minutes of baking, and we had a gourmet dish. But there were some tomatoes and plenty of hot pepper left over, and I did not wish to let them go to waste.

I have, unfortunately, always had a rather warped sense of humor. My Irish blood from Granny Mosley and Great-Granny Canada, who was a Garrett before her marriage, left me this heritage, no doubt. Papa's sober English ancestry from Grandpa Mosley usually restrains me, but at times . . . perhaps the wind is damp and smells of peat, or perhaps my own per-

sonal leprechaun demands special attention; whatever it is, I sometimes do very silly things which are quite funny to me at the time. Possibly they are not so humorous to the recipients.

David would not have brought home cayenne pepper the day before April Fool's Day. But Mac was happily ignorant.

A favorite food for the girls was tomato gravy. When this was served, they wouldn't eat anything else. I made a big bowl full of gravy for breakfast, flavored most of it with tomatoes, but the other part I doctored with pepper until it was tomato red. Filling the girls' plates with the genuine article, I put that bowl in the warmer and set the pepper gravy on the table.

David and Mac helped themselves to bacon and eggs. "Good gravy," Davene said, red dripping from her chin.

"Tomato gravy, my favorite!" Mac said and ladled gravy over three biscuits. Then he took a bite, chewed, and swallowed.

When I dared to look, his face was as red as his gravy, but courageously, he swallowed another mouthful. "Have some, Dave," he shoved the bowl at David. "Best gravy I ever tasted." Then his courage faltered; he turned aside and blew like a whale.

"Don't like it," David said.

"You never tasted gravy like this!" Mac ate hastily, swallowed coffee, and blew again.

"I want some more," Davene handed her plate.

"No, no. This is cold," I dissuaded her.

"Cold!" Mac bellowed, swiped another bite, swallowed, and blew again. "W-e-e-e-w!" he said in agony.

David, used to the children's chatter, didn't notice.

As the last of the gravy burned its way down his gullet, Mac ran to the sink and tried to drown himself.

"You should have known not to bring in hot pepper the day before April Fool's," I choked.

"Sue!" David looked at last. "What have you done?"

Fearfully, I explained. "But I didn't think he'd eat it."

"I'd have eaten every bite if it burned my tongue out by the roots," Mac said, beginning to laugh. "And it really was good gravy. If it hadn't been so hot, that would have been the best gravy I ever tasted."

I took the bowl from the warmer and ladled second helpings for Sharon and Davene. Mac helped himself to real tomato gravy and seasoned it quite heavily with the other.

I'M SURE THE PEPPER gravy wasn't responsible, but a few days later he came in happily reading a letter.

"The wife wants me to come home," he said.

"Work better now?" David's face brightened.

"Three or four days a month."

"You can't live on that," David warned.

"Neena has paid our debts with the money I've sent. I'll have a few dollars left when I get home, and it's gardening time" (as if we didn't know). "Plenty of poke salat, wild onions, and a river full of fish." His eyes moistened, "Dave, I'll never forget what you and Sue have done for me."

I was smiling as I waved goodbye, but my eyes were wet.

"Want to go back?" David asked.

I put my head on his shoulder. "You know that I do. But we can't. We've no furniture, no job, no anything."

"I shouldn't have left," David said.

Silently, I agreed with him. We'd have managed somehow; with chickens and a garden, I'd have canned every extra vegetable, picked blackberries—I could just see springtime at home. The dogwoods would have finished their blooming, but thousands of wild flowers would color the hillsides. David handed me his handkerchief.

Thunderbolt

How our roomers lived, we never knew. Bootlegging, we guessed. They ate regularly. We could hear her washing dishes. Certainly the man had plenty of lung power. He thundered his remarks about "furriners."

We grew very tired of the situation. I really longed to go home. There seemed no hope in the world. Yet there was one who promised hope. The Roosevelt thunder began to fill every corner of the land. But November was long, hungry months ahead. March actually: if Roosevelt was elected, he could not take office until March 4th.

Our house situation grew steadily worse. One day the tobacco juice hit my foot. My temper flared, and I spoke a few biting words.

"Tell your man to settle fer you," our guest said and, insolently, spat at me again.

I knew exactly what David would do if I told him. Knew also that his fists, no matter how expert, were not sufficient weapons against a shotgun held by a wild mountaineer. But how much longer I could put up with the man's churlishness, I didn't know. I seemed to have reached bottom, but no tobacco juice on my foot could make me bring David into this.

He came in a few minutes later, wearing his reckless smile, "Well," he said, gleefully. "We are moving again."

"Where?"

"To Marytown."

"You mean the company will let us move? Why not go back to Welch?" Hopefully.

"We can't. Marytown is eight miles away. Pocahontas Company owns the houses. They must be occupied, or they will lose their insurance. The company is offering them rent-free to employees."

Our roomer took this minute to stalk towards us, his shotgun at the ready. I smiled my biggest smile.

He stood a moment, as if disappointed, then stalked to the front.

I touched David's cheek. His face now seemed a little tired. He worked such long hours, and Marytown was eight miles away from the Hemphill mine. This was too much! Too much! I'd tell him to stay here. Then I saw our roomer once more, coming around the corner of the house. He chewed savagely at a new (no doubt) chew of tobacco.

I grasped David's arm and hurried him into the house before speaking. "Eight miles is a long way to walk," I said to David.

"I'll buy a car," he grinned.

"What will you use for a down payment?" I asked. But I knew David. If he'd made up his mind to buy a car, a little thing like no money for a down payment wouldn't bother him.

After supper, the girls were playing with paper dolls, and David and I sat down in the kitchen to figure. "There will be only two dollars left after we pay all of our bills," I said. There had been Easter outfits and new pants and shirt for David, charged at the commissary, and grocery bills had been pretty high.

"I'll manage," David said, grandly. His eyes searched the room and lighted as they rested on a portable radio we'd bought and paid for: cost, $14.50. Smiling triumphantly, David tucked the radio under his arm and took the road to Welch.

Two hours later, he returned, driving a car. How did he do it? Well,

you've never seen David operate. Before he finished talking to the manager, the price of the car had been cut from $150 to $125, and the man loaned him the radio until David could come up with the down payment.

We named the car "Thunderbolt" from the roar it gained after a few weeks of our expert neglect. At first it was just a 1926 Studebaker—California top, deluxe, five-passenger sedan—quite a large car in those days of weary miniature Fords and Chevrolets. But soon the car became a personality, and we spoke of it as "he."

Thunderbolt had a special brand of curtains. Nothing like the tricky, troublesome kind made of isinglass and kept under the back seat, then in bad weather you fumbled through patching, baling wire, tire tools, and pump until you found the crinkled, rumpled curtains. Then you had to stand in the wind, rain, or cold until the curtains were hitched onto the frames. Thunderbolt's curtains fastened to a rod at the top and rolled up or down like window shades. Since they were permanently attached to the car, you never had to search for them. They almost caused our death once, but that was later.

THUNDERBOLT MUST SURELY HAVE been the best car ever made. In our youth and blissful ignorance, David and I neglected him miserably. We bought oil and gasoline, but other attention he never received. Growl he did, until his growl turned into a thunderous roar, but he roared faithfully wherever we wished to go. Anywhere.

David had learned to drive on the comparatively straight roads of Alabama. (Any roads would be straight compared to those of West Virginia.) He knew only one speed, as fast as the car would go. And David had a new theory about curves: you roared up to one at top speed, took it completely by surprise, slammed on the brakes, and slid around. No curve, treated in this manner, would dare to throw you.

Surprisingly, they didn't. I clutched the children in my arms the first

few times we drove to Welch, closed my eyes, and sent frantic prayers heavenward. Then I grew brave enough to look. Pines, oaks, and hemlocks pierced the top of clouds that were level with the road. On a clear day, I could see to the bottom of the precipices around which we careened, and all the way to the distant depths below. Tires, fenders, and parts of cars hung on ledges, rocks, and trees. The scenery was half hidden by undertaker signs, a very appropriate place to advertise.

After a few trips, I grew numb and sat calmly beside David as we shuttled along. Drivers of other cars were not numb. They soon recognized David and would pull to the side of the road, thrust heads from their windows, and hurl curses as we passed. David, too drunk with speed to care, ignored them.

Weekends we drove through the mountains, sight-seeing, to other towns. As mentioned, the girls had the blue of David's eyes, his gold hair, and fairness. I didn't have any features worth mentioning—a pug nose, etc. But I had big black eyes, very fair skin, and a mane of jet-dark hair that was black until the sun hit it; then it gleamed with chestnut and mahogany tints. I must have looked strange with my blue-gold angels, but wherever they went, I was along.

In those days, a car seldom made a trip without a full load. Transportation was scarce, gasoline a thing to be used only when necessary. If one was fortunate enough to own and operate a car, he shared his good fortune with others. But after one ride with David, most people preferred to walk. Brave Virginian Jeff Carter, who had moved to Marytown ahead of us, rode to work with David.

MARYTOWN CONSISTED OF A dozen houses on a swatch of level ground between high mountains. A railroad ran through the valley, and big trains snorted past daily. I soon heard the story of a little girl, a beautiful child with fair curls—like my own fair-haired girls—who was killed the past

summer. The engineer helplessly tried to stop the train. "She ran to the center of the track and smiled at me," he sobbed afterwards.

No one blamed him. They knew it was impossible to stop a fast train suddenly.

A row of houses across the road stood between us and the tracks. These were a quarter of a mile away from the houses. And though I didn't believe in frightening children, I did my very best to make them afraid of the railroad, and succeeded, for they never ventured in that direction. Yet I lived in constant terror, for they would run away to play with small friends down the street. I tried spanking, pleading, shutting them in the closet. There could always be just one time when they'd be on the track before I missed them.

Once, in desperation, I tied a rope loosely around Sharon's waist and hitched it to a peach tree. "Maybe this will keep you in the yard," I said.

She could have untied the rope with one hand; instead, she fell to the earth in panic. "Mother! Please untie me; I'll be good!" she sobbed.

I loosened the rope and took her in my arms. She was trembling, her little heart pounding. "I won't tie you again, darling," I crooned.

"Tie me," Davene swaggered up to the rope. "I'm not afraid." She tried to tie the rope around her fat tummy. "I can't run away now," she laughed.

"Can't you, sister?" Sharon jerked the rope from Davene.

"You tie me," Davene said. "I haffa stay in the yard."

For a few days it was a nice game. Davene played cheerfully in the yard under the peach tree. When the rope fell, she waited for Sharon to tie her again. But she tired of this game. As independent as her daddy, Davene decided to join the nudists, of which there were five or six in Marytown. These native children played all day, sans clothing, and no one seemed to think anything about it. But not the Pickett children! I tried spanking, everything, to no effect.

I didn't have to worry about gaining weight that summer. I'd look out,

see Davene's little naked figure scurrying down the road, and race to catch her and wrestle her into her shorts.

Centuries of organic soil had washed down the mountains and settled in the valley. David and I dug furrows with a hoe, stuck seeds in the rich, black loam at the back of our house, and pulled weeds as they appeared. Warm midday suns and afternoon rains did the rest. Vegetables grew faster than we could use them. David took basketfuls to the commissary to exchange for items that did not grow in gardens. Jeff Carter shared the car expense, there was no rent to pay, and I felt close kin to Midas as we began to save money. Our hoard was kept in a sack, stuffed into the toe of a shoe, and this was thrust up the chimney in our bedroom.

David allowed himself the luxury of a bootlegger and arranged a charge account, but this bill was small. Just a drink or so on idle days. Another luxury: he would buy clothes for me. Perhaps the most beautiful dress I ever owned was one he brought in one day. His face was so happy I didn't have the nerve to return the dress. It was black satin-back crepe, long sleeves, cut out to a deep 'V' in the front, with a vest of eggshell white satin, overlaid with gorgeous, delicate lace. Down this was a row of jet acorn-shaped buttons with rhinestone centers. Cost: $18.75. Such a dress would be several hundred dollars today.

Our shoe-toe bank became a little crowded, so David took the ones and fives to exchange for twenties. We couldn't know what a sensation a twenty-dollar bill was to create in Gadsden, Alabama. Even here, they were not common.

ONE AFTERNOON, AS WE ate supper, a small boy and girl appeared at the kitchen door. The little girl was about ten and had a curious, old-woman look in her face. The boy, a year or so younger, stared at a plate of leftover boiled corn.

"Have you had supper?" I asked gently.

The girl's face reddened. "We was just going to ask if you have any food to spare."

"Of course there is food." I took down two plates.

"Could we have it in a poke?"

"Are there others?" I asked.

"Mommie and Aunt Bess and three small children."

"Where do you live?" I asked.

She bent her head, and her face reddened again. "Nowhere." It was only a breath. "We—we've got people over the mountain."

"Where did you sleep last night?" I put my arm around her shoulders.

"Down the road." She raised her head. "I aim to pay for the food. I'll wash dishes," she said.

"You slept outdoors?"

"We built a fire. Hit wasn't cold."

Nights in the mountains were always cold. "Go tell your folks to come here for supper," I said.

"If you'll let me work. I aim to pay."

"If that's the way you want it," I agreed. I knew the stern pride of the mountaineers.

"That's the way hit has to be," she said.

I stirred the fire in the kitchen stove, sliced salt pork, put it in a pan at the back of the stove, and ran to the garden. The pork just needed turning when I returned with corn, tomatoes, onions, and lettuce. By the time the corn bubbled on the stove in salted water, with a little butter added for flavor, and biscuits were browned, the girl was back with her family. The women, young and fair, looked tired and hopeless. The smaller children were shy, hardly speaking. After supper they were all a little more cheerful.

The girl's name was Irene. She washed her hands, cleared the table, and began to wash dishes. One look at her face, and I didn't interfere.

"You got some soap we could have?" her mother asked. "We ain't washed no clothes since we left Pennsylvania."

"How did you travel?" I took a bar of Octagon laundry soap from a pantry shelf.

"Rode a freight. They found us at the state line and throwed us off the train. Said if hit wasn't fer the children, they'd a throwed us in jail."

Irene swept the kitchen floor, then carried water to wash the clothes. They hung them up on my lines and stayed until dark; then the aunt said, "You mind if we sleep in yore yard?"

"We've plenty of room for all of you," I said, my throat dry.

"Just make us a pallet," she smiled listlessly.

But I crowded Sharon and Davene into bed with David and me, so the women could have a bed. Perhaps it was the first they'd slept in for many nights.

Irene spread their bedding on the floor. It was dirty and mud-stained. I offered my only clean sheets for cover. "I mean to pay," her eyes were fierce gray. "I'll sweep yore yard in the morning."

She had watched as I put the girls to bed, first kneeling with them for their prayers. She knelt and whispered, and I saw tears falling from her hands between her fingers.

I fought back tears. How had she kept her pride? Her mother, aunt, and the smaller ones had the very smell of the Depression about them. Pride, if they ever possessed it, and most mountaineers do, was gone and there was a trapped, animal look—I couldn't describe it, but when David came in from work the next day, I knew. It was the look of cheap, shoddy, used goods.

There was two dollars in my purse. I didn't even dare look at the fireplace, but slipped the money to Irene's mother and gathered corn and tomatoes, found half a box of crackers and some cheese, and put them in a bag just before they left the next day.

Irene washed dishes, swept the floors, and was sweeping the yard when her mother called. "Time for us to git on."

"I done what I could," Irene told me.

"You did more than you should," I stooped to kiss her.

She threw her arms around me and gave a big, gasping sob. "You are so good, as good as any angel," she wept.

"Oh, no," I whispered and held her close. "Why don't you visit with us for a week or so?" I asked. I'd bathe the child, cut her hair, make her a dress. "All right?" I asked her mother.

"You can have her fer good if you want," indifferently.

I looked at Irene, dreading to see the blow strike. But her eyes grew luminous and she ran to her mother. "I have to go with Mommie! I have to!" Her face grew protective, tender, burning with love, and suddenly I understood. The mother was whipped, cowed. Nothing was left to her, not even love for her children; but this child was not whipped. Somehow, Irene would get them through this Depression, if it ever ended, as a golden voice over our $14.50 portable radio promised over and over that it would end.

As they started away, Irene darted back to whisper fiercely, "Don't think Mommie wants to give me away. She just wants to get a good home fer me."

"Of course she does." I kissed her, and her face lighted at my words. I offered them as a sacrifice to the child, and if He will accept a lie as a sacrifice, I offered them to God, for I knew the words to be a lie. Irene's mother would be happy to be rid of the child. But no earthly power could make Irene believe this. Her love was so overwhelming that she wrapped it like a warm blanket around her mother. She was a swamp blossom. Pure gold, growing from black swamp mold. Perhaps her love would be strong enough to save her mother.

I scalded all the bedclothes against possible contamination from our guests. David, coming in from work, told that the women were prostitutes, plying their trade in mining towns.

A FEW MORNINGS LATER, he went to work and returned just after lunch time. "Mine's closed for repairs," he announced as if he had just inherited a million dollars. He whistled "Dixie" and poured water into the tub for his bath. Hanging his clothes behind the stove, he knelt beside the tub to wash face and hands, head and shoulders; dried them; and stepped into the tub. Coal-mining muscles rippled with his every movement, and his skin was like silk. He turned to me, and his eyes were as bright as stars. "The mine will be closed for two weeks," he said. "Like to go home while there is no work?"

I was too stunned to speak, too happy to cry. Then I managed a whispered. "Tomorrow? Oh, David, I can help drive." I'd taken Thunderbolt to the ball diamond below our house a few times. I could start the car, shift from low to high gear and go forward erratically. So far, I'd never managed to shift into reverse. But who needed to reverse when we were going home?

"Let's go today," David said.

Here We Rest

D avid, naturally, had everything arranged for the trip, even a spare driver—not his wife. Karl Hauser, son of a friend, a high-school graduate with no job in sight, was happy at the chance to see Alabama. Mr. and Mrs. Hauser drove up with Karl all ready to go as we scrambled to put things in the car. "Which road you taking?" Mr. Hauser asked.

"The Jumps," David said, having asked the shortest way.

"You wouldn't!" Mrs. Hauser reached a protective hand to her son. "That's the worst road in the world."

"The shortest way home," David grinned.

"You'll be sorry. You wait and see."

David would never let a road intimidate him, I thought with pride. Anyhow, no road could be worse than the road between Marytown and Hemphill. In less than two hours, I discovered that I'd never been more wrong in my life.

We were a tousled but happy crew as we shuttled through Marytown, passed Twin Creek, and took the road that led to the Jumps.

When I am a hundred, ask me if I remember the Jumps and no doubt I'll be able to give you intimate details. The road was a nightmarish thing suspended on sheer cliffs, brittle ledges, and crumbling walls. Now and

then dugouts had been whittled into the side of the mountain where one car waited if another approached.

Trees jutted through clouds below and stared at us. Far above, rocks heaped carelessly together by an army of giants dared us to jostle them; when we met a car—and there were other fools on the road that twilight—one had to back up or down hill.

David was not the one who backed. Cars snorted daringly towards us, then backed frantically. Curses, roared at us, resounded from hill to valley. Our guardian angels alone, I am convinced, kept our wheels from going the extra inches that would have sent us into oblivion.

Only once did David give ground. A big muddy lumber truck bolted down the mountain and screamed towards us. His brakes screeched as the driver saw us. The truck rocked and continued to slide downwards toward us, helpless below. David, seeing that the truck couldn't stop, ground into reverse and crawfished madly.

Screaming and screeching, the monster hurtled towards us. David hung onto the road. We careened, missed the edge of curves by a razor's edge, and heard the rattle of shale falling down the mountainside. We teetered at the edge, still shuttling backwards, and then found a dugout and jolted to a stop as the truck missed us by a fingernail, screamed past and on down the devil-begotten road.

I closed my eyes, thankful to God, then opened them when there was strength to raise my eyelids. It was strangely quiet in the car. Karl leaned against the back seat. "Gosh," he whispered at last. "Gosh!"

Sharon, her eyes as blue as the twilight, patted my cheek. Then David found his voice. He went into detail, profanely, on the personality, looks, and intellect of the truck driver. Then he mentioned the road builders for some time. Next, he commented on the state and county road commissioners and worked his way up to the governor. He began to speak of the president; then Davene cut in:

"Spongabick!" she said clearly. "Gott down spongabick!"

I clapped my hand over her mouth.

Another car or two, outfaced by David, backed hastily uphill or, seeing our determined roar up the precipice, waited in dugouts until we passed.

THE TRIP DOWN THE other side of the Jumps was gentler, and so we traveled safely into Virginia. A serene moon and lovely hills—not mountains—tried to soothe my nerves. But the Jumps had been too much for me. "Stop the car," I moaned.

David careened to a halt. I bolted out of the car, darted under a barbed wire fence, and headed towards the gleam of water in a sweet Virginia pasture. Before I could reach it, I sat on a stump and was very sick.

"Baby girl—" David had followed. He ran to wet his handkerchief in the stream.

"So sick," I whispered. "So sick."

There was a sudden wild yelping and a pack of hounds loped in, ringed us, and snuffled eagerly.

"Bunch of drunks!" someone yelled, and half a dozen men followed the hounds. We stared, dazzled by a blaze of flashlights that dimmed the moon. I leaned weakly on my stump and clutched Sharon, who had scuttled under the fence and came to me.

David was bathing my head.

"What you doin' in my pastuh, ma'am?" a soft voice asked. My nausea passed at the balm of that soft accent. Dressed in whipcords and a gray shirt and jacket, the man loomed tall in the moonlight. His face was kind; his upper lip wore a sandy handlebar mustache.

"Drunk!" the first voice said.

"My mother is not drunk!" Sharon turned on him. "She is sick to her stomach."

David rose and walked gently over to my accuser; his fist jabbed once,

and the man fell to the earth. He sat up, rubbing his chin. "No call for that, stranguh." His voice had that Virginia softness. "If I'm wrong, I apologize, but if not—" he rose. He was even taller than the mustache.

"We're going home—excitement upsets my stomach," I explained, happy under the balm of those voices, "and we came over the Jumps . . ."

"The Jumps! No wonduh!" he nodded in sympathy.

"Wheah is your home, ma'am?" the mustache asked.

"Alabama."

"Think of that; my mother came from Montgomery. Hathaway,"—to the taller man—"you owe this little lady an apology."

"I apologize, ma'am," Hathaway bowed. "And to you, too, suh. You did right hittin' me. I had it comin'. Heah, ma'am, heah's some muscadine wine. Happen it'll settle youh stomach."

"Thank you," I beamed. "But I'm stronger now."

"Make yourselves at home," the mustache bowed, and all left to fresh screaming from the hounds.

The rest of the night passed in the steady roar of Thunderbolt as we wended southward. Bright sunlight woke me. We breakfasted, smeared sleep from our faces, and combed our frowzy heads. A dash of cold water, powder on my nose, fresh lipstick, and mascara, and I felt able to face the whole world.

KARL TOOK THE WHEEL and drove for a time. My eyes marked every mile of the way. About eleven in the morning, we pulled into Gadsden, Alabama. The heat of the sidewalk burned through my shoes. The coolness of West Virginia was past, but we didn't mind at all. This was home!

Restrooms attended to and the car filled with gas, David handed the attendant one of the twenties. A tall, Ichabod Crane-type person with sad brown eyes and opossum-like hair on head, neck, and wrists, the man stared at the bill. "Buddy, ain't you got less than that?"

"No," David said, importantly.

"Hey, Joe!" the man bawled. "Come here!"

Joe ran from the garage. "Trouble, Hank?" He grasped a big wrench in black-greased hands.

"Look at this," Hank held out the twenty.

Joe took it reverently, than stared at David as if he expected to see a Chicago machine gun about his person. "A twenty-dollar bill!" he said.

"He wants it changed," Hank said.

"Sure he does," Joe laughed. "Thanks for the compliment."

"Joe," Hank said patiently. "The man's bought gas. He don't have less than a twenty."

"Yes?" Joe's eyes searched for machine guns again.

"I can't wait all day." David's lips began to get their white line.

"Hey, Gus," Joe called to the restaurant man who had come over to watch. "Got change for a twenty?"

"You joking?" Gus reached his hand. "Just let me touch it," he begged.

"Maybe Herbert can change it," Joe said. The three of them crossed to a fruit stand. David accompanied them.

At Herbert's they collected two more men and marched down the street. David stuck close to his twenty. Finally, they found change and returned triumphant. There was money in Gadsden!

"Is it really that bad?" I tried to swallow a big lump.

"It's bad, ma'am," Hank told me. "Nobody's working in this town."

A bewildered, hurt, sick feeling was in the pit of my stomach as we left Gadsden and took the uncrowded highway south. At last we came to Morris. If the rainbow-colored Stutz with Griff at the wheel had jostled past, things would have looked exactly as a year ago.

PAPA HAD RENTED ANOTHER farm, but we knew the place. My heart settled into a steady, joyous beat as we drove a mile, turned off the highway, and lurched down a rutted, dusty lane.

Bulger, the old dog, creaked to his feet and came to meet us. Hens squawked, a young calf in the barnyard stared at us, then bolted around the lot. The house was old, of age-silvered hand-hewn logs, and had the beauty of an old-world painting. Tears washed the dust from my cheeks.

Thunderbolt's roar had announced us. Papa came around the house, a chunk of watermelon in his hand. Still dusty from his day's work, his old felt hat, the same as the year before, rode high on his forehead. He pushed the hat off and ran, his face as bright as the afternoon sun.

"Papa!" I was laughing and crying.

"I'm a big girl now," Davene boasted. She was two years, two months. Then she went on, "I'm hungry."

"Papa, Papa," Sharon crooned, and her soft, white hands caressed the whiskers on his cheeks.

"This is Karl Hauser," David introduced them. Karl had a doubtful look as if he wondered suddenly why he was here.

"Glad to see you, son." Papa shook hands. His face was so friendly that you knew immediately he meant what he said. He was Papa. No one had ever been able to resist his charm. As he shook his hand, Karl's face changed, looked as if he'd unexpectedly reached the promised land.

Miss Mildred came running around the house. Her dark hair was damp-curled all around her face. "I knew somebody was coming; that old rooster crowed right in the doorway." She laughed and bent to kiss the girls.

The other children streamed around the house, dripping watermelon juice. We'd never seen Jerry, the baby. Clothed only in watermelon juice and dust, he crawled toward us. Davene's eyes lighted. Here was a fellow nudist. She tugged at her shorts.

"No, you don't!" I grabbed her.

The air was warm and rich with the scent of growing things. In the field were rows of okra, corn, beans hanging thick on vines, peas crowding low among the corn. This was home!

Steps pounded down the path from the house on the hill, and my sister Thelma ran up the porch steps and grabbed me. Her gray eyes shone and her black lashes were wet. She had Papa's straight black hair and his charm. George, just behind her, grabbed me, then turned to David. "You struck it rich?" He pointed to Thunderbolt. George had black hair and very black eyes. Used to my three blonds, I'd almost forgotten about all of these black-haired Mosleys and in-laws, too.

"Thelma, when did you and George get here?" I asked, still hugging the smaller ones; oh, beautiful children: Colleen the oldest, Daphne next, J. D., and Jerry.

Woodward plant had closed, we learned. George, out of a job, at Papa's insistence had moved to the empty house on the rented farm, and there was enough work for everyone.

We laughed and cried a little and learned, as we had in Gadsden, that things were far worse in Alabama than in the coalfields of West Virginia. Red Cross commodities kept people from actually starving. Too proud to accept charity, Thelma had a job with the Red Cross, keeping books two days a week. Her wages: $1.50.

Everywhere people wore flour-sack underwear. There was the standing joke about the lettering on the panties. Actually, the letters were easily bleached from flour sacks. Feed sacks, too, when bleached, starched, and ironed, had the look and texture of linen and made beautiful dresses for Sunday.

Old inner tubes were a rare treasure. Ezra, my sister Maurine's husband, shared his old tubes. Thelma's small feet were her great pride. She still owned one pair of real shoes. Many went barefoot most of the time, but Thelma's pretty feet were always shod. She cut out strips of

inner tube and wove them into sandals, and she had a perky hat made of corn shucks.

Clothing was home-crafted. But there was no hunger here. Farm tables groaned under their load of food. The next few days we visited kinfolk and feasted until our clothing would scarcely contain us. There was fresh corn, beans, field peas, tomatoes, cucumbers, potatoes, and fried chicken by the platterful. Cornbread, thick buttermilk, and country butter. For dessert—peach, apple, and berry pies.

The girls were petted and loved and taken swimming in the creek nearby. And they helped with farm chores. Davene's tiny finger would twist a grain of corn until it popped from the ear; then she held it proudly up to Papa. Never impatient, he threw it to a chicken and praised her until she puffed up with pride.

But in a few days her attitude changed. As we walked to Thelma's one afternoon, a young rooster, just frying size, clumped past on long legs. "See dat chicken, Mother," Davene said. "I can eat dat chicken."

PAPA HAD TAKEN A helper, a distant relative. Their beds were crowded, so we slept at Thelma's. She and George were used to a nice home with bathroom, kitchen sink, electricity. But the lack of these didn't change their hospitality. The farm house was filled with fresh flowers and spotlessly clean with fresh-scrubbed white-pine floors. A born housekeeper, Thelma could wash (on a rub-board), scrub, iron clothes, and then cut out and make a dress for Jean or Ailene, her daughters, with less effort than it takes me to clean one room. Thelma was forever doing curtains, painting furniture, switching it around—a habit I had completely forgotten. She did everything for our comfort. Nights, I'd rouse to find her swabbing kerosene on my legs to scare mosquitoes away.

David and George had gone to visit Uncle Lish and Aunt Stella Mosley one afternoon. The children were tired and sleepy, so I didn't go with

them. Uncle Lish had a fresh batch of blackberry wine, and David was eager to sample it.

Shorter than Papa, younger, too, with thick black and white hair and twinkling hazel eyes, Uncle Lish wasn't the best farmer in the world, but he must have been the most fun. A born naturalist, he knew every tree, root, and berry. One taste of honey, and he could tell where the bees had sucked. He dried roots and herbs for his own medicines. He and Papa had secret formulas for sore throats, colds, and fevers. Neighbors, unable to afford doctors or medicines, sent for herbs and bottles of medicine—free, of course.

When his pigs conceived, Uncle Lish would bore a hole in his thumbnail and didn't have to bother with calendars. When the hole grew long enough to need trimming, there was always a new litter of pigs. He made hickory-split baskets and chair bottoms, tanned calf hides for other chair bottoms, and made his own banjo, stretching calf hide over it. His fingers brought forth fairy melodies from this instrument.

After the men left, Thelma and I sat in the open hallway and shelled peas for tomorrow's dinner. Sharon, Jean, and Ailene cut out paper dolls from a Sears catalogue, then ran down to Papa's to play hide-and-seek with the other children.

I took Davene to the back porch to wash her feet and remembered my childhood—how I dreaded to thrust my dirty feet into the cold water. Dressed in a pair of pajamas Thelma had made from feedsacks, Davene wanted me to rock her. So we sat in the hallway in the dusk, as Thelma churned milk to have fresh butter for breakfast.

Mosquitos gorged themselves on our chicken-rich blood. In the hollow, a whippoorwill called for his mate. A breeze wandered from the fields, scented with dust and ripe peaches. Chickens plurped sleepily in the henhouse. A screech owl wandered across the hills; crickets and tree frogs shrilled. Davene slept, and I sank into lazy, luxurious comfort.

"I'll put Davene to bed," I said when Thelma took the churn to the kitchen.

"Want me to bring the lamp?"

"No, I'll make it."

"I'll draw a bucket of water, then," Thelma said. I heard the windlass screech as I entered the house. Like a cat, I have an uncanny sense of direction, so I walked confidently to the bed and deposited Davene on it—to discover, as my arms released her, the bed was not there! I caught Davene before she hit the floor. Then something attacked me, and I plunged into darkness.

"Sue," I heard Thelma say from a far distance. I sat up. Davene was still in my arms and still asleep. "The bed was there last night," I pointed, then rubbed my forehead. A lump as big as a half-ripe peach was there, and dirt from the flower box which had attacked me as I fell.

Thelma put the lamp on the table beside the bed, which was now on the other side of the room. Her face was dangerously red. "Go ahead and laugh," I struggled to my feet, walked over and laid Davene on the bed safely.

"I can't help it," she gasped. She led me to the kitchen, bathed my forehead, then rubbed it with Cloverine salve.

We were on the porch listening to the whippoorwill again when David and George returned.

"I've just churned," Thelma told them.

"I like yesterday's buttermilk," David said. Kept in a bucket let down in the well, the day-old buttermilk was as thick as yogurt and tasted far better.

George went to get the milk. Thelma took down a plateful of syrup cookies, and David helped himself. Then I turned to face him. His mouth opened and stayed open. Finally his jaws were in working order. "What happened?" he asked.

"A burglar, I guess," I stated innocently, I hoped.

George's eyes were as black as a seam of coal. "Heard about Dave's twenties, I bet!" He began to curse.

"I'll kill him!" David's blue-gray eyes turned green. "Oh, baby, I shouldn't have left you!"

I wallowed in his concern, but this was too much for Thelma; she whooped with laughter. George dragged the story from her; then he grinned. "You know how Pannie (his pet name for her) is. I never can find anything."

David gave me a few black looks; then pity took over. He stirred up the low fire in the stove, heated water, and applied hot towels until I was in danger of having blisters over my bruise.

"I HAVE TO SEE Lucile and Maurine," I said after two days. Lucile was my more-than-twin. Just younger than I, but far more efficient, she ironed my clothes when I was at home. "Sue, you can't do that," she'd say. And she watched after me to see that everything was in place. Friends pinch-hit for her now. Someone is always buttoning me, fastening things, or repinning strayed hairpins.

From the time I was eleven and she going on ten, Lucile and I were the same size and thought almost the same thoughts. One of us could start a sentence, and the other finish it. We argued often, but never in our lives were we angry with one another. Lucile and our older brother Clarence lived with our sister Maurine and her husband, Ezra Armour. Clarence helped Ezra, who owned a country store, and Lucile helped Maurine with the housework, sewed for her three girls, washed, ironed, swept, dusted. The boys, Tom and Ray, wore overalls she had starched and creased; she kept the whole family in perfect dress. In between times, Lucile sang at church, and she and Clarence were the ringleaders of whatever was going on in Haig.

No one had any money, but they managed plenty of fun.

Lucile was scrubbing the porch as we drove up. She stopped, threw bucket and broom aside, and ran with Maurine to meet us. More laughter and crying as we tried to cram a whole year into a few hours.

Karl was lost the minute he laid eyes on Lucile's pink cheeks, dark hair, and hazel eyes. Perhaps he didn't know that Alabama's motto was "Here We Rest," but he made it his own immediately and decided to stay with Maurine and Ezra while David and I left for a few days' visit with his parents, on Pea Ridge in Shelby County.

Hottest Day I Ever Saw

We drove into Birmingham the next morning. It was a clean city now, a sad, brooding cleanness that no one wanted. The big industries that had belched smoke and grime during the twenties were almost dead now. The city was quiet with little traffic. Laughter, gaiety, and bustle were gone. The joy, hope, and expectation of six years ago were all but forgotten.

Seen by night from the top of Red Mountain, the city is a gossamer dream. A wide river of jewels flows in beautiful, vibrant curves. Vulcan, the iron man, guards the city from his pinnacle atop the mountain.

We passed through the somber city and raced down the Montgomery highway. At Alabaster, a town of lime kilns, most of them idle now, we turned into a dusty road, ran a few miles, then began the ascent to Pea Ridge.

Eight miles from Montevallo College, Pea Ridge was a hundred years away in ideas then. Older women wore long dresses with long sleeves. They thought makeup sinful, and "bobbed" hair, too. They wore their hair tightly skewered into a bun on top. Most faces had an honesty and cleanness that was as pleasing as any beauty they lacked.

David's mother, Granny we called her, was sitting on the porch with Papa when we drove up. She looked very beautiful to us, tightly skewered hair and all. Her long-sleeved dress was the blue of her eyes. Starched

and ironed, the dress was clean and crisp, as dresses had to be then. Papa was too thin, with a long chin, fierce blue eyes, and pepper and salt curls. (Ours was really a curly-headed family.)

Buddy, the baby, had died since we left. Granny sunned* his clothes weekly, wetting the trunk lid with her tears. He was nine when he died. "I'd bring him back any time," she told me, showing me his clean, starched clothing.

Hubert and Huey, the twins, sixteen now, rushed from the backyard. Willard followed them. Vera, the youngest, grabbed the girls. We sank once more into the joys of home and family and love.

David's sister Meadie Smith and children came from Boothton to spend the day. The third day of our visit, we sat on the porch, the gnat smoke going full blast to keep gnats and mosquitos from bothering us. Granny saved every rag all winter to burn in summer. She rose now, soused the dipper in water, took a drink, poured the remainder over a geranium in a pot, and sat back down. "Mamie said the boys are sure growing," she smiled.

David winked at me. We knew instantly that she wanted to go and visit.

"Flora lives next door to her, in Acmar," Granny said. "It is just seventy miles from here."

Sharon, holding a white cat, sat on the steps beside Vera. Davene stalked a young rooster. Sated with cornbread, field peas, chicken, and blackberry pie, we drowsed and talked.

"Dave," Papa stared at the late sun. "We'll chip in and buy gas if you'll take us to Acmar."

"I'll buy the gas," David said.

There was an immediate clamor to go. A trip anywhere was a great luxury. "I promised Thelma she could go," Granny said. David winked at me. He knew this had been planned. His sister Myrtle came up. "I am going," she announced. Hubert, Huey, Willard, Vera, everyone wanted to go.

"The car will hold ten," David announced. "That is all."

Ten! I thought, and looked at the hot, brassy sky.

PAPA ALWAYS AWOKE ABOUT 3 A.M. By seven the next morning we'd eaten breakfast, washed dishes, swept the floors, and were dressed and ready to leave. We were to pick up Thelma and her son James in Dogwood.

Perspiration wet my forehead. I sat close to David and settled down into the inferno. Air-conditioned cars were unheard of then. Granny crammed herself against the door. Davene grumbled about room, then sat forward inspecting the chickens as we passed. Sharon, Papa Pickett, Myrtle, Thelma, James, and Willard squeezed into the back seat. A cloud of dust boiled behind us as we sped northward.

"Dave!" Papa's voice trembled. "Your wife and children are in this car!"

David increased his speed.

"Oh, Dave!" Thelma, his oldest sister, gentle, sweet, and—from her voice—now terrified: "You'll kill us all."

David, having driven the Marytown road to Welch time and time again, and then having driven safely over the Jumps, had total confidence in his driving ability. "Anybody's afraid can get out," he said.

No one, apparently, was afraid.

Papa bent forward, face red, dusty, and as stubborn as David's. He nodded angrily, and beads of sweat mustached his upper lip. Knuckles white, he clung to the doorknob. Thelma rested her head against the back seat and closed her eyes. Her lips moved. Myrtle, with quicksilver temper like Papa's and David's, flushed a dull red. "Dave, if you want to kill us all, go ahead."

David went ahead. In just two hours we reached Acmar, found Mamie's house, piled out of the car and onto the porch. Mamie came out and grabbed David first. Flora, next door, saw us and ran. More hugging, kissing, laughter, and tears. Then Mamie, accompanied by Granny, went

to forage in the garden. The sisters helped, and the table was soon loaded with squash, corn, tomatoes, sausage, biscuits, and a peach pie. We did full justice to the meal, sweating away in the oven-like kitchen. I felt blood kin to Shadrach, Meshach, and Abednego.

"Hottest day I ever saw," Papa said, his face almost as red as the eye of the coal cookstove.

Stuffed and wretchedly hot, we managed the dishes. Then, steaming like a Florida swamp, we migrated to the small front porch. Hottest day I ever saw, too, I thought, and for a treacherous moment I longed for the coolness of West Virginia. Blasting sun wilted the vegetation and reflected in the road in shimmering heat devils.

Too numbed almost to dread the trip home, I endured the heat, longed for my sister Thelma's open hallway, and remembered the giant, cool oaks of Piper. My vagueness left in a burst of homesickness.

Papa rose, poured water into the washpan on a plank shelf on the porch, washed the sweat from his face, and dried it. "Let's go! Let's go!" he urged. "Bound to be a storm. Never saw it so hot."

Even though I was used to large families, Southern hospitality, and visiting; for a moment I thought that we overdid the kinfolk bit. Was a few moments' visiting worth all the crowding, jolting, and sweating?

"I'll be ready in a few minutes," Mamie said from the bedroom. I turned to look. Granny was washing John A.'s face, and Mamie fastened a suitcase, then handed a sack to her oldest son, J. D., who was eight. "Take this to the car, son," she said, and began to wash Jack's face, which, at the moment, was almost as red as his hair. Thunderbolt couldn't hold five more!

"Mamie?" Papa asked hesitantly. "Reckon there's room?"

"Of course," calmly.

"We've figured it out," Granny said. "I'll hold Jack [he was five], and Sharon can stand between Sue and me. Mamie will hold Jerrold [the baby]."

LIKE SARDINES, FOURTEEN OF us crammed into the five-passenger car. Four grownups sat in the back. Five children sat on them or stood with heads, feet, and elbows in the way.

Davene sat in my lap—hair, neck, and body wet with sweat. She took a nap, then woke as mad as a copperhead. She pushed at Sharon, who had no room to move. Granny mopped her face, then wiped Jack's, pushing the fiery red hair out of his eyes. All of us were cross and snapped at each other. Thunderbolt coughed and lurched along. His engine, under my blistered feet, seemed boiling hot.

The children in the back quarreled and pushed for room. David stood this for a time; then a blast of profanity silenced us. The endless, dust-fogged road shimmered mile after hot mile. The air that filtered in to me burned my face. My dress was wringing wet. Sweat ran down my arms and legs. I sat as small as possible to give David room. For once I was glad of his speed. One way or the other, we would soon be out of our misery.

Then a thundercloud boiled up suddenly and spread menacing wings across the sky. Wind fluttered through a field, gained speed, and swooshed through the car. Oh cool, enchanting wind! Then lightning cut a ragged hole through the sky and wrote its name down the side of a tall pine tree. Thunder, like the voice of God, named us all as sinners, and rain sluiced down on us.

The children screamed. Thelma prayed again. God had named, then spared us. We scrambled to pull down curtains, but the rain found slits and washed us clean. Thunderbolt, cooling, went faster, split a sheet of water in the middle of the road and rocked into a mudhole. Valiantly, he dug a trough, slid sideways, almost turned over, righted, and spun mud from the rear wheels. Deeper and deeper the wheels dug into the mud. David turned off the motor, stepped out of the car, slogged down into the mud, and spoke his mind.

"Son!" Granny said fearfully.

David hadn't finished. Heads stuck out, and we stared at the mud. "Don't just sit there!" David's wrath blasted us. The rain had curled his hair all over his head, his teeth gleamed, and his eyes were the angry purple of the clouds.

"Son," Thelma explained. "I've got on my best shoes."

"Me, too," Mamie and Myrtle said.

Granny opened her door, stepped out, and slogged to the side of the road. Papa took one of the children and followed her. I slipped out of my white pumps and splashed through the mud to hand Davene to Granny.

David started Thunderbolt. Papa and I stood in the slush behind the car and pushed. The wheels bit deeper. Yellow mud decorated our faces. We pushed harder. The car moved an inch, gained speed, and crawled out of the mudhole. Finding a puddle beside the road, I smeared dirt from my face and feet; then we jammed back into the car.

LONG BEFORE DARK, WE arrived safely home, untangled, and spilled from the car. "I'm starving," David said. I put a gentle hand to his mud-smeared face.

The boys piled wood into the woodbox. Granny fired up the stove and washed her hands. The rest of us took turns at the washpan and tub. "Dave, catch us a chicken or two," Granny said.

"Dave's going to run down a chicken!" Vera called. We all crowded into the yard to see the show. When David caught a chicken, he literally ran it down. No coaxing with feed. Just as he attacked every chore, David, with grim determination, ran down a chicken. He started after it, lightning fast, and no matter how the poor bird changed course, David was behind, as if reading its mind. Like doom, he followed until the chicken was caught. Why we never entered him in the Olympics, I shall never fathom.

In record time, he captured two young roosters and wrung their necks. While I ran to gather and shuck fresh corn, Myrtle and Mamie plucked

the chickens and cut them up. Granny made a blackberry pie and biscuits. The table and cooktable were cleared. In a very short time we sat down to chicken and gravy, biscuits, corn, tomatoes, cucumbers, and pie. Depression? Oh, yes! Papa Pickett sometimes worked all day for a bushel of corn to make meal and feed the cow and chickens. Corn sold for sixty-five cents a bushel. Now and then, he and the twins found a day's work cutting timbers for the mine. They had almost no money.

But there was no hunger here—not in summer, with a matriarch like Granny who kept chickens, a cow, and pigs, and saw that a garden, heavily fertilized with manure, was planted and every weed and blade of grass pulled as it appeared. Shelves were already lined with canned blackberries, pickles, tomatoes, peaches, beans, and corn. Cows roamed the countryside, coming home nights to be milked. Sweet potato vines, corn shucks, and a handful of meal was sufficient food for cows in summer. Hens scratched most of their food from the earth, eating grubs, crickets, worms, grasshoppers, and termites in rotting wood. There were no termites in the houses then. Chickens devoured every one they could find.

Pallets lined the floor that night. David and I slept on a spare mattress which we dragged to the front porch for coolness. The stars were bright. A cool breeze came from the west from our beloved Piper hills. Oh, how I yearned to see them! Not for just one day, but to wake each morning and look out my window to see the beauty everywhere. We'd started housekeeping in Piper, and we loved that small coal-mining town more than any other place on earth.

"Like to go to Piper tomorrow?" David must have read my mind.

"Yes! Oh, yes!"

Such Good People

Afterbreakfast the next morning, we dressed and were on our way. Every bend in the road was familiar. Trees, heavy with dust, leaned over the roadside. Briars turned orange-blighted leaves towards the sky. Sumac's red berries shone through a coat of yellow dust. "We are going home," the dust whispered to me. I rubbed David's arm, proud of the rippling muscles. A miracle was sure to happen, and he would find work.

But our return put a dead, desolate weight on my chest. The people I loved best in the world, next to family, were existing somehow on three and four days' work a month. There were angry, bitter, and hopeless tales. One that rankled above all: a group of men had gone to the head of the company to ask for credit. "Our children are hungry," they told him.

"Let them eat mussels, plenty of mussels in the river. Let them eat hickory nuts," he told them.

"Yes, we stole a calf from a pasture," a friend told David. "The man had plenty more, and our children were hungry." He almost boasted of the deed.

The hardest thing for us was to see their resignation—a waiting patience, numbed, hopeless. "This dust is terrible!" David said as we started up the river hill. "One thing about West Virginia, it rains so much we don't have dust there."

"Yes," I agreed, too heartsick to defend Alabama.

The next day it was time to leave. Granny cried; Papa's face was red.

My eyes were as dry as cottonballs. On the way to Morris, though, the floodgate opened.

"Don't cry," David said uneasily.

"But they were hungry," I wept.

"Things will get better," he promised. I had seen him slip a dollar to one or two friends, was glad, and trusted that we'd have sufficient left to buy gasoline for the trip home.

As we drove up to Papa's, there was a crowd on the porch. Granny Mosley was at home. She'd been visiting Uncle Gus and Aunt Josie in Winston County. Little Granny wasn't pretty, but she was so pure in heart, so humble, she was a blessing to everyone. Her small, wrinkled face wore the scars where a crazed neighbor had cut her long ago. It must have been her soul, so big the frail body could scarcely contain it, that made you smile when you looked at her, and you were a better person and the world was better because she lived.

The scars didn't worry her. She told how the neighbor had had a mental breakdown. Granny was staying with her while the husband went to the mill. That night she woke to find herself lying in a pool of blood. The neighbor, standing over her, screamed. "Someone has tried to kill you, Sue! I'll cut his heart out!" Totally unaware that she had cut Granny, she stood guard all night, axe in hand.

"She bandaged my face and did everything she could," Granny said.

"Weren't you scared to death the rest of the night?"

"Mary would not hurt me if she knew," Granny said. She lived with Uncle Lish and visited the others. Grandpa had been a Civil War veteran; Granny had a small pension. She gave away most of her money but kept fifty cents for each Sunday's church collection. Often it was the biggest single contribution.

Papa came walking around the house in deep conversation with a white-haired man and introduced him as "Brother Morrow." Papa had taken in

the gentle itinerant preacher, questioned him on doctrine, then gathered a nightly crowd—kinfolk, mostly—for a five-day revival under a hastily constructed brush arbor. Past seventy, the old preacher had a feeble voice, no regular church nor income. Any homeless person was always welcome at the Mosley home. Papa invited, and Miss Mildred cooked for them. If there were only salt pork, gravy, and bread, Papa never complained or apologized. I believe if a hungry tiger had wandered through, he would have found a pen and something to eat.

WE SPENT OUR LAST night with Thelma and George and were up at four. Breakfasted and dressed, we walked down to Papa's. "Why don't you go home with us?" David asked.

A cup of coffee was on the way to Papa's lips. His eyes brightened. He waved the cup and said, "Wish I could, son." Born at Morris, he'd never been a hundred miles from there.

"Why not?" Miss Mildred laughed. "The crops are laid by."

Papa's face became as bright as the morning sun.

"George and the others can take care of things." Granny emptied her cup, rinsed it, filled it with hot water, and put in a teaspoon of sugar and a teaspoon of whiskey, her morning "toddy." This she took daily. One spoonful and no more. It must have been good medicine. She lived to be ninety-three and was in good health until the last few months of her life.

"Papa," I said, "if anybody deserves a vacation, you do."

"Deserves?" He looked astonished. He'd worked hard all of his life. Fervently in love with the whole world, he had seen little of it. But he made friends; men stopped to talk as he leaned on his plow, or sat on the porch with him evenings to chew tobacco and discuss religion, politics, or any other subject.

Papa observed nature—birds, clouds, and winds—as he worked. He'd take a handful of soil, smell it, and let it filter through his fingers. He read

widely, even medical books that old Dr. Hardcastle had willed to him. He read mornings as he drank a last cup of coffee, by firelight at night. His mind was young and hungry for new friends, places, and things. I inherited his love of people, nature, reading, and travel, and his worst faults also, adding a few of my own. I argued with him (often a heated argument if we disagreed), told him of his faults, and loved him always.

He asked nothing of anyone and did so much for others; he worked on his rented farm, enriched the land with manure, planted Austrian peas in winter and plowed them under to supply organic fertilizer long before the "cult" for organic gardening. He planted fruit trees, paid his three bales of cotton for rent, and improved the land as if it were his own.

"I'll pay your way home, Papa," David begged eagerly. It was settled in a moment. Miss Mildred ran to pack clothes. She was such a good wife. Lee and Grayson brought tomatoes and melons. At the stove, Papa finished his coffee, cleared his throat, and said, "Could you take Brother Morrow?"

"To West Virginia?" I tried to sound casual, to keep horror from my voice, but the memory of Acmar started beads of sweat on my face.

"No, to Pisgah. He begins a revival there tomorrow."

"Always room for one more," David said.

WE HAD TO PICK up Karl at Maurine's place. When he first reached there, Karl stared at Lucile. Now he blushed when she spoke to him, and kept doggedly near. Clarence's ribald jokes made him choke with laughter, and Karl practically lived on home brew. Even Clarence began to hide it from him. The local brew, compounded of corn mash, sugar, carbide, rotten apples, peaches, or any other available material, packed a kick like a one-eyed mule. Maurine emptied every bottle she could find, but Clarence found new hiding places.

Maurine was on the front porch when we drove up. "Karl is hiding," she said, her eyes twinkling.

"Hiding!" David exploded. This was no time for games.

"He wants to live with us. Said he'd work for his board."

We began a search for him. "Here he is!" Lucile called from the store, next door. Karl was in the back room behind the chicken feed. Tearfully, he nursed a bottle of homebrew. "Won't leave these good folks," he wept.

We pleaded with him. David was ready to use force when Papa said, "You go back with us and show me around; then you can come home with me. I'm going home with David and Sue."

"All right," Karl agreed. He stepped out and went to the car. We had tied bundles, boxes, and suitcases to the fenders and crowded melons, tomatoes, and packages inside. Davene sat in my lap, naturally, and my legs soon acquired their accustomed numbness.

"Never saw such good people," Karl wept.

"Times are bad everywhere," David complained.

"Haven't gone hungry yet, have you, son?" Papa asked.

"I'm hungry," Davene announced. I'd never heard of prepared baby food, and mine were not bottle babies. They went to glasses of milk and table food as soon as they were weaned, and they were as healthy as young lions. With our delayed start, it was late afternoon when we came to the road that turned off to Pisgah and learned there was no bus until morning.

"I can walk," the old preacher said.

"Seventeen miles?" Papa waved his hands. "Now, now, could we get to Chattanooga that way?"

"Oh, you could get there," the attendant at the gas station where we'd stopped said. "Rough road, though."

"I'll buy extra gas, son," Papa offered. "We didn't pay for the meeting."

"Fed me, though—best you could do."

"They that preach the gospel should live of the gospel," Papa quoted, and soon they were in a deep theological discussion.

I dodged Papa's waving hands and leaned against the back seat. Sumacs

were bright red, and pawpaw bushes leaned over the road. I looked at the familiar Alabama vegetation with dry eyes.

The road to Pisgah was just two ridges over gashes in the earth. It took David over an hour to drive the seventeen miles. Miraculous driving, keeping the tires on those ridges. We located the Smiths, where Brother Morrow was expected. Papa's hands busied themselves as he made new acquaintances. David asked instructions, and we were riding again.

13

The Worst Road in the United States

Dark purpled the hills as we sped towards Tennessee. With Davene off my lap, fairly comfortable now, I nodded drowsily. Fog rose, thickened, grew so dense that it was impossible to see the road a few feet ahead. David slowed to an unheard-of (for him) fifteen miles an hour. I settled to drowsy delight. Night riding excites me. I've a strange feeling of faraway places. My wanderlust rises with the steady roar of the motor, the feel of night wind in my face. I forget past and future worries and live for the pleasure of the moment. Davene was asleep now, leaning against me. Papa, his feet twisted around boxes, suitcases, and watermelons, held Sharon close to his side. We crept through the eerie fog. The car's roar was muted; the lights peered anxiously ahead.

Then a giant bulk loomed in the headlights. David slammed on the brakes too late and hit a young bull. The animal gave a surprised bellow, then dashed away into the fog.

"Was that the Devil?" Sharon cowered against Papa. "I can see his horns." (She must have heard tales somewhere; I'd never told her the Devil had horns.)

"Just a young steer," Papa kissed her.

"Is Jesus stronger than the Devil?" Sharon asked.

"Stronger than anything," Papa assured her.

She leaned against him, sang "Jesus Loves Me," and secure in that love, fell asleep.

David dismounted and looked at the bumper. He had only touched the animal, with no damage to the car or bull, so he started Thunderbolt, and we roared on again in a strange, separate place apart from the earth. The only visible things were wraiths of ghostlike fog.

This was a night of ghosts, so naturally I saw one.

At midnight, we reached Horseshoe Bend and saw the Chattanooga lights reflected in the river. Papa roused, peered out the window, then sat forward and read a sign, Chickamauga Park. "Paw fought in the battle of Chickamauga," he said. "Then he went on to the battle of Atlanta, where he was wounded."

BEFORE MY EYES, GRANDPA appeared. My imagination, of course. I was half asleep, and no one else saw him. But if he should appear anywhere, it would be in this area. In my half-waking state, I could hear his violin. Grandpa had never studied music, but he didn't need to any more than the mockingbird does. Music was as natural as sight with him. When he was only nine, people rode twenty miles to get little Billy Mosley to play for dances.

If Grandpa heard a tune once, it was his, and he added his own variations to it: silver and golden tunes such as the late great Fritz Kreisler or Yehudi Menuhin could make, but no other that I ever heard. A deep, rich bass and high silver, almost human, tones came from his violin.

An undiscovered genius, until he died at the age of eighty-three, Grandpa's frail hands could set feet to dancing with his fairy music. When he and Grandma came to visit, crowds flocked to our home to hear him play, which he did with joy. "Cotton-Eye Joe" was his last number. Why, I never knew. He had his own secret reason. You could beg, offer to pay—an insult Grandpa never forgave, but when he played "Cotton-Eye Joe," it was his last tune.

He was stubborn, bad-tempered, senselessly jealous of Grandma, but totally honest. He simply would not lie, and he paid every cent he owed if it meant starvation for himself and his family. A common saying from all who knew him was "Billy Mosley's word is better than another man's bond."

Grandpa was strong and healthy on a very unhealthy diet, which consisted chiefly of cornbread, fried bacon, and "grease gravy," commonly called "red-eye gravy." Not once after Lee surrendered at Appomattox did Grandpa ever taste wheat bread. He had fought and half starved on a diet of cornbread and thin gruel made of corn meal. If it was good enough in war, it was good enough afterward for Grandpa. Mama always knew to cook cornbread for breakfast when he was visiting. He filled his plate with bread and ladled hot bacon grease over it along with the hottest pepper sauce that could be found. Some of the sauce must have gone to his head, for his disposition was as peppery as his diet. He erupted into frequent blasts of temper. I rather think he enjoyed his temper and used it to get his way about everything.

And Grandpa always wore a hat: a black one for Sunday, a brown army hat his youngest son, Milton, brought back from service in World War I for every day. Grandpa almost burst with pride when Milton volunteered for that war. "A Mosley has fought in every American war," he boasted.

He wore his white hair shoulder-length, in a row of curls. There was a large "wind" in the bald spot at the top of his head. Perhaps it was vanity, but on arising, Grandpa combed his hair, donned his hat, and didn't take it off until he undressed at night. Only for funerals (Grandpa never went to church) or for some "great" occasion would he remove his hat. If "Dixie" was played, the hat rested reverently over his heart, for "Dixie" was his supreme love and his religion. He never admitted that the North really won the war. "They didn't whip us!" he would say angrily. "They starved us to death." And Grandpa was never whipped. He was wounded and captured in the Battle of Atlanta. A Yankee doctor removed the bul-

let from his thigh, gave it to him, and he kept it, wrapped in a bit of gray flannel, until the time of his death. He let me hold it once. I had learned to play his favorite tune, "Under the Double Eagle March." He was so proud of me, he brought out his most cherished possession and let me hold it for a moment. My brother J. D. Mosley now has that bullet.

My father was named Lee. Uncle Lish was Robert E. (Elisha). If Robert E. Lee had had a dozen names, all of them would have been used.

Now, years after his death, Grandpa smiled at me. His hat was in his hand, for he was near sacred Chickamauga. Mists hung on his white hair, and a lone flute played "Dixie."

THE CAR STOPPED, AND I sat up in fright. David had changed places with Karl. Believing in Divine Providence and secure in David's driving, I had slept soundly. But Karl was something else. He had sobered, but he was tired and groggy. But the old preacher was praying for us. I dozed confidently. The car's coming to a complete stop woke me. I could see the white line in the middle of the highway. We straddled it exactly, but nothing else was visible in the heavy fog. Karl, his head on the wheel, snored softly. I touched his shoulder. "Want me to drive?" I asked.

"Huh?" His face was puffy in the light of the dashboard.

"Hold Davene."

He slept again.

I shook him. He roused slightly. "Back here," I said.

He opened the door and staggered to the back seat. I put Davene in his lap. Her head rested on his shoulder, and they both slept, dead to fog, ghosts, or real danger. Papa and David slept, too. We had bought a tankful of gas a few miles back. At our slow pace, it should last until morning. "Be with me," I threw a prayer to Heaven and slipped under the wheel. David slumped against me, his lips parted slightly. His white teeth gleamed in the light, his hair curled on his forehead, but I didn't take time to admire him.

My feet played a Confederate march on the floorboard. I thought of Grandpa running, gallant and brave, towards Chickamauga. Trying to be brave myself, I mashed the clutch and gas pedal with my feet, and my shaking hands endangered the gear shift as we jerked along in low gear, second, then high.

In spite of my bravery, I fed the gas in jerks. Only the line in the middle of the road was visible. This couldn't be Earth and a material road. We seemed to be on a cloud and had died, and this was the highway to heaven. But, I thought in alarm, some of us, in our present state, would never make it.

The thought woke me, and I concentrated on driving and clung to the middle of the road. When a car showed its lights, I inched to the right of the white line and blessed the mastermind that had conceived it and the engineers and workmen that had painted it in the exact center of the road. Faith and prayer brought us safely past the oncoming car; then it was back to the middle of the road as we traveled onward.

Thunderbolt, sluggish but game, toiled bravely. The sleepers sighed or snored softly. A moist wind chilled my cheek. Were the girls cold? I had put light sweaters on them. Thunderbolt's roar became the hum of bees. I jumped, woke, and searched for my lifeline. There it was—dangerously to the right! A car approached, blew his horn, then swerved to the left to miss us. In his lights, I saw how near we had come to driving into a chasm at the left.

Fright kept me awake for a time; then drowsiness fell again. I suffered at the wheel and thought in anger of those who snored away in the back. Little did they care what happened. I couldn't drive anyhow and was half asleep myself. My eyes just wouldn't stay open. We were entering Knoxville, a city famous for its narrow, crooked streets. Our money was almost gone. We couldn't stay on the road much longer. With grim determination to get home, I drove into Knoxville.

The wicked, white fog changed to black; then the blast of a horn woke me. I'd stopped in the middle of the street. A bus, too wide to pass, blew his horn profanely. I started the motor, shot into low gear, and darted to the right.

The bus gave a last angry blast as he passed me, and I saw an arrow pointing the other way to Bristol. "I've taken the wrong road," I wept. In my drugged state, I forgot that I'd never learned to back the car. I threw the lever into reverse, backed an inch, killed the motor as another bus passed. Thunderbolt bucked and jolted, but somehow I turned around in the middle of that narrow street, inching forward, then backward, and we drove on toward Bristol.

To stay awake, I began to slap my face—a stinging blow that would wake me for a moment. "Sue," Papa chuckled, "if you need a whipping, I'll give you a good one."

"Huh? What?" David woke and sat up. "You driving?" he cocked a dazed eye at me. "Don't you know you'll kill us all? Where are we?"

"A few miles past Knoxville."

"You drove through Knoxville! Are you crazy!"

"Just sleepy," I said, too tired to fight. I pulled over, stopped Thunderbolt, and changed places with David. Karl and the girls slept heavily. Papa nodded. With David under the wheel now, I slept, too.

It was foggy daylight when we stopped at a service station. "I want to eat," Davene announced.

"I'm hungry." Sharon stared at donuts in the window of a small cafe. We crawled stiffly from the car, stretched our legs, went to the rest room, then to breakfast. The children, too hungry to talk, ate bacon and eggs and swigged coffee almost thick with cream and sugar. A donut each finished off their meal.

BACK IN THE CAR we piled. Karl, awake now and certainly sober, drove

again. David and the girls settled comfortably and slept as if they'd never heard of strong coffee. A cold wind chilled us.

Karl roared along at seventy miles an hour.

"I'm cold." Sharon woke and began to cry.

"I'm freezing." Davene accompanied her.

Karl didn't lessen his speed as he pulled down his curtain. It stuck and he looked to see what was wrong. Alerted to danger as the car slowed, David woke. "Slow down!" he said. "Are you crazy? Slow down!"

But he was too late.

The road, newly built, was eleven feet high. A row of houses ran along below the built-up highway. Thunderbolt swerved, sprang forward, and was airborne for a moment.

"Keep this car in the road!" David yelled, uselessly.

Karl, unfortunately, was too frightened to even try to steer the car. His hands had frozen to the wheel. Thunderbolt touched earth the way he had headed and bolted down the eleven-foot drop.

Both of my hands automatically held the girls, one on either side of me, and I was helpless when it came to myself. My head hit the back of the front seat again and again as the car lurched and thumped down the steep side of the roadbed.

After David's shout, none of us spoke. We were too busy and too frightened. There was only the jolting, rending noise the car made and the thump of my head against the back of the seat. Rending, crashing sounds came amid the squawk of chickens, and finally the car halted.

I looked to see that the girls were all right; then, my strength gone, I leaned weakly against the back seat, with closed eyes.

"Mother's dead!" Sharon tried to pry my eyelids open.

"I'm all right, darling," I managed to whisper, and opened my eyes. It took a great effort. Then as strength returned, I examined Sharon and Davene more carefully. They didn't have a scratch or a bruise. But a goose

egg as large as the one given me by the flowerbox was on my forehead. One thing was sure, if the old head held out, the girls would always be all right. True, I was young and perhaps a little bit stupid, but instinct as old as Mother Eve guided me, made me forget injury to myself and hold onto my babies.

All of us were dazed for a few minutes. People crowded around the car and looked at us anxiously. Someone opened the back door, someone else opened the front door on the other side, and we were helped out of the car. David examined the damage to car and to property. How we escaped with so little injury, none of us could understand. There had certainly been terrific force to stop the car. Two oak fence posts had been uprooted, two small oak trees were severed, and two hens had been killed. The car rested an inch from the pillar of the house. That close we had been to possible death.

"Oh, we killed your chickens." I wept from relief, in a sort of daze. "We'll pay for them."

"I don't want pay. You are all alive, thank God!" a tall man said. He was the owner of house, chickens, posts, and trees, we learned.

"But we have damaged your property," David said.

"Don't mind that! No one was killed!" The man began to weep.

"They built that road too high," a woman told us. "Lots of people have had accidents. He ran off and . . ."

Except for my head bump, all of us were all right, but the car was a total wreck, it seemed. It would never, never run again. We were more than a hundred miles from home, almost broke, and certainly could not pay for a bus ride.

David and everyone examined the car. "It is ruined. We'll never get it up that bank," Karl said.

"Looks like you are right, son," Papa agreed.

The left fender and left bumper were so badly bent that the tire could

not move, even if the motor would run. David walked around it several times, bent, examined fender and bumper. "Do you have any iron tools?" he asked the man.

"A crowbar and a few other things."

"We can straighten the fender and the bumper," David announced.

"But that fender is strong!" Karl said. "Look what it did—broke two oak posts and cut down two small oak trees."

"We can straighten them enough so that the car will run," David insisted. When the man brought the crowbar, David's muscles plus his strong willpower did the trick. He did straighten the bumper and the fender, enough to give room for the tire to move. Thank goodness, for due to their strength, nothing else—neither tires, doors, nor even the sides of the car—had been damaged.

And what a car Thunderbolt was! David started the motor; it bellowed and roared proudly. He backed, turned until he faced the highway, then decided it was better to try to go up at the angle we had come down—not straight up, but veering a little, crawling up the side to the road—but this was too much even for Thunderbolt. He just couldn't make it up that steep hill.

"Not another car would go through what this one did and even start," Papa said.

"If some of you will push," David turned to the men who had gathered.

About six of them put their hands and shoulders to the rear of the car. Thunderbolt growled, struggled, and slowly climbed that high roadbed until he was safely on the highway.

We waved to the good people below and were off. Coming to a filling station, we stopped for gas. David's pocket was almost empty, but I found some change, enough to buy all of us a Coke. "I'll pay for them," Papa insisted.

"No, Papa. We pay," I said, so firmly that he knew I meant what I said.

David whispered to me, "We don't have enough to buy gasoline to go the long way home."

"So?" I said and began to shake once more. I knew the alternative.

"We'll have to take the Jumps again," David stated.

I had promised myself that never, so long as I lived, would I ride over that road again—that I would walk before enduring that. But I knew that the six of us couldn't walk more than a hundred miles. We didn't even tell Karl and the children. No need to try to tell Papa. No one could tell about that road. You had to ride over it yourself to understand.

David's face was grim as we entered the car and headed once more for "the worst road in the United States."

Score One for West Virginia!

Leaving the hills of Virginia, we traveled into the West Virginia mountains. Reaching the Jumps, we screeched around curves, clung to the walls whenever possible, dodged cars, heard the rattle of rocks and shale below, and finally reached comparative safety. Papa stuck his head and neck out the window and stared up and up at the black rocks and trees above, then far below to the chasms on the lower side of the road.

"Now, now—" he said, his hands waving. "I've seen them, and I still don't believe." Papa's head nodded in rhythm to his hands.

"I told you, Papa."

"You tried to tell me," he corrected. "Nobody could really tell. The everlasting hills," he said reverently now and then, but he caught his breath and his interest waned as we perched on the edge of chasms, slid, and missed other cars by inches.

"Hadn't you better slow down, son?" For the first and perhaps the last time, Papa tried back-seat driving.

Out of his deep respect, David slowed.

Once Papa stuck his head all the way out the window to stare. A ladder was fastened to a jutting rock. At that moment, a man stopped hoeing a patch of corn and beans and began to descend.

"Climbing a ladder to plant corn," Papa grieved for the man. "No mule could climb it. He must have dug the earth with a mattock."

He didn't talk so verbosely the rest of the way home, but all of his life he told people about the sky-grown corn. "He must gather it and let it roll to the bottom of the mountain," he said.

As we veered around the curves of the Jumps, Papa's hands, corded and brown, were too busy to talk. He clung to the door and the back seat of the car. "If snow were a foot deep," he said when we finally crossed the Jumps and reached the safer roads that slid around curves towards Marytown, "I'd walk that road at midnight, the coldest night of the year, before I'd ride over it again."

We reached home just before dark. Mr. and Mrs. Hauser had been notified; they waited in the yard for us. Karl staggered from the car; they left in a few minutes; and we made it into the house. David built a fire in the stove. I made coffee and took out what was left of the crackers and bread we'd brought from Morris. David gathered tomatoes; I sliced them and opened two cans of beans. We ate, wiped dust from hands and feet, and fell into bed.

PAPA STAYED WITH US a month and loved every minute of it. Incredulously, he walked through our garden, took a handful of dirt, and said, "If I had sixty acres of this soil back home, with our heat, and the rain you have here . . . If I had this soil . . ." He gazed in wonder at the black leaf mold, which had washed down from the mountains for countless centuries.

Beans were hanging thick in the garden. We'd planted McCaslins, even better than Kentucky Wonders, we thought. Papa asked to gather the beans, refused to take a basket, but stacked them across his arm like firewood. "A foot long," he marveled, "and as thick as my thumbs." Along with his corn patch tale, Papa told of our beans.

We pointed out other glories of West Virginia: dark hemlocks, apples

growing wild, mountains full of wild flowers. "Isn't it beautiful?" I'd ask.

"Yes, but take Alabama now . . ." Loyally, he always found something better at home.

"Nights are so hot at home and so cool here," I'd say just to hear his defense.

Papa's fidelity never wavered. "Well, now, takes heat to ripen watermelons." That silenced me for a time. David's melons, planted so hopefully, never did ripen to the point of sweetness.

"We sleep under blankets all summer," David stated.

"I'd rather sleep without cover." Papa was undaunted.

At twilight the second night, we all sat on the porch. I took sweaters for the girls and put on a coat.

"Better get your coat," David advised Papa.

"A coat? Why, it is almost this cool at home," Papa said, ever loyal. We talked; Papa chewed his tobacco, David smoked his handmade cigarettes. Chill crept down from the mountains. Papa talked bravely on.

The thermometer took another drop.

At last, Papa slipped into the house and returned wearing his coat. "It is just a little cool," he admitted.

Score one for West Virginia!

Davene, in Papa's lap, nodded her head and flourished her hands in exact imitation of his. But this wasn't enough like her idol. "Papa," she said, "you got another chew of that tobacco?"

PAPA MET PEOPLE AND talked to everyone. Religion, Alabama, politics, Alabama. An ardent Democrat, Papa seemed to think he'd invented the blaze that was Roosevelt. Yet he was a little kinder to Hoover than most people. "We've had Depressions before," he said. "Panics, we called them. Things will get better."

He loved the mountaineers, and they, usually suspicious of "furriners,"

loved him in return. Men loved Papa. Women too, especially women, and he had an eye for a pretty face until the day he died.

Papa liked his whiskey, too. As a child it had always been in his home. Before the mad cry that brought on Prohibition, most homes kept a bottle of the "medicine," and hot toddies were not immoral. Even my sainted grandmother, as already mentioned, took her hot toddy daily. "I love the taste of whiskey," she'd say. But her religion prevented her taking more than the one teaspoonful daily.

Temperance wasn't so easy for Papa. "My, how Lee could drink when he was young," Uncle L. B. Clark used to laugh. "Drunk as a lord every Saturday night. And temper! Fought like a tiger. But Lee would never cuss, no matter how drunk he was. 'You cuss 'em, L. B.,' he'd say, 'and I'll whip 'em.' And whip them he did. Worst temper I ever saw."

Papa's temper I inherited, his stubbornness and vanity, and added several faults of my own. But he taught us to do the right thing and thought it his duty to tell me the right way, as Mama was gone. "Sue," he said one day when I was fifteen. His hands were still and his eyes serious. "You've got a bad temper. I can't say a thing against you, for you inherited it from me. But, Suzy, if you don't control your temper, it will control you."

That small lecture did more to help me control my temper than anything he could have said. When David and I were first married, his family marveled, thinking I didn't even have a temper.

Another of Papa's lectures regarded women's virtue. There was a double standard then. Men and young men were allowed to have experience—there were always plenty of "bad girls"—but a "good girl" was a virgin at her marriage and was forever faithful to her husband. This worked, too. Marriages lasted in those days. So Papa took it on himself to do the duties that Mama would have done. He took me aside one day, hemmed and hawed; finally he said, "Sue, remember, you are a Mosley. In all of our history, there has never been a Mosley woman who went wrong. Remember

that." I was innocent and very naive, but I knew enough to realize what he meant, and I did remember.

As I said, I inherited Papa's temper and other faults, but not his love of whiskey. I hated the very smell of alcohol. David certainly didn't. He had his regular bootlegger, charged his whiskey, and paid every two weeks. He couldn't hold his liquor, though. One drink, and David had a certain look in his eyes. Two, he reeled slightly; and with three or more, he grew tearful, belligerent, or romantic, depending on his current mood.

Papa's love for God finally made him realize his weakness. Before his death, Papa didn't even wish to take the spoonful of sherry his doctor ordered, saying they had done everything they knew to give him an appetite.

And David, bless him, had "an encounter with God" one night in the Piper Methodist Church, the summer of 1935. The Baptist and Methodist men held a regular weekly prayer service. I'll never forget that night. David came home a totally changed person; his drinking and his cursing stopped then and there. But he was still David.

But this was the summer of 1932. "A few drinks won't hurt anyone," Papa argued, and David certainly agreed with him. On the days the mine was idle, Papa and David careened recklessly over the mountains, slightly tipsy. The children and I, along for the ride, were tipsy with mountain air and good health.

Joy, next to being in Alabama, was having Papa with us. He had such a good mind, such a store of knowledge, ideas, curiosity. Life sparkled, was more exciting when Papa was around. Yet I could grow furious with him. We were too much alike not to have a few fireworks when together. We'd talk and argue, then forget our differences and talk again.

ONE NIGHT SHARON WOKE vomiting. Sluggish water ran from a hydrant across the street from us. She and Davene would drink from it. She was very sick this night. I bathed her face and used my home remedy of Karo

and water. She slept to wake and vomit again. "She'll be all right when she purges herself," Papa comforted me the next morning.

Usually I trusted his judgment, at least for myself. But this was different. I became all worried mother. "I want a doctor," I said.

"You know a doctor won't come this far," David reminded me.

"He'll send her some medicine."

"I tell you, she'll be all right," Papa said. But I insisted, and they left to see what Dr. Anderson, at Hemphill, would do.

I washed dishes, fed Davene, made our bed, and poured my home remedy down Sharon. Noon came. Sharon seemed a little better, so I left off worrying about her and began to worry about the men.

One o'clock passed. I fed Davene and spooned a little soup into Sharon; it stayed. More soup, and she seemed a little stronger. Finally, I bathed and dressed and took the girls next door. "Will you keep the girls?" I asked Mrs. Carter. "I'm afraid something has . . ." I bit back the tears. "I'm going to see what has happened to David and Papa."

The shortest way from the valley was across the high train trestle. Foolishly, I took this way and almost paid for it. I heard the lonesome "who-o-o-whooie" of the train as it came through the pass, and I began to run. My high heel caught in a railroad tie. I grabbed both shoes off my feet and raced ahead of the train and barely made it. The engineer hurled curses at me as I scrambled off the track and the train rushed past.

In the road again, I walked past Twin Crick, then began the climb from the valley and into the mountains. As I walked, I peered over the edge of the road, down to the chasm that lay below. Fenders hung from pine trees and hemlocks; engines littered the rocky cliffs, but there was no sign of Thunderbolt, nor a fresh slide where a car might have gone over the cliff.

Fearfully, I walked close to the edge and looked below. "This is a nightmare," I'd think. It isn't really happening. Blisters formed on my heels, burst, and stung as I limped towards Hemphill.

A car approached, slowed, and stopped. "Lonesome, beautiful?" a masculine voice drawled.

I walked faster.

The car kept pace. "I'll take you wherever you want to go," the man said. Then the car stopped, the door slammed, and a big, dark-jowled man confronted me and grasped my arm. Dark hair grew low on his forehead. His eyes were dark-rimmed and bluebird blue. A handsome man until he smiled, then tobacco-yellowed teeth gleamed. His breath smelled of whiskey.

What to do, I thought. What to do? I couldn't outrun the man. I tried to smile to keep from infuriating him, and I backed slowly across the road, away from the chasm, toward the high jutting rocks on the other side of the road.

"Don't be afraid. I won't hurt you," he smiled, showing the yellowed teeth once more. And he followed me across the road.

As I backed, I stumbled over a large rock that had fallen from the mountain. I stooped and picked it up. "You come one step closer," I said, "and I'll kill you!"

Hot Dogs for Thanksgiving

The man lunged at me just as a car came around a curve and stopped, and the most welcome voice I ever heard said, "Mrs. Pickett, is this man bothering you?" It was Mr. Hauser.

"Just offered her a ride." The dark man turned and hurried to his car, stepped in, and drove away.

"Where are you going?" Mrs. Hauser's eyes had a tender, mothering look.

I began to sob. "I'm looking for David and Papa. They left this morning to go to the doctor. Sharon was dreadfully sick. I—I'm afraid something has happened to them."

"Get in; we'll take you to the doctor," Mr. Hauser said.

I climbed in the car and eased off my shoes. It was only a short drive to where another road turned off, and we were able to drive into it, back up a time or so, and turn the car around, headed for Hemphill.

"I'm going to tell her," Mrs. Hauser said then.

"Now, Mother!"

"Nothin' wrong with your paw and Dave," she sniffed. "Just flanderin' around. Saw them pass with two women in the car."

Flanderin', I puzzled, then, oh, *philandering*. "Oh, surely something had happened. The woman must have needed help badly," I said, chiefly for my own benefit.

"Them kind always gits help," Mrs. Hauser said. "Pritty as a maggaline*. Your paw was really enjoyin' hisself, noddin' his head and wavin' his hands."

I sat numb and stiff until we reached Hemphill; then I ran into the doctor's office. "The medicine help any?" the doctor asked.

"David got the medicine, then?"

"Yes. He and your father and two women . . ." He stopped suddenly, turned, selected more medicine, and I took it back to the car. We said very little as the Hausers drove me home.

Sharon was sitting in a chair on the porch, definitely better. Davene was on her good behavior. We brought the children home. Sharon slept, then woke, still stronger. I fed the girls more soup, and Sharon seemed almost normal. The Hausers stayed until four o'clock, then left. "I have to milk the cow," she explained, her voice sorrowful.

The girls ate a little more soup. I wasn't hungry.

AT FOUR-THIRTY, THUNDERBOLT ROARED to a stop in his accustomed place. David and Papa, unhurried and unworried, came into the house.

"How is Sharon?" David asked then, and suddenly his face wore a very guilty look.

I turned my back.

"Sue . . ." Papa began.

"I know! You have been out with two women!" I spat my anger at him. "You left Sharon, dying for all you knew—to ride about all day—all day—with two women . . ."

"A mother," Papa told me. "And her sister."

"I'm a mother! I had a sick child . . ."

Papa's face turned a dull red. "The woman's baby was dead. They were mountain women—so ignorant—we took them to the doctor and then to the undertaker. She was so pitiful, Sue—walking and crying—"

"I walked and I cried, too! Her baby was dead. You couldn't change that, but Sharon was weak and sick. You left her, Papa, you! And David, her own father . . ."

"I told you Sharon would be all right," Papa blew his nose.

"You couldn't know that!"

"Sue," David tried to kiss me. But I couldn't bear his touch. Couldn't bear to even look at him. "We had to help them," he said. "They were from far back in the mountains. So ignorant. She couldn't even read or write. Her husband was dead . . ."

"If she ever had one!" Savagely. I left them in the kitchen and went to sit on the porch beside Sharon. What they found for supper I didn't know or care. And our joy at being together had lost much of its luster. I think Papa was relieved when a letter came from home a few days later.

"The cotton is white," he said. "I have to get home to start picking."

"Oh, Papa!" In a rush, I forgave him. "Oh, I wish you could stay. No, I wish we could go home!" I cried out my hurt and homesickness until the hurt was all gone. But the wish to move back home was a very big longing in my heart. A useless wish, I knew. Daily, the Depression seemed to grow worse. America was a helpless, hopeless mass of humanity. "Happy Days Are Here Again" was Roosevelt's theme song. But even that golden voice brought scant hope that summer of 1932.

"Soon now," Papa said. "Soon things will grow better. They always do; they always have."

"Oh, Papa! You really believe . . .?"

"Just wait." That voice I believed. "Soon now. Soon."

I was able to say goodbye without tears, without any anger remaining, for I loved him.

AUTUMN APPROACHED, AND THE days grew colder. I knew how David would treat the snow-covered curves when driving to work. "We can't stay here this winter," I said one morning and poured an extra cup of coffee for David.

"I've already rented a house." He drank the scalding coffee. "A house and

a truck." The driver came with it. We followed our furniture to Hemphill. I visioned a house on level ground—perhaps the same place as before but without our housemates. David parked Thunderbolt at the commissary, took Davene in his arms, and with Sharon and me following, we climbed a cowtrail of a road that stretched up to where the truck, still loaded, leaned against the back porch.

A three-room shotgun house, it perched above the commissary and office buildings far below. We could look down and see their roofs. Across that cowtrail was another row of houses. Behind these, the jagged mountains grew almost straight up towards the sky.

Our few pieces of furniture were unloaded, and I stood on the porch to watch the truck driver back down that road, as swift and sure as if he had a super highway all to himself. David had disappeared but returned in a few minutes with Thunderbolt. The car roared up the cowtrail and rested close to the porch.

When David took the car out again, he didn't back down the road. That would have been too simple. With great foresight, he'd brought a huge block of wood. David meant to turn the car. If he went over the chasm, he might have the good fortune to land on the commissary roof. But he had the whole process figured out. I was to stand behind and throw the block of wood as he inched backwards towards the precipice. He'd only apply the brakes when he hit the wood, then inch forward, two feet at the time, and back again.

We always managed it. I stood at the edge of the chasm and screamed as he neared, threw my block of wood, and held my breath. David, tuned to my scream, slammed on the brakes, wrestled with the gear shift, inched forward, then back and forward until the turn was accomplished.

In my terror for David, it never occurred to me that if he went over the cliff, I'd go, too—under the car. Only a block of wood and my judgment, never anything to brag about, stood between us and death. This would

have been an ideal way to get rid of David if I'd wished. Just leap from behind the car and miss the wheel with my block of wood; he'd thunder down the jagged rocks, and I'd be a widow.

AS ELECTION DAY APPROACHED, Hoover was crucified again and again. I couldn't really hate him, nor believe that he personally was responsible for America's grief and hopelessness. Yet grief and hopelessness had certainly come.

On election day, I checked the Rooster*—a very big black check for Roosevelt. He was elected and could have made it without my vote; he went in on a landslide, as you know. Soon a New Deal would begin.

In the meantime, wind whistled down from the mountains. Cookstove and fireplace kept us reasonably warm. We listened to the radio, read about gangsters and murders in Chicago, and waited for the promised deliverance.

David and I planned a trip to Bluefield, Virginia, with our friends Burt and Norah Ellis, for Thanksgiving. At least we could be in the South. The fact that I'd had a sleepless night with an abscessed tooth didn't change our plans. The dentist's office in Welch was open for two hours Thanksgiving morning. I climbed into the chair blithely. A needle punctured my gum; then everything turned black.

"I—can't—see," I whispered. Then whiskey strangled its way down my throat. The doctor opened my eyelids, poured more whiskey down my throat, and felt my pulse. I could breathe at last, and sight returned. Dr. Klutch leaned over me. Sweat poured from his face as he massaged my wrists. "Feel better?" he asked.

"A little. Can you hurry?"

He began to probe at the tooth. Every few minutes he went to lean against the mantel and rest his head in his hands. Back to my jaw, he wrestled with the tooth. "Corkscrew roots," he grunted, leaned against

the mantel, then set to work again. There was a rending sound in my jaw. "Split it!" he said, triumphantly.

Dig! Gouge! Cut the gum. Sweat ran down his face. "Ha!" he shouted and held up a fragment of tooth. A long, vicious-looking root dangled from the forceps. Another and another were wrestled from my pounding jawbone. "Worst I ever saw," he said, happily. "Want to keep them?" He held up the roots.

"I don't even want to see them!" I managed through the cottony swelling of my mouth. He swabbed my jaw, squirted antiseptic, and gave me some tablets.

More than a little "under the influence," I staggered from the chair, washed my mouth again and again, powdered my nose, put on fresh lipstick, and, not so blithe now, staggered into the waiting room.

"Better take her to the hospital next extraction she has," Dr. Klutch told David.

"The hospital? To have a tooth pulled?"

"She came near dying," the doctor said. "Can't take Novocaine. Never came so near losing a patient." He turned to me. "If you hadn't told me that you were blind," he gulped. Then back to David. "Her pulse went down to forty in just a minute. Good thing I had plenty of whiskey on hand."

Staggering drunk, I only smiled and said, "All ready to go."

ONLY HOMESICK FOOLS WOULD have traveled in the bitter cold with no heater in the car and icy wind blustering through our once-proud curtains. But we were only forty miles from our beloved Southland, Bluefield, Virginia, just across the street from Bluefield, West Virginia. And this was Thanksgiving. Even fools would not have gone after such an experience as mine, but we never thought of turning back.

The girls were bundled in flannel petticoats, knitted long underwear, and long stockings. Heavy, interlined blue wool coats and tams to match

their eyes kept them reasonably warm. My own thin, unlined coat barely kept me from freezing to death.

As the effects of the whiskey wore off, I talked less and less. My usual chatter and laughter sort of liven things up. But this wasn't the nostalgic, fun day we had planned. It was more like the king's horses and the king's men who marched up the street and marched back again.

We drove into Bluefield, West Virginia, crossed the street, and were in Virginia, which was, unpatriotically, as cold as West Virginia. We bought hot dogs, ate them, looked southward longingly, then turned around and headed back to Hemphill. As a special treat, we let the girls eat all the hot dogs they wanted. Davene managed two, and Sharon worked valiantly on her third while David devoured his fourth. I barely managed one and drank cup after cup of scalding coffee, which, unfortunately, made me cold sober.

"Last Thanksgiving we were at home and had chicken and dressing," Norah said wistfully. "Today we all had hot dogs for Thanksgiving," she said, her large gray eyes sad. I knew that she, too, suffered from homesickness, and I silently resolved that never again would my family have hot dogs for Thanksgiving.

"You look horrible," Norah told me. "Put on some lipstick."

The lipstick didn't help, and the biting cold didn't ease my jaw. Norah had on a wool sweater and skirt and a heavy coat. She took the girls in the back seat and placed them between her and Burt. They soon slept.

We were not a jolly group as we drove back to Hemphill. Icy wind played hide and seek through the car, and snow began to fall. Sharp thrusts of pain attacked my jaw. I swallowed pills. The pain retreated only slightly.

Reaching Hemphill, we left Burt and Norah at their door, then made it safely home. David built fires. I warmed over yesterday's beans, found a can of milk, some sugar and cocoa, and made a pan of fudge for the girls. As they enjoyed this, I told them the story of the first Thanksgiving.

My only sleep that night was a pain-filled doze. I heated water in the

fireplace, sat before it, and applied hot towels to my jaw most of the night. Next morning I swallowed an extra handful of pills, cooked breakfast, saw David off to work, and stumbled into bed and nightmarish dreams.

David had taught the girls to drink coffee. "It isn't good for them," I pleaded. Now he agreed and told them, "Santa said he wouldn't come to see you if you drank coffee." Sharon put down her cup. But Davene looked at him, said, "Santa just said a lie," and took another drink.

Mercifully, they slept that morning. Pain taunted me awake at nine. The girls, in the kitchen, were eating bread and drinking cold coffee—Davene unconcerned, Sharon deliberately; if Santa didn't come to see her sister, she didn't want presents either.

My whole head was burning. My eyes seemed ready to explode. The dishes weren't washed. The beds were unmade. The doctor's pills gone, I chewed aspirin. Bitter cold had arrived during the night. David had walked to work, but I couldn't drive to the doctor and couldn't leave the girls before an open fire. I kept hot towels on my face and wept silently. The girls ate apples and peanut butter for lunch and drank the last of the coffee.

THE TORMENTING DAY FINALLY came to an end. David, coming home, brought a strange man with him. He looked at my red eyes and swollen jaws. "Baby girl! I'm taking you to the doctor!" he said. Then he remembered his friend. "This is Bill."

It was the same old story. Bill, looking for work, had made it to Hemphill. David took another look at my face. "Stay here," he said. "I'll bring the doctor." He chose the quick way and slid down the vertical path.

Dr. Anderson parked his car in a neighbor's yard halfway up the road, and he and David walked to the house. My swollen jaw would barely open as he probed in my mouth. "You should have sent for me sooner," he growled. "The damn thing is infected."

"Blood poisoning?" David's face whitened. His aunt Jeannie Goggins had died of blood poisoning the past summer.

The doctor only said, "Have to take her to the office."

"I'll watch the children," Bill volunteered.

"Don't die, Mother!" Sharon wailed.

"I won't die, darling," I promised.

In his office, the doctor put me in a chair and took out his tools. "Have to cut out the proud flesh," he said and began to hack away.

I didn't have the good fortune to faint.

"Don't swallow," he warned. "This is deadly poison." He poured carbolic acid into my jaw. No germs could live after that bath. Flames seared my mouth, but it was over! Blessedly over.

"Two hours more would have been too late," Dr. Anderson said, and gave me pills. "Send for me if you need me." He patted my shoulder.

David wept as we walked home. "I didn't know! I went off to work and left you—dying!" He cooked supper, bathed the girls, and put them to bed. Bill washed dishes, took up ashes, and swept the floor. Unable to eat, I managed a trickle of coffee down my throat. We sat around the fire after supper and talked about home. The pain in my jaw was just bearable.

"You'd better go to bed," David said. "I'll sleep with Bill." He put the girls to bed and showed Bill the back bedroom.

Pain woke me during the night. I sat before the fire, gobbled pain pills, and managed to sleep again. David, stirring the fire, woke me. I heard the familiar roar of fire in the cookstove and sat up. "Lie down; I'll cook breakfast," he said.

David had never learned to cook, but he made coffee, toast, and scrambled eggs. By now the swelling had almost gone from my jaw. David went to the company office with Bill. I washed dishes, made the beds, bathed the girls and myself, and both occupants and house looked almost civilized when they returned.

Bill's face told that he'd not found work. We asked him to stay another night. The next day, Sunday, he walked forlornly towards the railroad tracks. Another on the long list we had kept a night or so and sent on their hopeless way.

BUT A SMALL SURGE of hope began to replace the despair. Roosevelt's campaign promises made sense. Hoover vainly tried to get things started, but a "lame duck" Congress wouldn't pass relief laws. And now, letters from home seemed more cheerful. Work was better. People were using coal again. I forgot the rare beauties of West Virginia and longed to see a muddy road between cut-over timber and on through rolling, red-clay hills.

A young girl who lived across the road swept her porch each morning as I swept mine. One day she crossed the road, broom in hand, and sat on the steps as I swept soot, coal dust, and grime from my porch. "My name's Pearlie," she said. "You're a furriner, ain't you?"

"We have been here for more than a year."

"I know. I seen Dave, that first time he came. Seen that Jade, too. Still, best not speak ill of the dead."

"Won't you come in?"

"You a poet, ain't you?" she asked as we sat before the fire. "My man, Starling, read me some of yore poems."

"Well, they weren't exactly poetry."

"I reckon not. Leastways he said they wasn't so good."

I managed a smile.

"Me and Starling's just been home a month. We tried Pennsylvania, but work's no good there either, so we caught us a freight train and come home." Pearlie lifted a snuff box and filled her lower lip.

"Weren't you afraid?"

"I toted me a knife. Starling had a club."

She was just sixteen and beautiful—fair, silky hair, soft eyes—as so

many of the mountaineers were beautiful. Their Scotch-English heritage was very evident. She and Starling lived with her parents. After that visit she came often to regale me with her marital problems.

"Me and Starling had a row, and he hit me again," she'd say most Mondays. "That man drinks away every dime. But I stole a quarter from him." She held it up. "Will you bring me a box of snuff? I ain't got nothin' fit to wear to the store."

"Put some clothes on credit," I said indignantly.

"He'd whup me," she stated, her face proud. Mountain women! The man was Lord and Master, and they gloried in it.

SHARON PLAYED OUTSIDE WHILE Davene took her daily nap. I warned her never to get out of sight. Just steps away were hills, a wilderness of jutting peaks, tumbling rocks, and frothing streams. I looked out every few minutes. One day she was not with her playmates.

"Sharon!" I called. No answer.

Davene woke and came to help me. "Sister!" she bellowed. "Are you losted?" She began to cry for her beloved sister.

"Of course not!" I bundled Davene into her coat and ran to knock on Pearlie's door. "Have you seen Sharon?" I asked.

"She was playin' with Breck's cat. He's big as a painter [panther]. She tooken him home."

Breck was a familiar figure, but I'd never seen his wife. Davene and I hurried up the trail and knocked on the door. It opened a crack. "What you want?" someone asked.

"I've lost my little girl. Pearlie said she came here."

The door opened. A girl with a heart-shaped face, long-fringed dark eyes, and pink lips stared at me. Inside, Sharon crooned to a large, tiger-striped cat. "Can you read?" the girl asked.

"Yes." I knew better than to ask why.

"Come on in," the girl said. Inside, a thin woman looked me over. "Set, stranger," she said. I sat.

"Breck can read," the girl informed me proudly.

I smiled. You don't ask questions of mountaineers. They will tell you if they wish you to know anything.

"Maidie," the girl turned to her mother, then pointed at me. "She can read."

The woman looked me over; finally she smiled, reached behind a calendar, found a card, and handed it to me. "Read this," she commanded. "Hit come fer Josie, here."

"Dere Josie," the card read. "I've got me a job and I'm comin fer you Sunday."

Josie's face lighted. "Maidie, what'll I do?" she asked. "I ain't got nothin' to wear."

"I'll git you a outfit."

"Breck'll hide* you."

"He'll just have to hide me," Maidie said; then, "Yore youngun wasn't botherin' nothin'. Hit would pleasure me iffen you didn't say nothin'," she said when I took the girls' hands and turned to leave.

Monday morning early, Maidie came to visit. She pointed to her eye. "Breck give me this. That man's got a temper. Still and all, hit didn't keep Josie from havin' her man. They run away."

After Maidie left, I looked in the bag she had brought. There were a dozen eggs and some country butter. If I'd offered to pay, she'd never have forgiven me. Mountaineers are fiercely independent. From then on, I wrote letters for her and read the ones that came from Jim. "Wish't I'd made her learn schoolin'," Maidie said wishfully. She and Breck had moved to Hemphill from far back in the mountains. "A school bus run three miles from our place, but Josie wouldn't no ways take hit. Wish't I'd a put the switch to her back and made her go."

So Dad-Burned Purty

Parents of local children used the sheriff as bogeyman. All were in deadly fear of him. One day I heard Sharon and Davene screaming and ran. "The sheriff's got Daddy!" they said.

Bodine, the sheriff, tried to help David from his car.

"What happened?" I whispered.

Stubbornly David, without aid, stepped from the car. "Broke my foot," he said, his face as happy as if he'd inherited a million dollars. He turned to Bodine. "Good of you to bring me home." His right foot was in a large cast. Part of the mining machine had fallen on it.

David clumped into the house. I held his arm, trying not to cry. "Oh, David, David, David," I yearned over him and his hurt. I'd never found a word more beautiful than his name. Once I looked up the meaning, found that it was an endearment—"Beloved" or "Darling." No wonder that Jesse had given it to his beautiful, best-loved son who was to be king of Israel.

"I'll be out of work for at least five weeks," David boasted. How could he be so happy about this? "Compensation will be sixteen dollars a week."

"That will feed us. Maybe a payment on the car and the rent." I said. Then he began to sing, started out of the room, came back to kiss me. "Best thing that ever happened to me," he said.

And I still didn't get the message. David stalked about the house for a

day or so, returned with an even happier look on his face. He had never been lazy for one day in his life. What was wrong with him?

Three weeks' pay was due him. Work had been better; there would be plenty for Christmas. David left for his regular clomp to the store, and I bundled the girls into warm clothing and let them go out to play. Then I washed our clothes and hung them to dry around the stove. To get the job over with, I ironed things as they dried.

DAVID TOOK HIS TIME coming home. We finally ate a late dinner. I bathed the girls, took my bath, made up my face, combed my hair, and he still hadn't come home. About 2:30 he clomped into the house and looked for food in the warmer. His eyes were bright, his curls tumbled on his forehead. Then he did an unheard-of thing. He washed and dried the dishes, turned to me, and exploded his bomb. "Let's go home for Christmas!"

"David!" I said, "David! Can we go? Just like that?"

"Just like that," he said; then his eyes slanted at me, and I knew. I remembered August. "I won't be able to sleep a wink, will you?"

"Sleep? When are we going home?"

"How long will it take you to pack?" he asked and reached under the bed to grab a suitcase. I ran to the kitchen for a cardboard box. "Give me thirty minutes," I gasped. "Call the girls." I filled the suitcase and the box and put things in sacks. We fed the girls until they couldn't hold another bite and crammed peanut butter, cheese, and crackers into a box. Then I bundled Sharon and Davene into their heavy winter clothes, put on my one wool dress—black waffle check, and my thin coat. At the last minute, I grabbed a blanket from the bed.

Neither of us had a watch, so David put the clock in the car. The hands stood at 4:30 when we drove down the hill and crossed the Tug River. The Tug was usually black with coal dust; now it gleamed with silver and a hint of the sunset showing pink near the middle. The Tug was frozen across!

A bitter wind blew from the north, and dark descended rapidly. "David, is it too cold to start now?" I chattered.

"It will get warmer as we head south," he promised. "Sit in the back; it will be warmer there."

Then it was surely far below freezing in the front, for icy wind blew through the curtains, caught my breath, and tugged at my eyelashes. The girls huddled close to me. I wrapped the blanket around them. "Keep under cover," I warned, my teeth like castanets.

The night blackened to onyx; then the stars came out. They shone like distant cities between the mountain peaks. "Mother," Sharon asked, "is that heaven?"

"One of the heavens. Keep your head under the blanket, darling."

"All right, Mother." She pulled the blanket over her head and leaned close to me. I'd never known such bitter cold. Would the girls freeze? I held Davene in my lap. Sharon relaxed against me, and Davene's soft breathing told that she slept. The sleep of death? My numbed hands found her cheeks under the blanket. They were quite warm.

But I was not warm! There was no button at the neck of my coat. I reached a numbed hand to hold the coat closed against the wind, and released the blanket. "I'm freezing to death!" Davene lamented as the ice wind hit her face. I held the blanket around the girls, and my coat opened at the throat again. My dying of pneumonia would ruin Christmas for everyone. I bent to fumble in the box and came up with a dress that I'd ironed so carefully. I looped it around my head and throat.

The girls slept; Thunderbolt's roar was a steady song. David hummed or sang aloud, and I held Davene close in my arms and felt Sharon's warmth against my side. But I knew that I couldn't make it through the night. My fingers were numb, and my back seemed ready to break in two.

David stopped to buy gas about ten o'clock and went to the restroom. I placed Davene on the back seat, dumped a pile of clothes on the floor

to make a bed for Sharon. There was a little warmth down there from the motor, and shelter from the wind. I wrapped Sharon's head and chest in a pair of David's long underwear and piled clothes on her.

"I'm cold," Davene tried to rouse.

"You'll be warm." I doubled the blanket and tucked it over her, head and all. When David came back from the restroom, I was in the front seat.

"You'll freeze," he warned.

In comparison to the back, it felt like summer. The windshield kept drafts from us, and heat from the motor warmed my frozen feet and legs. I reached back now and then to check the girls. They lay still and warm under their covers.

"Want me to drive?" I asked.

"Later," David said.

THE HUM OF THE motor became the steady drone of bees. I snuggled into my collar and dozed, but even in sleep, I knew that something was wrong. Thunderbolt had a new choke, followed by a hiss, then a gurgle. "What is it?" I sat up.

"Got to find water," David said. "The car is boiling dry." In the headlights, steam made a white cloud. We were in Tennessee now. "The motor will freeze if we stop too long and burn up if we don't find water," David predicted.

I'd been brought up on prayer; but now David and I used the Lord mostly for emergencies. We'd give Him a little time if the weather was fine and we had pretty clothes and nothing else to do; we'd even go to church. But certainly not if it inconvenienced us.

This was an emergency. I bowed my head and sent an urgent prayer heavenward. Then I opened my eyes. From my bowed position, I saw what I would not have seen had I been sitting erect, a light in a window on a hilltop. "Stop the car!" I said. "There is a light!"

David slammed on the brakes. "Tired?" he asked as I leaned against the back seat.

"Dead," I told him and reached to the back seat with exploring hands. The girls were warm and sound asleep.

"Go with me to see if we can get some water," he said. "They will be all right."

"But—"

"It is only up the hill. I told you they will be all right. They are sound asleep."

Loud, angry voices greeted us as I followed David up the icy path. "I've told you a thousand times, no!" a man said.

"You ain't never give in to me," a woman said.

"That's all I ever done. The worst henpecked man in Tennessee, I am. This time I'm going to have my way."

"Just like a Kramden. Have his way or die!"

"You was glad enough to marry one."

David went to the door and knocked loudly.

The voices stopped. An old man came to the door and peered at us. Firelight warmed the room, and a kerosene lamp burned in the corner. "Yes?" the man said.

David took off his hat. In the lamplight, his hair was bright gold.

"Could we get some water, please?" he asked. The wind blew his hair across his face.

"Water?" the man asked, as if it were a foreign word.

A woman came to inspect us. She wore a long-sleeved, black dress. A white lace collar was pinned at the throat with a cameo brooch, and a purple wool shawl was about her shoulders. "Let them in, Joshua," she said and stepped back.

"Step in, stranguhs," Joshua said cordially. "Come to the fire and warm your chilled bones. Thought maybe you was angels, unawares." He was a

big man with white hair, crinkled blue eyes, and a shepherd's hook for a nose that towered between white eyebrows and sharp chin.

His wife was big-boned with sparse hair, thin lips, and the sweetest blue eyes in the hills, no doubt. "Joshua, throw on another log," she ordered.

"Yes, ma'am," he gave her a tender look. "Old wife's thoughty of other folks," he said with pride.

"Now, Joshua, you're the thoughty one."

"There you go, startin' another argument."

"Watch where you put the log!"

He reared, opened his lips, then put the log gently onto the coals. "Got to have everything just right, that old wife has." His eyes were tender again. "So dad-burned purty, she's always had her way with me."

Except for her eyes, the woman was as plain as anyone I'd ever seen. But she looked at him, and the room filled with light softer than the firelight. Why, the old couple were still in love with each other!

David explained about the car. The woman drew a chair forward. "Set, child," she told me.

"I've sat all night. Just let me warm my hands and feet," I held the chilled members to the fire.

"Look at them little fingers, cold as ice." She took my hands and began to rub them. "Thawed out, son?" she turned to David.

"Yes, ma'am," his smile was as warm as the red logs.

"Help the boy with the water, Joshua," she said.

"This way, lad." Joshua opened the door.

"Well's on the back porch," the woman boasted. "Joshua dug it and built the house before he asked Paw for me." She eyed me a minute. "Your man good to you?" she asked sharply.

"Oh, yes!"

"Better watch him! Them purty ones can't be trusted most times, and he's dad-burned purty."

"I know."

"Put a little meat on and you won't look so bad." She took my hands again. "Too little," she frowned. "Look deformed."

I smiled. All my life, my little hands had been one of my chief vanities. (But now, age has made them large enough to suit the old lady.)

WIND SWOOSHED THROUGH THE door Joshua had left open. A windlass creaked, screeched from the back porch, water sloshed into a bucket, and David and Joshua crunched down the hill. I revolved before the fire as the woman closed the door. Returning circulation tingled my "deformed" hands.

"Warm yet?" David stood in the door.

"Uh-huh," I was so sleepy I could have bedded down on the floor for the night. "Warm yourself; I'll see about the girls."

"I looked. They are all right." David stood before the fire, his strong brown hands to the blaze. The firelight brightened his hair, deepened the indentation in his chin, gleamed on his white teeth.

The woman eyed him suspiciously. She admonished, "You be good to this little girl, young man!"

David looked at her in surprise.

"Got to boss the whole creation, she has," Joshua said.

"Could do a better job than most," she replied saucily.

"She could, at that," Joshua smiled.

"You take this," she flung her shawl across my shoulders.

"But—I couldn't—"

"Made it myself. Carded the wool and dyed it. Got a right to give a present if I want. Young man!" She shook her finger under David's nose. "Remember what I told you!"

"Yes, ma'am," he backed away. "Yes ma'am, I will."

"Just a minute," she said as I followed David. She darted to a door,

hurried into a dark room, and came back, wrapping a fried pie in brown paper. "Eat this," she said. "Eat lots of pies. Put some meat on your bones."

"Thank you, oh, thank you!"

"Too little." She took my hand, dropped it, and kissed my cheek. "Don't forget," she said.

"I won't!" Fervently.

"Is she crazy?" David blazed as we walked down the hill.

"No." I took a bite of the pie. Filled with home-dried apples, the pie had crisp, brown edges. "She has mighty good sense."

"Give me a bite," he begged.

"Oh, no. I need it."

"If I had wanted a fat wife, I'd have married one."

"You sure?"

He kissed me.

I broke the pie into three pieces, keeping one for the girls. The wind changed suddenly, swooped down from the house, as the door flew open. "Bossiest woman on God's green earth!" Joshua bellowed. "Dad-burned if I stand it another minute!"

"Road's not crowded," the old wife said.

"Think you can run me away from home!" the door slammed.

"I bet they quarrel all night." David swallowed the last of his pie. "That woman's crazy, but she sure can cook."

"I'LL DRIVE FOR A while." I slid under the wheel.

"Think I'll take a nap in the back," he said.

"You'll freeze."

David huddled in the back seat with Davene's feet in his lap, and part of the blanket over his legs. Stars, big and bright. The moon, a silver sickle, fled before us or followed, with the turning of the road. Half-hypnotized by the hum of the motor, I jumped and swerved as a

big dark object plumped suddenly beside me. I fought the wheel, righted the car, and turned.

"You'll kill us!" David snarled.

"Thought you were in the back."

"It's too cold back there."

"The girls warm?"

"Yes."

"Are you sure?"

"*I — am — sure!*"

"Are they covered?"

"Yes!" he exploded. "They are covered!" He was silent for a time, then, "Sue—" His anger was gone. "Reckon that woman was crazy?"

I grinned under the darkness. "She was the smartest woman I ever saw," I said.

He leaned against my shoulder and slept. Steam began to spurt from Thunderbolt's radiator as, providentially, an all-night service station appeared around a curve.

"Mother," Sharon woke and reached up to touch my shawl. "Did Santa come last night?"

"No, darling. A woman gave this to me."

"A crazy woman," David muttered.

Happiness sent spurts of energy through me as the hours passed. But even happiness can do only so much. The bitter cold lasted on to Chattanooga. In a restroom, I looked at my face. What conceit I had (and Mosleys are a conceited lot) died and was buried at the foot of Lookout Mountain as I looked at my wrecked face. The eyes were red with ugly circles under them. The lips were cracked, and the nose was a strange new color—a mixture of blue, purple, and red. No amount of lipstick and powder could make that face presentable. I'd better be exceptionally good to David. My mane of thick, once-glossy hair had lost its faint wave and

its shine. It was a stiff, dead-looking brush heap. Even David's curls now resembled a worn-out mop.

Across the thin strip of Georgia we passed and were in my own beloved Alabama. Even this miracle hadn't raised the temperature. The rows of tattered cornfields were beautiful to my heart. Snowflakes turned to freezing rain. Cows faced away from the wind, bowed with cold. Only Thunderbolt knew any heat, as, still faithful, he roared southward.

David took the blanket to lie in the back again. The girls, sitting beside me, had lost their sweetness. Davene fought, and Sharon wept. "If you don't hit back, I'll spank you, Sharon," I said at last.

"I might hurt her," Sharon sobbed.

Shamed, I kissed her. "Mother won't spank you, darling."

"I won't do it again," Davene kissed her, too. They sat with arms around each other for a few minutes.

"Don't crowd me!" Davene said then.

"I'm just keeping you warm."

Davene whacked her again.

"I'll drive," David woke, refreshed.

At four, I put the girls in their bed again and leaned against David. Clouds hung low, and it was almost dark.

"Tired?" He reached over to kiss me.

"Dead tired. Will we ever get to Papa's?"

"I'll take the short cut," he kissed me again. "You're beautiful," he smiled.

MAYBE HE BELIEVED IT. I forgot the cold and the exhaustion for a moment. Every day of our lives, David told me that I was pretty. Ordinarily, he was a truthful person. Possibly, he saw what he wanted to see. It was when I was at my most unglamorous that his compliments were most fervent. I thought of Joshua saying, "She's so dad-burned purty," and I glowed. Maybe that is how David thought of me.

We left the main highway and took the short cut. It was almost six now. Soon we would be at Papa's. If we could ever make it into the house, warmth, food, and a bed could be found. Looming suddenly ahead, a car blocked the road. David swore, stopped Thunderbolt, opened the door, and stepped to the ground. An extra blast of icy wind shot inside and flapped the curtains.

"How about a push, buddy?" a man in overalls, blue shirt, and denim jacket smiled. His teeth were yellow, and he needed a shave.

The girls woke. "I'm hungry," Sharon began to sob.

"I know, darling. But do you have to cry so much?"

"I'm cold and hungry. Davene, you hungry, too?" Sharon kissed her.

"You leave me alone!" Davene whacked her.

"I've never seen you so mean!" I reached to give Davene a taste of her own medicine.

She aimed her small fist at my jaw.

"Don't you hit Mother!" Sharon grabbed her.

I reached down and picked her up. She bellowed like a lost calf. I held her until she quietened. "I love you, Mother," she kissed me. "But I am hungry."

David and the man measured bumpers to see if ours would fit. They wouldn't. "Sue, help me push," David said.

He expected me to get out and help push! All right, if I died, it would serve him right! Anger sent a small spurt of energy into my hands and legs. We heaved. The car rolled. Sharon and Davene tried to help. The motor of the car showed no life as we pushed up a hill and down another. David and the man lifted the hood, took out sparkplugs in Thunderbolt's waning lights. I drove our car close, and we pushed again.

The girls wept. Anger did no good this time. Exhaustion claimed me. "I can't go another step." I led the girls back to Thunderbolt. "David!" I yelled as he and the man looked at the motor of the other car.

No answer.

"David Pickett!"

"In a minute."

Thunderbolt's motor cooled. My feet grew numb. The children gave lost, sighing sobs. "David!" My voice blasted a hole through the night. "The girls are freezing!"

"In a minute, I tell you!"

I opened the door of the car, staggered out, and stumbled towards the men. "David!" My teeth chattered so that I couldn't get the venom I felt into my voice. "We've got to get these children to a bed!"

"Do you want to leave a man stalled in this weather!"

"It is a half a mile to Bradford through those woods." I pointed. Lights from the houses could be seen. "He has feet. Let him use them."

"Will you take me to Bradford, buddy?"

"Yes." David gave me a stubborn look.

Fury almost warmed my chilled body. "Mister," I said with cold politeness, "we have two cold, hungry children. We don't have much gas, and there are no service stations between here and home." I paused for breath. "Across that hill is Bradford. You can walk it in five minutes. But it is five miles by car."

"Shut up, Sue."

"I won't shut up! I know these roads, mister," I addressed the stranger again. "We have traveled since yesterday. I am not going to Bradford."

"What about it, buddy?" The man came close. I smelled whiskey on his breath. "You have to mind her?"

"I'll take you," David said.

"David, if you do, I'll never speak to you again as long as I live!" I said and meant exactly what I said.

"All right!" he took my arm. "We'll go!"

"What about me, buddy?"

"Do the best that you can."

"But it is too cold to walk."

David used his whole vocabulary of swearwords, and it was not a small one. He did have cold, hungry children. A man who refused to walk half a mile to help himself . . .

The man muttered a curse and reached into his pocket.

"David! Look out!" I screamed.

David wrested a knife from the man, threw it into the woods, and hit him on the chin. The man sprawled to the earth, cursing viciously.

"Want some more?" David asked.

"Don't hit me again," the man sniveled.

We walked to the car. The girls waited for us. "Did you hit the man hard?" Davene asked.

"Oh, Daddy, did he hurt you?" Sharon wept.

"No, darling," he kissed them both, then climbed into Thunderbolt. As we roared down the road, the man stood directly in the center. David kept a straight course.

The man dodged, fell, and rolled to the side of the road. We missed him by at least an inch. I thought it best to keep any spare comments to myself. The girls huddled close together, and we jolted through Crosston, Haig, past the Morris road. Thunderbolt gurgled and steamed.

The clock said five till nine as we turned into the muddy lane and rolled up to the farmhouse. In the pale moonlight it was the same: age-silvered, with hand-riven shingles. The porch was ragged with broken boards all along the edges. At the moment, it was the most beautiful place on earth.

Bulger stood up and escorted us to the steps. We opened the unlocked door and stumbled inside. Firelight gleamed dully on full beds and the pallets that lined the floor.

"David! Sue!" Papa sat up in bed and began to laugh. "You must be half-frozen." He stepped from the bed into his pants.

"Company?" David looked at the row of pallets.

"Yes," Papa admitted. A cousin and five children had dropped by. "But there is always room for one more."

"Where?" I wondered, and for an unholy moment, almost wished the cousins in a more uncomfortable spot.

Every River Leads to Piper

Miss Mildred slipped into her dress under the covers. "There's potatoes and milk," she said and came to the fire to kiss us. We sat before the fire and ate. I nodded, totally exhausted.

"Mildred, fix a bed," Papa said, as if one would appear by magic.

"All right." She seemed to believe in the magic, too.

Their faith sparked the one brain cell of mine that was working. "We'll sleep in the cotton," I said. (There was always cotton in the shed at this time of year.) "Can you put the girls anywhere?"

"The boys are in the cotton," Papa said. "But there is room for a dozen more."

"I'll put Jerry at the foot," Miss Mildred said. "Davene can sleep with us." Davene peeled off shoes and stockings and fell into bed.

The girls on the pallet moved. "Sue's here!" Colleen said. "Oh, Sue!" She sat up and smiled at us, then held out her arms to Sharon. "Darling, come here," she said.

"Now, now, Sue," Papa waved his hands, lighted a lantern, and started out the door. "I'll sleep in the cotton. You'll catch your death of cold."

"No, Papa. I am sleeping in the cotton!" I stated.

"Never saw anyone as stubborn as she is," Papa went towards the cotton house*. Then he paused. "David, what is wrong with your foot?" he asked.

"Broke it," David told the happy story. "That is why we were able to

come home." Our shadows loomed before, around, and behind us as Papa swung the lantern. Ice spewed up from the ground. The air was cold, but it had the feel of a Southern night.

Wind whistled through the logs of the cotton house. Starlight gleamed through chinks in the shingles. An owl hooted softly behind the cow lot; roosters crowed in the barn lot and on neighboring farms. A distant train sent its wail across the fields.

We were home!

Cotton spewed behind David like snow as he dug a bed. "Pile in, Sue," he said. I fell into the fragrant cotton. David heaped mounds on me. Papa hung the lantern on a nail and helped.

Through blurred eyes I saw them make a bed for David. "We made it home for Christmas," I marveled. Then I fell into a well of dark slumber.

"BREAKFAST," SOMEONE CALLED AND woke me. I sat up and blew cotton from my face. Grayson, Lee, Royce, and little J. D. stood in the door. They began to heap cotton on David, who was still asleep. He erupted from his mound. We brushed cotton from our clothes, pulled cotton from hair and eyebrows, and looking like fresh bales of lint we were windblown across the yard. The scent of woodsmoke, coffee, and sausage pulled us straight to the kitchen.

People were crowded around fireplace and kitchen stove. Clarence was living at home now; he, with the kinfolk, was up and ready to do justice to the food. We washed faces and hands; Papa motioned to the table. His face was bright; there was food enough for everyone. The table was heaped with biscuits, sorghum*, butter, and fresh country sausage. Mary, one of the cousins, was rolling out more biscuits. Miss Mildred turned the sausage and looked in the oven. Colleen and Daphne had washed the girls' faces and hands and spread newspaper on a flat-top trunk; the four of them were eating on it. Butter and sorghum dripped from Davene's

mouth. Sharon was cramming biscuit and sausage into her face.

All that day we skimmed from house to house, visiting kinfolk. The next day we left for Pea Ridge. Granny was so happy to see us that she sacrificed one of her best Rhode Island Red hens. Chicken and dumplings. Dressing, too. Baked sweet potatoes, green tomato pickles, and canned blackberry pie. We talked, laughed, and cried a little.

Then Papa told astonishing news. "Piper is working five days a week," he said. "Why don't you get a job and move back home?"

David rolled a cigarette, lighted it, opened the door to look at the hills, then slammed the door. "I mean to do just that," he said. Skyrockets began to explode inside my head.

Early the next morning, we drove across the beloved hills and at last saw the faded red and green houses of Piper. "Is this home, Mother?" Sharon asked.

"Yes, darling. This is home."

"I don't like it," Davene announced.

We jolted around a curve and took a left turn. Then we stopped, sliding gravel under the tires, less than a foot from the steps of the green building that housed the post office and company offices. Friends looked and ran to greet us. David's big plastered foot seemed very conspicuous. He covered it with his hat.

Mr. Randle, the superintendent, came out of the office, saw us, and hurried down the steps. "Looking for work?" he laughed.

"Anything for me?" David asked.

"You wouldn't stay six months," he said and started away. My heart plunged a thousand feet and landed at the bottom of the Cahaba River. Then Mr. Randle turned. "Rosalyn is getting married tonight," he grinned. "See me Saturday." Rosalyn was his very beautiful, oldest daughter.

David picked up his hat, started Thunderbolt, and we headed back to Pea Ridge.

"Aren't we going to visit anyone?" I gasped.

"Not with this foot," he said.

"Oh, David! You can't take a job!"

He drove a little faster.

"Did you find work?" Papa asked, as we came in the door.

"I'll know tomorrow." David said.

"But David, your foot—" I whispered.

"My foot is well!" He sat before the fire, took out his knife, and began to cut away at the plaster cast.

"Dave," Granny said. "Sue is right."

"I know what I'm doing!" He unwrapped his white, shriveled foot and stood on it. No bones crunched.

"Please take it easy," I begged.

"All right," he sat down and held out his foot, stretching his toes. I ran for a pan of hot water and bathed the foot. Having no other medication, I rubbed the foot with Vaseline. David held it closer to the fire, then drew back. The foot was not used to exposure.

"EVERY RIVER LEADS TO the sea" is a familiar saying. But I just didn't believe it. I had been too homesick for too long. David went to Piper alone the next day; two hours later, he was back. "Got a job," he swaggered. "Night wall boss." Part of the job included running a machine and cutting coal. "Three eighty-five a shift," he said. "We are used to lots more than that."

"Three eighty-five will buy a week's groceries here," Granny said. "Sweet potatoes are fifty cents a bushel, eggs ten cents a dozen, pork chops ten cents a pound."

Granny had a very short lower lip which gave a natural downturn to her mouth. "You could all stay with us," she said the next morning as we packed to return to Morris.

"I haven't seen Maurine and Lucile and Thelma," I explained. "We'll be

close to you when we move and can drive over any time."

David left the car with me. "You'll need it," he said. "Clarence can drive you wherever you wish to go." As Clarence drove us to the bus station the next morning, David explained Thunderbolt's idiosyncracies. The car had been stubborn of late, but David knew how to tinker with the motor and speak a few magic words; the engine would rattle into life.

"Never saw a car I couldn't start," Clarence laughed.

"Remember," David repeated his instructions until the bus roared up and stopped. He kissed me, slipped into the bus, and it swooped out of the station.

The motor was still running, and Clarence had no trouble driving us home.

"WANT TO GO TO Haig?" I asked Miss Mildred the next morning. Any trip was a rare event to her, and both of us needed to do a little Christmas shopping. Papa agreed to watch the children. We hurried with dishes and beds; then we worked on my black dress again, this time getting most of the lint brushed off. She put on her one good dress, a blue wool crepe. This was an event!

Clarence had shaved and even wore a tie. It wasn't every day he had the chance to drive a car. We all sat in the front seat, and he mashed the starter. Nothing happened.

Clarence tried again. And again. "Needs hot water," he said, and hurried to the kitchen and came back with the black kettle, steam spouting from its throat. That didn't work.

Clarence lifted the hood, jiggled wires, walked around the car, kicked a tire. But Thunderbolt remained silent. "Nobody can start that car!" he snorted, and stalked to the house.

"If it weren't so far, I'd walk," Miss Mildred said.

"Why not ride the mules?" I asked.

"Nobody can ride Jack."

"I'm not afraid of him."

"You haven't got sense enough to be afraid," Papa frowned. "Jack is mean. He'll kill you." I looked at Papa in surprise. Jack was his favorite of the two mules. Big Johnny was gentle and slow, but Jack, Papa vowed, "would kill himself if I didn't make him rest."

"Sue can ride Jack," Lee boasted. "She is not afraid."

That did it. I had to ride him now. We dressed again, in the boys' overalls this time. Lee and Grayson harnessed the mules and tied blankets on their backs. No saddles on this farm. Papa's hands waved frantically. I'd kill myself; nobody could ride Jack.

But Sue, unafraid, smiled in her stupidity. Lee brought Jack to the edge of the porch. "Now, now, Sue," Papa waved. But Sue was off the porch and safely mounted.

Jack looked at me, stretched his neck, and galloped down the lane. "Hurry!" I threw the word at Mildred.

She hurried until Johnny was close behind. Jack was unhappy with another mule that close to his tail. Like a freight train, he shot ahead. We won the race by half a mile. "Whoah!" I sawed at the reins. Jack swerved and galloped back towards the house. We passed Miss Mildred and Johnny. Papa and the boys raced to assist me, but Jack turned again. This was fun!

Johnny had slowed to a walk. We overtook him like a Pony Express rider. Johnny, fired by Jack's example, entered the race, but Jack wouldn't let any mule that close to his tail. He increased his speed. "Can't you hold him?" Miss Mildred called.

"Just keep farther behind." I pressed my legs to Jack's sides. This infuriated him. Jack did not like close contact. He bounced and galloped madly. Getting the message, I held my legs wide. Jack slowed to a brisk walk. Once, he even walked beside Johnny a few paces. But when my legs tired and I let them rest against his side, he tried to break the all-time speed record.

The road had puddles of ice. Jack slipped once and knelt on his fore-legs as if in prayer. I clung to his neck, my legs tight against his ribs. This indignity he remedied by galloping almost before he regained his feet. But now Johnny was ahead. We sailed past with flying colors.

In record time, we reached Maurine's house. Lucile was in the yard, pruning shrubbery. She ran to meet us. Jack took an instant aversion to her person and headed back the way he had come. I sawed at his right lip, and he turned. Tommy and Ray, Maurine's boys, almost grown now, stopped us, held Jack until I could dismount, then tied him to a small tree. I staggered to earth for the usual crying and kissing. Maurine, Cora, Malone, and Verna ran to join us. By the time we had kissed a round or two, Miss Mildred arrived and was helped to the earth.

WE BABBLED AWAY AS we selected things from Ezra's store and tied the packages to the mules. Then it was time to go. Jack and Johnny drowsed peacefully under their trees. "How can we mount them?" Miss Mildred asked. Maurine's porch was too low to be of any help. She was short, and Johnny was very tall.

"That's easy," I said and walked up to Jack. "Hold him, Tommy." I grabbed a limb and swung high.

At the last second, Jack stepped expertly aside, and I jolted to the earth. A crowd of men from the store stood on the porch to watch. This didn't increase my poise, but I tried again.

And again, and again.

Jack had never had so much fun. He timed his moves to the split-second. I made feints, then didn't grab the limb. Just as he was off-balance, I jumped, but he outmaneuvered me and glanced around. His eyes (I solemnly affirm) were twinkling. A chorus of laughter from the watchers made Jack raise his head and give a close imitation of a smirk. Papa could have hired this mule out in Hollywood.

Lucile grew angry at the laughter. "Somebody could help!" she said and ran to grab me by the seat of the pants. She heaved as I swung high again. Jack, interested in this new development, forgot to step aside. I was mounted and ready to go.

So was Jack.

Off we started at a canter. "Whoah!" I shouted. The only language Jack understood was the cut of the bit on his lip. He turned, never lessening his speed, and galloped past the house and store.

Mildred was trying to mount Johnny. Jack turned again at the one signal he understood. We made about six runs back and forth, to the total enjoyment of the onlookers. Dignity forgotten, I held my legs wide to lessen Jack's speed. Ray finally thought to lead Johnny to a stone wall. Jack and I were making a turn beyond the store when he saw Johnny ahead. He remedied this in a few seconds, and we would have broken our own record on the way home, but adventure was ahead.

A giant road machine came towards us. Johnny, a true Southern gentleman, pulled to the right. But Jack was no gentleman. He had filed claim to the center of the road, and no machine was going to take it from him. He charged straight ahead. But the machine was a giant. At the last minute, Jack turned and started back the way he had come. A driveway circled a house at the side of the road. Jack, obedient to the suggestion of my reins, entered the driveway. We circled the house and were on the road, headed home again. A pair of eyes appeared at the window as we passed.

Then a second machine appeared on the horizon. The first stopped to watch. Jack held his resolution until we were a few feet from the machine. Then he turned and bolted Haig-ward again. I managed to start him into the driveway. We circled the house a second time, and again were homeward bound. Two pairs of eyes were now at the window.

Machine number three now appeared. Jack had begun to enjoy the game. So had the drivers who had passed. Their laughter was loud and

appreciative. Jack now fully entered into the spirit of this new game. He came almost nose to nose to the next machine, whirled, circled the house, and was headed towards home and fodder.

A tall woman, wearing a pink sunbonnet on this cold day, now stood on the porch. She carried an enormous fat stomach before her with evident pride. Above the stomach was a waistline that seemed stuffed with pillows. Three abundant chins nestled under the bonnet. Dwarfing a miniature man who stood beside her, the woman clung to his arm and began to chuckle—the most musical yet most infuriating chuckle I had ever heard. The man, short and thin, stood with the pride of a bantam rooster, and his pointed, snowy beard followed every move that Jack made.

I nodded, said "How do you do?" and we entered the main road again. Feet held wide, I sat with as much dignity as possible until this ordeal was over. My business was to get home to my children, if not in good shape, at least alive.

Seven road machines were in that caravan. All of them outwitted at last, Jack, in the center of the road, missed Johnny and galloped ahead. There Johnny was, far down the road. The blanket was thin and Jack's spine not the most comfortable spot on earth as I bounded up and down.

I wasn't much help around the house for the next few days, and I took my meals standing. David didn't write, and I remembered the housing situation in Piper. No one ever moved from Piper, if it were possible to stay. Would we ever, ever be in our own home again?

Best Medicine in the World

A slow drizzle had fallen all day. The chickens stood around the doorway, feathers wet, tails drooping. Now and then one tried to sing, but the notes stuck in her throat. The old rooster clucked at an occasional crumb, tried to interest a hen, then clomped sullenly towards the barn.

Any note I tried would have stuck in my throat, too. This last waiting seemed harder than all the times before. Christmas was almost here, and I wanted to be in my own home. No matter how welcome our stay, this wasn't the best time to visit. Clarence and one or two boys still slept in the cotton house at night.

David, his first week's work finished, should be here any minute. I made a path from the fireplace to the door to stare into the gloom. Through the mists he came at last, slogging through the mud. Was he limping? I ran into the rain to meet him. As I tried to kiss him, he dodged; then I saw his red nose and watery eyes. "You have a cold," I accused as if he personally were to blame.

In the house, he dodged the children's kisses, but they didn't mind: he'd brought something better, a sack full of candy. Enough to share with all.

Papa was reading his Bible. "How are you, son?" He paused for a minute, then returned to his reading.

"Plenty to eat," Mildred smiled.

In the kitchen, I went to the old stove, took a match from a box on top of the warmer, struck it, and lighted a kerosene lamp. David's hair was the brightest thing in the room.

"Do you have a house?" I asked as he wolfed baked potato and milk.

"Not a house for rent in Piper." He wiped his lips and rolled a cigarette. Seeing my gloom, he said, "We could go back to West Virginia. I haven't quit my job there yet."

"Have you completely lost your mind?"

He laughed and shook his head.

Like chickens, the children went to bed at dark. Miss Mildred pulled the churn to the fire, looked at the milk, and went to scald the dasher and lid.

"I'll draw a bucket of water," David said when she emptied the black kettle that had been on a bed of coals. He filled it from the bucket and put it on to heat again.

I went to the well with David. The long zinc well bucket leaked so much it took four drawings* to fill the water buckets. David sneezed.

"I've got to do something for that cold," I said.

"Brought my own medicine." He took out a bottle.

"That won't do any good!"

"Best medicine in the world," he said.

"Papa, will whiskey help a cold?" I asked as we came into the house.

"Paw always said it was the best medicine in the world."

David gave a triumphant grin.

Papa was reading the paper now. He peered over his spectacles. "Bring your own medicine?" he asked.

"Sure did." David sneezed again, took out his bottle, and handed it to Papa.

He took a drink and returned the bottle. David didn't stint himself with his own dose of medicine.

"I'll soak your feet in hot water," I offered my remedy and went for the washpan. I pulled off David's shoes and socks and looked carefully at his broken foot. It seemed to be all right.

"Onion is good for a cold," I said.

Miss Mildred, coming from the kitchen, laughed and held up a big yellow onion.

David soaked his feet, ate onion, and sipped at his bottle. His tongue was thick when he finally went to bed.

The old rooster woke us the next morning. "I never felt better in my life," David said. "Grandpa was right."

His cold was certainly better. "It was the onion and soaking your foot," I affirmed. David was so sure that his remedy had been the cure that he didn't even bother to argue.

CLARENCE HAD SPENT THE night with Forrest and Gert. He came in soon after breakfast. "That car won't start," he told David.

"You just don't know how to start it," David said.

"That's what you think." Clarence fished in his pocket and handed the key to David. We all escorted him to the car.

David raised the hood, hit the motor a few times, jiggled a wire or so, and turned to me. "Bring a kettle of hot water," he said.

"I tried that." Clarence was smug.

David filled the radiator and mashed the starter. Thunderbolt protested, chugged, skipped a beat, then bellowed, giving off firecracker sounds a minute or so before he settled to his steady roar.

We had gorged ourselves as usual on sorghum, biscuits and butter, and home-cured bacon. Keeping a fire in the kitchen stove, I bathed the girls; then I closed the doors, went behind the stove, and took a bath. I didn't know what David had planned, but I knew the day would be exciting. My black wool dress had been steam-pressed and the last of the cotton

brushed away. A white linen collar gave it an almost-new look. It was nearing eleven when we all were dressed.

George had been called back to work at Woodward Iron, and we hadn't seen them. "Let's go to see Thelma and George," David suggested.

"Better eat a bite first," Miss Mildred told us. She took out a pan of sweet potatoes, freshly baked, and poured glasses of thick buttermilk. Thirty minutes afterward, I was all packed and ready.

The gray house was the first on the left after crossing the railroad going towards Bessemer. Soot and grime settled steadily over the area. Thelma saw us at the door and came running, a half-plucked turkey in her hand. George, with his usual luck, had won a turkey in a raffle.

Soot and grime were welcome. They meant that men were working, but none of it was allowed to stay in Thelma's house, which shone with cleanness and Christmas decorations. She could take pine cones, scraps of red, and greens from the shrubbery and fill a house with Christmas.

Our unexpected arrival didn't upset her. George helped David with the last of his medicine even though he didn't have a cold. Ailene and Jean, Sharon and Davene, the wonder of Christmas in their eyes, whispered and laughed and talked.

David and Thelma seemed to have lots to say to each other in private. "Oh, Sue will just die!" Thelma said once, loud enough for me to hear. My ears had been tuned their way.

David has bought me an expensive present, I thought miserably. We had so little money; he should have saved every penny to buy furniture.

He must have read the look of thrift in my eyes but ignored it. "Need to get anything in Bessemer?" David asked after we'd had an early afternoon snack. We had all talked ourselves hoarse. "This is Christmas," he said, "and my compensation check came yesterday."

And you've spent just about every penny of it, I thought. But it was Christmas. And his face was so happy—just glowing with Christmas and

other spirits. And the girls would love to see the decorations and lights in Bessemer. Early dusk had come on now.

"Why don't you all go with us?" I asked Thelma and pulled a comb through Davene's curls, then brushed at Sharon's coat collar. "David, bring in the suitcases. It is almost dark," I said.

THELMA, UNLIKE HER USUAL self, seemed in a hurry to get rid of us. The suitcases and boxes were still in the car as she rushed us through our last-minute preparations and almost ran us to the car. "No, Jean, you can't go!" she said when Jean begged to go. And almost before I had checked to see if the girls were warm, we were racing through Bessemer, scarcely taking time for red lights. "David, where are we going?" I asked.

"Driving around," he grinned. "We haven't been alone a single minute." Then we were on the road to West Blocton. The children talked about Santa Claus and Christmas.

My heart spoke a different language and began to thud almost danger-ously as we rattled through West Blocton and took the dirt road that led to Piper. Around curves and bends we rode, crossed the small bridge over Little Ugly Creek, and began the drive along the Cahaba River. Rain had stopped, and stars glimmered in the slow, rolling waters.

"David—" I was afraid to ask the question. I turned from the river and looked up at the stars as if one of them might speak to me.

David drew the car to the side of the road and took me in his arms. "Merry Christmas, darling," he whispered. "Sue, we have a house, and I have bought furniture and groceries."

This was too much—too much! I couldn't bear it! He dried my tears and started Thunderbolt. We drove up the road, crossed the high bridge, and began the crooked ascent to Piper. The road wound around rocks and ledges—"So crooked," people laughed, "you can see your tail lights." We turned a last curve, and I saw lights glowing from the windows of the old

Methodist Church. Cars took up all the parking space. David drove up the road, found a spot, parked, and helped me from the car.

My legs were weak, and I stumbled. I had not spoken since his announcement, nor been able to speak. Davene reached her arms; David took her, and I held Sharon's hand while we walked to the building and up the familiar steps, and we were inside.

Then Christmas exploded in my heart and head. Not one thing had changed! The giant tree was loaded with gifts as it was each Christmas, and fruit in brown bags perfumed the building. The same smiles, the same wonder and joy in every face. Mr. Randle was there. Wheeler Fancher, Mr. Allen, Mrs. Hayes, Mrs. Randle at the piano. All—all of them were there.

"Here're our singers," Mrs. Hayes laughed, her dark curls a striking contrast to Mrs. Randle's pure silver hair. David was leading me up the aisle. Someone took the girls and seated them near the front. Mrs. Randle struck a chord on the piano. Oh, David had really planned a Christmas surprise!

"Welcome home," Mrs. Hayes's voice was as warm as the big stove which heated the building. She hugged and kissed me and wiped tears from my cheeks.

"Everybody sing," David held up his hands. "Silent night, holy night . . ."

The walls of the old church house rang. And I will not forget that night of brightness; it will be with me as long as I live.

Who could believe that hatred and anger and a bitter night would come?

≋ 19 ≋

'Sleeping Sickness'

Home at last! The year 1933 brought new life and new hope not only to me, but to all of America. That golden voice had made promises. Americans, believing, had elected Roosevelt. A new world of love and brotherhood stretched ahead. A world of peace.

Peace?

Paradise, we learned, is not in this world. But the black night at Coleanor was fifteen months ahead. For a moment of time, I knew almost perfect happiness.

We had food, shelter, clothes, and once again we woke each morning in our beloved hills. With scarcely a ripple, we settled back into life at Piper. Our house, in the bend of the road, had three rooms, a long front porch and a double, V-shaped back porch. The outhouse leaned against an oak tree. Rent of $7 a month included water and electricity.

David not only had furnished kitchen and bedroom, but also had bought two overstuffed chairs, a sofa, a table, and a radio for the living room. We had a place to entertain. But former renters had cemented the living room fireplace, and our budget didn't run to a heater, so we had to wait until spring to use our "parlor." In the meantime, the chairs were not wasted. Moved to the bedroom (we did have a fire there) and shoved together, they made a perfect, though snug, bed for two small girls when David was home nights.

We wrote to Pearlie. If they would send our dishes, linens, clothes, etc., we'd give them what we'd paid on the furniture and write to the company to let them take over the payments. Pearlie mailed a small box to us. It contained a few things, but she kept most of the linens, dishes, and even a new pair of David's work clothes and shoes. I had learned to love Pearlie. Maybe she wanted to ship our things but was afraid that Starling would 'whup' her. When I thought of Pearlie, I excused her in my mind.

SOME IN PIPER HAD wounds, though, that would never heal. David and I had missed the time of slow bitterness that had come to a helpless people here. Weeks passed before we understood the bitterness and determination of the men never, never to suffer such things again. They had been hungry, humbled, brought to their knees. Worst of all, their children were hungry. Those on the appointed committee were proud men, yet they had gone to beg, not for free food but simply for credit to the miners. Every cent would be paid. They were honest men, hardworking when there was work, and they had guaranteed the debt.

But no credit was granted. Instead, there had been those words spoken, words quoted often in the year ahead: "Let them eat mussels; let them hunt hickory nuts." There are men living today who have never forgotten nor forgiven that remark, though payment in full has been exacted, not only against that man, but also against all other coal operators.

When Roosevelt, newly elected, guaranteed freedom to organize, and when a strong union had been established, they could and would and did strike if things were not to their liking. People outside coal mining whose jobs were affected criticized miners, grew bitter against them. But they had not stood in these men's shoes. There came a time when it was common to joke, saying, "If a miner at Piper or Coleanor stumps his toes and spills his water, the others, thinking a strike has been called, pour out their water and go back home."

The old, peaceful days were gone forever. Piper still had its pure air and its special beauty. There was still love between the men and the company officials, but it was a strained "chip on the shoulder" sort of love.

But that first January, I was at home and very happy. Furthermore, I knew that I was happy, a rare thing for humans. Usually, we look back to happier times (even though they did not seem so happy then), or we look forward to happier times. But one person in the world knew, for a short time, that she would not change places with anyone on earth.

No silly adventure had befallen me yet, and I didn't expect one. January often has one perfect week. On one of those rare days of spring-like weather, I dressed the girls, and we walked the mile to Portertown (Portertown, Sweet Ridge, and New Ell were names for different areas in Piper). We went to spend the day with "Mama," Mrs. William Hayes.

January jasmine bloomed in the yards, sent its spicy fragrance across the hills. At the highest point in the road, I stopped to look at the scene I had yearned for: distant purple hills against a blue sky. Sharon and Davene skipped ahead of me, their cheeks strawberry pink, their eyes as bright as the January day. A perfect day.

Mrs. Hayes was the best cook in the county and had tornado energy, but she had hurt her leg and it was slow healing. Dr. Phillips had given her some tablets for pain. She took one or two daily, hobbled about on her bad leg, and did not miss one visit to the sick, a shower, Missionary or P.T.A. meeting, or any other local event.

She had adopted me, and I was part of her large family. Mrs. Hayes practically ran everything in Piper and still had time to mother me and see to her own large family. She was a talented musician and director of most pageants and plays that were often put on in the community. Perhaps it was her unfailing love and loyalty to me that made Piper more home than any I had known since my mother died.

I was happy and halfway between laughter and tears all day. Then there came a familiar twinge. One of my bad headaches signaled that it was on its way. "Do you have an aspirin?" I asked.

"No," Mama Hayes's voice was low, husky, and warm. Now it sounded concerned. "Take one of my tablets," she said.

The small white tablet had a groove across the middle. "Is it strong?" I asked.

"Of course not. I'm supposed to take one every four hours."

"Anything stronger than aspirin puts me to sleep."

"This won't." She laughed her deep, husky laugh.

"Well, I have to get home." I swallowed the tablet, talked a few more minutes, and then we left. My headache began to wane as the girls and I walked across the bridge and passed the Methodist Church, but my eyes were slightly blurred. Up the winding road we climbed and came to Mrs. Florine's boarding house. From her yard, Mrs. Florine called, "Sugar darling, let me see them babies. You know I love them like my own."

I smiled vaguely. Everyone was "sugar darling" to Mrs. Florine. We stopped, sat on the steps, and I thought I could never rise again. I suppose we talked; I was struggling with my eyes, trying to keep them from closing. I must get home, cook supper, and get David off to work. I managed to rise, took the girls' hands, and we walked on down the endless road.

Smoke from kitchen fires sailed lazily into the sky. As we rounded a curve, Lorraine Champion called from her mother's porch, "I am coming over to see you right away." I was so vague, I mumbled something and spoke to her mother, Mrs. Dailey, who stood beside Lorraine.

THERE WAS THE JIM Ledford house across from the Baptist Church. Every place was special to me even in my dazed state. A door opened. "Well, Sue," Flossie Ledford said in her slow, Tennessee drawl. "How I have wanted to see you. Do stop by a minute."

I didn't have time to stop. I must keep moving.

"I'm thirsty," Sharon said.

"I'll get you a drink," Flossie said; then she smiled. "I just baked some cookies; let me give some to the girls." Her smile told how wonderful it was to have food to share.

We followed her. The fresh-scrubbed porch and house were spotless. Jim and Flossie, born in the mountains of Tennessee, of good old English stock, had come to Alabama shortly after they married. "We moved so many times," Jim told us later, "the children hardly knew which was their daddy, the truck driver or me. But when we came to Piper, we knew we'd reached home."

Humor, friendliness, slow Tennessee drawl, individuality, and incredible energy described the Ledfords. Jim's tales of the mountains often kept us laughing for hours. Flossie had big, grave, blue eyes, naturally blond hair, and English fair skin. "Stuck up," local people called her. She was a wonderful friend and neighbor, but she earned this title by keeping herself and her children not only spotlessly clean but "dressed up."

For a simple trip to the commissary to buy white meat and butterbeans, Flossie wore a hat and white gloves. She worked as hard as any man picking blackberries, gathering poke, growing vegetables and flowers. Flossie kept chickens, a cow, and a pig. She raked manure and brought it from the cow lot to grow organic vegetables, but when she went anywhere, she wore a hat and white gloves and carried a clean handkerchief. This, in a mining camp where people often dressed informally (some few even slovenly), was "stuck up."

Somehow, we were sitting before the fire. The girls munched cookies while I stared, half-conscious, into the flames. A heavy weight sat on my eyelashes. But the call of duty was strong. David, innocently asleep, depended on me to have his supper ready in time for him to get to work.

"I'm so sleepy," I murmured. "I don't know what is wrong."

"You may be working too hard," Flossie said. "Look at your little wrists; I could break them in two. Your bones are too small, not made for hard work."

"No danger of my abusing them," I managed a grin, mindful of my own inefficiency. The clock began to strike. Even in my drugged state, I counted the "dong! dong! dong! dong!" It was four o'clock! I staggered to my feet. "I have to get David off to work."

"Work" was still a magic word in Piper. If you were able to crawl, you had meals ready for your husband. And if he were able to crawl, he put on his "muckers," as miners' clothes were called, took his bucket, and made it to the mine to earn that still-rare dollar.

"Sue, are you ill?" Flossie worried.

"Just sleepy," I muttered. I clutched the girls by their hands and lurched out the door.

I managed to make at least a mile out of the remaining quarter-mile walk to my house by staggering from one side of the road to the other. Davene, who had missed her nap, began to cry. I reached down, picked her up, and held her in my leaden arms. Sharon clung to my dress, looked at me, and began to sob. "Mother is sick," she whispered and held onto the skirt of my dress. I tried to comfort her, but my eyes wouldn't focus as I looked down at her. We lurched onward in a fog of exhaustion.

Davene clung to my shoulders. My arms slipped, she roused, and wept again. Mother-love being stronger than my deathlike state, I clasped her to my breast again. At last, our small green house in the bend of the road appeared. Sharon opened the gate for me. I may have been crawling when we reached the porch. I remember holding on to the banisters as I pulled myself erect, held on to the wall, and navigated the miles to the door and into the house.

Habit must have been very strong. Vaguely, I remember that a fire got itself built in the stove. Vaguely, I remember reeling, running into the walls

of the room. What Sharon and Davene did, I never knew. Once, I sat at the kitchen table and slept. My hands, falling from under my chin, woke me, and horror gave me energy to rise as I remembered recent news in the papers. They had been full of tales about encephalitis, "sleeping sickness," carried by mosquitoes; certainly Piper had her share of mosquitoes. Three persons had died in the United States, perhaps others. Mules and horses, too, and Piper had work mules. Possibly, the papers had warned, an epidemic was near. Three had died. Now my dulled brain registered; I was the fourth victim.

Through the kitchen I reeled and across the vast distance from kitchen door to the bed at the far side of the room where David, unaware that his wife was dying, lay in peaceful slumber.

"David," I fumbled for his face. "Get up. I've got sleeping sickness!" Then the blackness of the dread disease hit me squarely in the face.

20

A Burglar Wouldn't Try to Break In

Dimly, I heard voices as I floated up through fog and darkness; then someone called my name. "Mrs. Pickett, have you taken anything?"

My eyes would not open.

"Do you have anything she might take to put her to sleep?" a voice asked.

"Nothing stronger than aspirin." This, clearly, was David's voice. He should have gone to work long ago. I struggled, managed to open one eye. Dr. Phillips's face floated somewhere between the eye and the ceiling.

"Mrs. Pickett," he shook me. "Have you taken any medicine?" He pried open the other eye and stared at my eyeballs.

"I—" Sleep overcame me again, but David shook me, and the eye, obediently, opened. "At Mrs. William Hayes's," I managed with thick tongue. "A tablet."

"Small? With a groove in it?" Dr. Phillips asked.

"Yesh." I slept again, and again David shook me. Why didn't he leave me alone, and why was the maniac laughter filling the room?

The faithful eye opened again. Dr. Phillips was bent almost double with laughter. "She's just doped," he said. "One small tablet knocked her out. Give her some coffee; she'll be all right."

A woman hurried into the room. My good eye registered a blur of fair

skin and blue eyes. "I'm your neighbor, Mrs. Hendon," she said. "Sharon told me you were sick. Can I do something?"

But where is Sharon? I thought groggily. A few minutes later she rushed into the room. Mrs. John Hayes (my other "Mama Hayes"), who lived over the hill from the doctor's house, and her little girl Jean were with Sharon. Jean's red-gold hair was so bright in the glare of the light bulb that the room seemed on fire. "What's wrong with Sue?" Mrs. Hayes asked.

I slept again.

The next thing I knew I was sitting at the kitchen table while someone poured strong, scalding coffee down my throat. "You go on to work, Dave," Mrs. Hayes said and handed him his lunch bucket. "We'll look after Sue and the girls."

Someone held me erect, and more scalding coffee ran down my throat. At last my eyes would open. The room was full of people: my new neighbor, Mrs. Hendon; her three girls, Edith, Fay, and Betty; Bella Eddings; Mrs. Davis from up the hill! Hazel and Mildred Hayes opened the door and walked in. Hazel carried a chocolate cake.

More coffee was perking on the stove. My last coffee took effect, and I was able to keep my eyes open. Neighbors, I thought, and blinked my eyes to hide tears; friends who rushed to help when needed. This was Piper! We ate cake, drank more coffee, and laughed; they teased me about my "drunk."

OUR BRIEF JANUARY SPRING ended the next day with rain turning to ice. The second morning after my "binge," every tree and shrub was covered with crystal. Diamonds sparkled everywhere as the sun rose and ice spewed from frozen ground. Roads were hard with ice and as slippery as glass.

Men went to work piled with sweaters and jumpers, and newspaper beneath the jumpers. But no living thing would be out in such weather unless necessary, I thought. Certainly not at night, as I bundled David and kissed him and wrapped tow sacks* about his feet. But I had forgot-

ten the power of love and friendship. Hydrants ran day and night, and smoke drifted over bare oaks and green pines from fires that roared up chimney throats.

David left for work at dusk each day and returned at daylight. Never much afraid of anything, I might have forgotten to lock my doors, but David gave strict instructions daily. So as soon as he left, I battened the hatches. Doors were dutifully locked, and I even placed chairs under doorknobs and moved a heavy piece of furniture against the kitchen door.

"If we were millionaires, a burglar wouldn't try to break in in such weather." I laughed as David gave his nightly instructions before leaving the second day after the big freeze.

"You lock everything, though." He kissed me and strode away. More than half a mile he'd walk in bitter weather. Thunderbolt couldn't be trusted in such weather even if we could afford gas to drive to work.

David, who always overdoes everything, had boxes and buckets of coal in the kitchen and near the fireplace. "Be sure to put lots of ashes on the fire," he warned as usual. For some reason, he thinks he must tell me every move, as if I might die or get myself killed if he isn't there to watch. The session with the pill hadn't increased his confidence in my ability to take care of myself.

I bedded the girls down, listened to the radio for half an hour, and read all the want ads in the paper. My hunger for reading led me to this. We had no books and no magazines and not even a catalogue. The rest of the paper had been devoured and, for want of better material, I pored over the want ads.

THEY MUST HAVE BEEN unusually dull, for I dozed as I sat before the fire. And perhaps David's warnings had taken their toll, for the fire blurred, turned to a small flashlight, and a burglar stood just outside the door, rattled the knob, and tried to push his way through the door.

I woke, started to smile at my silly dream, then jerked erect. It was not a dream! The door handle turned, and there was a tremendous knock at the door.

David had provided for this. Each night he brought in the axe and put it under the bed. "Or you could use the poker," he advised. The poker was heavy iron, made for us by the local blacksmith; it easily could have felled an ox.

No time to get the axe, so I dived for the poker. "Who's there?" I held the poker aloft, ready, I believed, to bring it down on the head of who or what might break through that door.

"Willard," a voice chattered.

David's youngest brother Willard was sixteen now, but certainly too young to be out in such weather. "What is wrong?" I gasped as I wrested the door open.

"Nothing," he laughed between his chattering teeth and almost tried to sit in the fire. Willard's voice was, if possible, more beautiful than David's. Already it was deep-toned, and he was almost half a head taller than I. "Willard Honeycutt came over to see his girl and wanted me to come with him."

Willard Honeycutt's girl lived in Coleanor. Our Willard (his nickname was Kaiser) was a frequent visitor after this, until, in fact, the other Willard married.

This night I marveled at the strength of love, and even more at the strength of friendship, that had brought our Willard/Kaiser out in such weather.

"Are you hungry?" I asked foolish question number umpteen-hundred. Who ever saw a growing sixteen-year-old when he wasn't hungry?

"Oh, no," he lied manfully.

"I'll make some coffee," I offered. Still chattering, he followed me to the kitchen. A few red coals glowed in the firebox. We piled coal in the stove.

I put water and coffee in the percolator and set it on the stove, wondering what I could feed this sixteen-year-old.

"Gee, that smells good," Kaiser sniffed as the coffee began to perk. I peered into the warmer. Eureka! Three biscuits were left from supper. In the cabinet was a bowl of cooked, dried apples, set aside for pies for David's lunch.

Kaiser buttered the biscuits, finished off the pot of coffee with my help and scraped the apple bowl. We put another pot of coffee on the stove. A scuttleful of coal disappeared. I found apple butter and a glass with a few scrapings of peanut butter inside. At eleven both were empty, and Kaiser nibbled hungrily at some stale crackers. "Something is wrong," he worried. "Willard promised to be back before ten."

"Maybe his car won't start," I guessed (correctly, as we learned later). The night was bitter. A blustery wind rattled the windows and fingered at cracks in the door. We sat around the stove until the kitchen was cold. The effects of my coffee died. Chilled, almost as sleepy as the pill had left me, I wished earnestly for bed.

We sat before the fire now. "Something is really wrong," Kaiser said drowsily. I peered at the clock. Past one now. We couldn't sit up all night. But there was no extra bed. The sofa in that bitter living room was too short, and there wasn't enough extra cover to keep a cat warm. I longed for Papa's cotton house.

"You'll have to spend the night," I suggested.

"Yeah," Kaiser yawned.

"We are out of coal," I announced, pouring the last of David's hoard onto the grate and looking earnestly around for a genie who would produce a bed.

I went with Kaiser to the coal pile. Poker in hand, he hacked away at the frozen coal. Thunderbolt drowsed peacefully in the moonlight. Good old Thunderbolt, my genie of the night.

"Give me the coal and bring the car cushions in the house," I laughed. "Just the thing for a bed in front of the fire."

Hope for a place to lay his head gave fresh energy. Kaiser lugged first one, then the other cushion into the house and deposited them before the fire. The car doors had been frozen, but his strength was proof against any frozen door.

I poured coal on the fire, dumped ashes atop, and ran for more lumps. "Good old Thunderbolt," I murmured. He seemed to hear me. In the moonlight, he took on grandeur as if remembering past glories.

The seats, end to end, filled the space before the fireplace. Here was a bed, but what would we use for cover on this frozen night? Even Sharon's blankets were used on our bed the past two nights. When Kaiser went to the kitchen to wash coal dust from his hands, I slipped a blanket from our bed.

On nights when David was home, the blanket was doubled over Sharon and Davene, who slept in the overstuffed chairs pushed together. The chair arms kept the girls' warmth in their makeshift bed.

Tonight I bundled them in winter underwear and flannel nightgowns, piled my coat on top of them, and if ever I had cursed in my life, I would have cursed Pearlie, especially this night. Wish I had my hands on her, I thought, and hoped that she was extremely uncomfortable under my blankets that she had failed to send.

The seats made a narrow bed. "Careful you don't fall off," I warned as Kaiser doffed his shoes and, fully clad otherwise, lay himself down to sleep. I spread the blanket over him.

His feet, like those of most youngsters, had grown even faster than the rest of him. Like two tombstones now, they towered at the foot of his bed as he lay on his back. He peered down at them. "Goodnight, little boys," he said, wiggling his toes.

Tired, almost hysterical with fatigue and sleepiness, I turned out the light, crept under my cover to undress, and put on my flannel nightgown.

Not even a burglar could wake me now, I thought, and sank into instant slumber.

But I was wrong.

A thrashing, pounding, shouting at the door woke me. "Open this door; we are freezing to death!" someone called.

Wild Over Roosevelt

I sat up in bed. Kaiser jumped, rolled to the floor, then rose and ran to open the door. Two muffled figures staggered into the room. "Put some coal on the fire," I told Kaiser, the covers clutched about my shoulders.

He turned on the overhead light. It swung on a long, fly-spattered cord from the ceiling. My eyes blinked in the harsh glare. Kaiser dumped the last of the coal onto the low, red coals.

Papa Pickett and the other Willard's father, Ped Huneycutt, swathed in coats with tow sacks wrapped around their shoulders and other sacks around their head and feet, huddled close to the fire.

I slipped into my dress under the covers, rose, went to the fire, and used the poker. "Who brought you?" I asked. Cars, I knew, were scarce on Pea Ridge.

"Nobody brought us," Papa croaked. "We walked, every step of the way." His cheeks were mottled purple, but red swept across his neck and spread onto his face. "Kaiser— What do you boys mean? Why didn't you come home?" His chin jerked, and his teeth rattled like castanets.

"Willard didn't show up." Kaiser hunkered down in his bed.

"You walked sixteen miles in this weather?" I said. The room was bitterly cold. Blasts of wind shook the house and found their way between cracks. "I'll make you some coffee."

"No, no," Papa said. "We'll be all right."

I looked at the empty coal bucket. "You are half-frozen," I shuddered, picturing the long, bitter walk over frozen roads under the cold moon while wind pierced underwear, coats, and the tow sack coverings.

Mr. Ped turned to the door. "I'm going to Coleanor. I bet the car is frozen—that boy wouldn't hear of staying at home. Had told Ruby he would be there."

"Take my bed," Kaiser said to Papa after Mr. Honeycutt left.

"No, no, just let me sit near the fire." Papa drew a chair near and put his feet into the ashes.

"Put the percolator on the fire," I told Kaiser. "You know how to make coffee."

"Ought to, after tonight." He shivered and went to the kitchen. "The hydrant would have frozen in a minute," he said, bringing the percolator and setting it on the coals. "Ice had already formed and hung all the way down."

"But I left it running."

"Not enough, though."

"You'll ruin the coffeepot," Papa worried. Nevertheless, he drank the whole potful. He wasn't shivering as much as he swallowed the last drop. "Thought I'd never be warm again," he said.

"Take my bed," I offered. "I'll sit up the rest of the night."

"No such thing! Stay where you are! Couldn't sleep a wink anyhow. I'll just sit by the fire and keep it going. Never passed such a night."

"How is Granny?" I asked, guessing who had been the most worried.

"Sick. Just plain sick from worry. Walked the floor crying until midnight. 'The boy is dead,' she said. 'Froze stiff in a broke-down car, or they ran off the road and now lay dying'; to stop her, I finally told her yes, I'd walk the road and look for the boys."

I remembered a similar walk the summer before, but at least I'd not been frozen half to death. "How about Mr. Ped?" I asked. They lived two miles apart.

"Met him comin' after me. Had the same idea." Papa nodded drowsily. "Never passed such a night. We looked into every fill, expecting to see the car down there."

"Well," Kaiser reached to turn off the light, "if you two won't lie down, I will."

Papa didn't answer. His head had lowered until his chin rested on his chest, and I heard a soft snore. I climbed into bed, and the next thing I heard was David pounding on the door. Sunlight shone through a window. There was no fire in the kitchen and no hot water for David's bath. Papa's chair was empty. I saw a movement on the floor. There he lay, his tow sacks spread over cracks in the floor just before the fireplace. Almost in the ashes, he lay between Kaiser and the low fire, and part of the blanket covered him. He stirred, mumbled, and slept on.

"What is the matter?" David looked at the cold stove when I let him in the kitchen. I pointed to the bedroom. Through the door, we saw Kaiser sit up, look around, and then grin. "Best bed I ever saw," he said.

David didn't really need a fire—he had been so hot on not finding warmth and breakfast all ready. But a look at Papa, still sleeping, and Kaiser's explanation cooled him off. A dash to the coal pile finished the job, and by the time breakfast was served, we were all laughing as we swigged coffee.

A THAW SET IN that day. January passed, slowly as always. President Hoover, helpless to do anything about the continuing Depression, held back by the lame-duck Congress, lived his last agonized days as president of the United States. He was a good man, an honest man; he didn't take from the government but turned back every penny of his salary to the Treasury. Such a good man, and yet there was little sympathy for him in Piper or in the rest of America. The coal miners, helped by that accusing, persuasive voice, thought that Hoover was an ogre. Half of our sufferings were attributed directly to him. His very name was a bitter word on our tongues.

Roosevelt was the new god. This winter had brought better times to Piper, but with the approach of summer, we would have bogged down in despair again, only—only—there was that vibrant voice, that promise sent from God, we thought.

And surely God protected Roosevelt. The innocent must die for the guilty, this we know. But sometimes one innocent dies for another, as in the chilling, dread affair in Miami when Guiseppe Zangara fired again and again at our new hope, Roosevelt. Surely, he was spared by God's grace. But an innocent, Mayor Anton Cermack of Chicago, who stood beside Roosevelt, died of wounds received at that time.

We grieved for the mayor, yet grief was mingled with wild joy. What if the bullet had hit its intended victim? Or—could it be that Chicago gangsters had really meant to kill Cermack? The answer to this died with Zangara, who was executed shortly after the black deed.

February passed, and March came into Piper with all of its usual beauty. Green fronds were beside the Cahaba and the small creeks that ran into the river. Green leaves and grass and gold of daffodils. Green and golden were our hopes now. "The only thing we have to fear is fear itself," that golden voice promised.

He was in our room, speaking intimately to us. Persuasive, magnetic. Voice of hope, voice of promise. You would follow him to the ends of the earth, and jump if he told you to jump; such was your faith. When the warm voice said "My friends," you shivered with happiness. No longer were you one of the little people, for a great man, the highest in the land, was your own personal friend.

Radio commentators, newspaper writers, everyone went wild over Roosevelt—at first. He had given us an original idea, along with such hope as we had thought dead and buried. Over and over, he was quoted and lauded. "The only thing we have to fear is fear itself." Who had ever thought such before?

Blackmore, for one. Someone had loaned me a copy of *Lorna Doone*. I had an almost-photographic memory then and knew that John Ridd had said, "Then I bestowed my fish around my neck more tightly, and not stopping to look much, for fear of fear, crawled along over the fork of rocks . . ." Even the Jewish writer Josephus had used this idea of "fear of fear" almost two thousand years ago. But who read *Lorna Doone*? And certainly few read Josephus. I was too loyal to my new friend to call this to the attention of anyone. If America wished to credit him with originating this thought, then let them. He deserved the credit, for surely he had given the thought new application. So the "fear of fear" remained his own original idea to most people. Perhaps a few scholars and voracious readers knew better.

Inauguration day came—March 4th—and kept us glued to our radios. The next day brought excitement and slight panic. That great man up there had started off with a resounding "Boom!" At the commissary, everyone was talking about it and about money. "I don't even have a dollar!" was a common expression. Except for the small change in your pocket, there was no money anywhere. Every bank in America had been closed. We had our own bank holiday, or moratorium. Gold could no longer be hoarded. Every person must turn in whatever gold he possessed: the price, $32 an ounce.

Murry Langston, the store manager, was broke. Miss Florence Fancher, who worked in the store office, and who certainly had a very respectable bank account, was stranded with only a little change. She had her own small, private loan business and made perhaps more money from it than from her job at the store. When a person needed instant money, Miss Florence would cash company scrip at a discount. She resold the scrip for a small profit. Now she, too, was broke, having deposited her money the day before the inauguration—you could deposit money to Birmingham Trust Bank at the company office. Mr. Henly, the bank president, was the

owner of Piper and Coleanor, spent time there, and offered this service. Everyone, it seemed, was almost flat broke now. No one had thought to cash a check.

Hourly, the radio brought stories. Millionaires didn't even have a dime to buy a paper. What gold you possessed couldn't be spent. You would be prosecuted. All—all of it must be turned into the Treasury of the United States.

I reveled in the excitement, and for a few days I felt quite rich simply by being as broke as the former millionaires.

THE MORATORIUM ENDED, AND now even the most ignorant person listened avidly to the news. For there was news from Washington hourly. The first hundred days after the inauguration, more legislation was enacted—more new, strange laws—than anyone in the history of America could have believed. Congress was ready to vote almost before Roosevelt asked for something new.

Everyone learned a new alphabet. There was PWA, Public Works Administration, to provide direct relief with a fund of more than $3 billion to finance national, state, and local projects. And even a million dollars was real money in those days. Roosevelt, a scholar, knew of course of Pericles, who built the Parthenon and other works of lasting beauty in Athens, in the same manner: as public works to give employment to the unemployed. But who since then had thought of such an idea?

There was FERA, Federal Emergency Relief Administration, to distribute $500 million among the states for direct relief to the unemployed. A million dollars was big money then, even for government spending. But billions to provide jobs! Here was hope. Here was a kind father in Washington who cared.

The CCC, Civilian Conservation Corps, took over reforestation and flood control, thereby employing 300,000 young men. Before a year had

passed, four million more had been given employment through the CWA, Civil Works Administration.

Oh, yes, we learned a new alphabet, especially the letters NRA, National Recovery Administration, and more especially, NLB, National Labor Board. Through NLB, men at last were guaranteed freedom to protect themselves from oppression by employers.

Piper blossomed with hope. But under the hope was a determination to exact vengeance, to never again be brought into a condition close to slavery. That remark, "Let them eat hickory nuts . . .," could never, never be forgotten. Men had been made lower than men. They had come in faith; helpless, they had asked, not for charity, but for credit that their families might eat, and this had been their answer.

Forgotten was much of the good of the past. For years, there had been a sort of benevolent, paternal feeling from those in power. There had been friendship, unity, love. There had once been peace and joy. But the wounds left by the Great Depression did not heal quickly. In fact, not at all. Men now had a small amount of money on payday, and some (an almost unheard-of thing before this) began to buy groceries at one of the chain stores in Bessemer.

The local commissary had always provided almost all of our needs. Prices were far higher than those of stores in other places. But when one didn't have transportation, nor even money to pay cash, where else could he buy groceries? Company scrip was issued and taken from your paycheck. Usually, there was almost nothing left when payday came. For those with good credit, who still traded at the commissary, books were issued in five, ten, or twenty-dollar amounts, with nickels, dimes, or quarters for change. On payday, you paid for these books. Others, without credit, drew scrip at the company office. You could always draw out as much as you had to your credit. Paying for this was not voluntary; the amount was deducted from your pay envelope.

David and I began to have a little money left over when we paid for our books. So did our neighbors, the Hendons.

"Sue," Mrs. Hendon said one day in April. "Hap will buy the gas if you and Dave will take us to Bessemer to buy groceries."

David didn't have to work Saturday nights, so one Saturday, we thundered away. Sharon and Davene were with us. Mildred Jones would stay with Edith, Fay, and Betty Hendon. Thunderbolt was growing feeble. He choked, rattled, groaned, and balked now when we took a trip. Because of these problems, he usually sat under a tree at the side of our house, dreaming, no doubt, of the days when he was "King of the Road" back in West Virginia.

As we drove down the winding road and crossed the river, I exclaimed over and over at the beauty surrounding us, as if I myself had created it. Grass was so green in the sunlight that it sparkled like the ocean. Honeysuckle bushes (wild azaleas) and late dogwood brightened the hills. Blue violets, purple spiderwort, red snakeroot, wild sweet williams made a tapestry of the hills. Laurel was beginning to show pink. Birds darted from tree to tree, singing extravagant arias as we bolted down hills; with the help of our angels, no doubt, we arrived safely in Bessemer.

We took the children window-shopping and walked through a department store now and then. As a special treat, we let the girls ride the elevator at Erlick and Lefkovich's store. Davene, eyes bright, cheeks pink with excitement, held David's hand. Sharon sucked in her breath as we descended.

"I want to ride again," Davene said.

"Daddy," Sharon whispered, "does it cost anything?" God bless her little heart. Children learned early in those days. You had few pleasures if they cost anything. For her sweetness, Sharon was allowed three rides. Davene went along for the fun, eyes bright with happiness. People gathered to enjoy with them, the third time.

"Why don't you ride?" Davene asked the crowd. "It don't cost anything."

Next we went to the A&P store and reveled in masses of food at unheard-of prices. Vic and Hap bought a month's groceries. I bought all that our treasury would allow. Thunderbolt was well-loaded as we heaped purchases together on the floor and in every available space. The car didn't have a trunk.

Dear, faithful Thunderbolt, I thought with such affection it must have warmed his whole interior. But even the warmth of my thoughts didn't have strength to bring alive a dead battery; for dear, faithful Thunderbolt didn't make a sound when David mashed the starter.

Dusk had settled. We had no lights without a battery, and the car wouldn't start. We were broke. Night was falling, and we were far from home.

Is This a Deathwatch?

David must have been bored with our recent uneventful life. Instead of anger, his reaction to the dead battery was excitement. It brightened his eyes, and even his hair curled energetically. He and Hap did the usual things—peered under the hood, then jiggled wires. Hap kicked the tires, but even that didn't bring the battery to life. I did my usual automatic wince. A too-energetic kick could mean disaster to a tire in its present state.

"It must be the battery," David observed with profound wisdom.

"We could push," Hap came up with a brilliant idea.

David approved the idea. "Sue, you steer," he said.

The street was slightly downhill, and there was little traffic on 20th Street where we had parked. Coal-mining muscles came in handy now. Half a block and we were almost speeding. I let out the clutch, and Thunderbolt sputtered gallantly.

Rain, April-like, had descended steadily the past quarter hour. Not a shower, but a businesslike downpour that clearly meant to keep up its work all night. The dead battery gave no light, and street lights were dimmed by the rain. The brakes had practically given up their job of stopping the car, but David had an answer for that. Mash the brake pedal, grind into low gear, and with the special aid of Providence you were able to stop. Providence, low gear, and brakes, aided by the curb at which I

aimed, were successful. "Well," Vic laughed. "We made it."

"But we can't drive to Piper without lights."

"Dave," Hap said, "we are in trouble." His brown hair was much curlier than David's. It bushed up on his head in the rain. His forehead was wrinkled, and his round gray eyes stared.

"We will have to have the battery charged," David said.

I had parked before a small, grease-stained, cluttered building that was clearly a garage-service station. Davene had not forgotten the chief use for service stations and loudly vociferated her needs. She clung to me. Vic took Sharon's hand, and we found the ladies' restroom. Needs attended to, we ran through the rain to stand inside the garage where David was shaking his head.

"I can't buy a battery," he said.

"I could charge your battery," the man said. "Only costs fifty cents."

"Charge away," David said. "Do you have a dry place where we could wait?"

"Man, it will take all night."

There was dead silence. We couldn't all sleep in the car. I thought wildly of walking the four miles to Dolomite, to sleep with Thelma and George. But the girls would never make it. Providence was still looking out for us, for just then Hap yelled, "Tandy Seales, what are you doing here?"

A man who had been passing stopped. "Hap, what are you doing in Bessemer?"

"Looking for a place to sleep."

"Honest?" Tandy asked. "In trouble?"

David looked at me, then eyed my purse. I knew its contents to the penny. Knew there wasn't enough to buy a new battery. None of us owned a watch or anything to pawn.

Hap explained about the battery and about the state of our finances. "Ain't none of us got enough left for even one hotel room."

"Mom and Dad ain't at home," Tandy said. "There is plenty of bed room. I will be home sometime tonight. I'll sleep on the sofa. You all use the beds." He grinned an elfish grin, his face so friendly you would have trusted him with your life, as he reached in his pocket, took out a key, and gave it to Hap.

"Man, you mean it?" Hap laughed.

"Of course I mean it. See you later." Tandy hurried up the street and out of sight.

"But to go into a stranger's home and . . ." David began.

"Man, they are not strangers to us. Best neighbors we ever had."

"I'm sleepy and cold and hungry," Sharon began to cry.

"I'm sleepy and cold and hungry, too," Davene howled.

"Are you sure it will be all right?" David asked.

"All we have to do is get there. Me and you can push and let Sue start the motor again."

MINING MUSCLES WERE CALLED into use again, and we were off. Policemen had business on other streets or stayed out of the rain. No one stopped us as we drove by street light to find the Seales' home. Vic and Hap, like homing pigeons, knew the way. We arrived, parked before a bungalow, and ran up the steps out of the rain. The key fitted, and we were in a plain, five-room house. There were two bedrooms, a kitchen, a living room, and a dining room.

"Better bring in our groceries; somebody might steal them," Hap said, and he and David made trips and managed to bring in bags and boxes safely. Vic made a fire in the kitchen stove, found a percolator, and made coffee as I undressed the girls down to their petticoats, fed them sandwiches, and put them to bed. Davene could sleep with Hap and Vic, Sharon with David and me.

In spite of strong coffee, I yawned and yawned again.

"Might as well go to bed," Hap yawned, too. "Tandy may not be home before daylight." They had chosen the back bedroom, and we were to sleep in the front.

I fell asleep instantly, then roused as there was a fumbling at the door. "David," I shook him, and thought, What if the Seales have come home early? What would they think of strangers in their bed?

David snored. The shuffling and thumping at the door grew louder. Then a voice: "Get the hell off this porch!" It was Hap's friend and our host. David heard this, woke, and sat up in bed.

In his current state, Tandy must have forgotten that he'd sent strangers to his home to sleep. There was a click as the overhead light in our room came on. He turned, saw me in bed, and stared. I had the cover up to my eyes and stared back at him.

"We found your place," David said, just in time, and saved the day—or what was left of the night.

"See you did." Tandy reached up cautiously, as if he might damage the cord, and turned off the light. Then he marched into the living room, closed the door, made undressing noises, and flung his shoes against a wall.

There was little sleep for yours truly the rest of the night. When I dozed, I dreamed of footsteps on the porch and guns being flourished. Other times, I dreamed that all of us had been arrested. The charge: breaking and entering, and we were carted off to jail. Those were not the most pleasant hours I ever spent.

A STEADY DOWNPOUR AWAKENED us the next morning, and a cold, wet wind blew around the house and through cracks in the doors. Hap built a fire in the kitchen stove. The men and children huddled near as Vic and I hunted through our groceries for bacon and eggs and bread. We breakfasted, washed dishes, and began to load groceries into the car. A bag or so, still damp, burst, but we found boxes and stored the overflow in

them. On our last trip, Tandy, pouring the last of the coffee, said, "Think I'll go home with you."

Thunderbolt, as always, made room for one more. Vic and the girls entered the car. I sat under the wheel, the men pushed, and I steered down a small hill. The car roared and emitted smoke. Wet, laughing, congratulating each other, the car, and even me, they found seats among the groceries. David slid into the driver's seat, and we bowled along towards Bibb County.

For some reason the whole thing seemed hilarious, and we laughed and talked as we roared southward. The windshield wiper was a hand-operated gadget; you turned a button inside the car to make it swish back and forth, so I bent to operate it every minute or so. David, Davene, and I, and the groceries piled at our feet and beside us, were comparatively dry. Those in the back had no such good fortune. Rain poured on them through cracks and holes in the curtains. Vic held Sharon on her lap. Boxes of groceries were heaped between Hap and Vic, and Tandy perched somehow half on the seat.

Water for the radiator was no problem. David stopped at rivulets along the roadside to dip muddy bucketfuls and pour into the steaming vent. We left Jefferson, crossed a corner of Tuscaloosa County, then entered Bibb and came to the "Y" which was named for the shape of the road as it forked to go to West Blocton and on to Piper. A large, sagging old dance hall stood at a corner of the Y. In the golden twenties, this place had been known for fun and frolic, had seen raids and bottles of contraband whiskey thrown in all directions. Deserted for three years, showing signs of decay as deserted places do, the old dance hall stared with forlorn, paneless windows as we stopped.

"Maybe there is an empty bucket in there, and I can help Dave," Hap said. David stopped and Hap ran to the place. Tandy hopped out of the car, found a can, and dipped water for the radiator from an overflowing ditch. But Hap had found greater treasure.

"Now we can keep out the rain," he laughed and hugged a dusty quilt to keep it from getting wet. What was an old quilt doing in a deserted dance hall? Sometimes children were brought to dances and parked in corners on such while their parents danced. Someone, evidently, had been too giddy to remember this one and had left it for a wet, chilly group of people to find.

"You are not going to use that?" I asked, horrified.

"Better than rain in the face."

"But no telling who used it?"

"People, like everybody else."

I watched, fascinated, as Hap pulled the quilt over them all. Spatters of rain dampened cheeks as we headed toward West Blocton, but they seemed warm and happy under their log-cabin quilt.

WE MADE IT HOME. The sun came out, and wet leaves glistened as if made of green-gold. Thunderbolt expired in a last snort. Tired, dirty, and damp in spite of the possibly vermin-infested quilt, we staggered from the car to unload groceries.

We'd stopped to let the Hendons and Tandy take themselves and their groceries out of the car. Very happy to be safely at home after spending the night in a strange home and sleeping in a strange bed, we brought in loads of groceries, then went to the bedroom. "David," I backed out and stopped him, "there is someone in our bed."

A head full of dark hair raised. "Where have you been all night?" Lucile asked. Ezra had made a trip to Birmingham. Lucile had packed her clothes, gone with him, and caught the bus to Piper.

I forgot that I had ever been tired. We built a fire in the stove, heated water, and almost scalded Sharon against possible vermin from the quilt. And we talked and talked. Then Lucile took a card from her purse. "Who is Herbert Allen?" she asked. The card read, "My name is Herbert Allen.

Who the hell are you?" He had been on the train with her. She didn't speak, of course, but kept the card.

Herbert, we explained, was the mine foreman's son. Mr. Allen was foreman at No. One mine, Mr. William Hayes at No. Two. In Piper, any bossing job put one in the upper echelon socially. Even the store clerks—they were white-collar men—at salaries of perhaps $50 monthly, along with their wives, thought themselves on a slightly higher social scale.

Herbert learned that Lucile was visiting us, so did other young men, and the living room sofa was seldom unoccupied on evenings. Bud Harris, Billy Harrison, and others, like bees, were attracted by Lucile's dark hair, fair skin, and hazel eyes.

Billy Harrison suddenly became very buddy with David and planned a night on the river, going in his car. We took the log-cabin quilt for cover. On Monday after our grocery trip, Lucile and I had built a fire under the boiling pot, lifted the quilt with a stick, and put it in the pot. Vic had refused to take it home with her. "Burn it," she told me. But Lucile had a better idea. She shaved a bar of Octagon soap into the pot, and we threw the quilt in. It came out faded but boiled, then rinsed, and very clean. Someone had put a great deal of work into this quilt. A log-cabin design, the stitches were small and even.

We raked pine straw to make a big, fat bed for the girls and covered it with a blanket and a quilt. Snuggled under it, they slept. David and Billy put out trot lines and checked the lines hourly. Their catch was one small catfish and an eel. For breakfast, we had white meat, fried potatoes, and a few bites of catfish. David and Billy wallowed eel around in their mouths, chewed, and managed to swallow a bite or so.

As the girls slept that night, we sat around the fire. The night wind was sweet and the April air soft. We sang old songs while fireflies danced the night away. Fish, though they didn't bite, leaped in the nearby river. A herd of cows, attracted by our singing, came to stand near the fire. When

the singing stopped, the cows left, to sleep no doubt under nearby trees in case the entertainment started again.

Lucile, from past visits, was under the spell of Piper. When her visit ended, Thelma came as soon as school was out. She had resisted Piper's spell in the past and thought I was half-crazy to enjoy living so far from what she considered civilization. But June, on the road to Piper, was too much for her. "Sue, that road is the most beautiful thing I ever saw," she exclaimed over and over, her enchanted eyes still viewing it in memory. "It was like heaven, all the green overhead, and the sun shining through the leaves, and the rocks and flowers and ripple of water."

The old road wound through the laurel-gorged ledges on one side and a small creek called Little Ugly on the other. A few pink blossoms still hung on the laurel. There were dark, fern-decorated rocks, oaks, maples, hickories, and vines and blooming plants climbing the steep hill to the right. Trees from both sides made a canopy for the road, meeting overhead. On the left, Little Ugly foamed over rocks and boulders, and sun shone on the giant poplars, sycamores, and other trees that met over the road.

Little Ugly was possibly named for its many turns and the rocks that bedded the stream. Water rippled cheerfully over, under, and around the rocks and made small waterfalls here and there with white spray and the sound of far-off bells. The road followed the winding stream, then veered sharply to the left to cross a bridge over the creek where it flowed into the Cahaba River. The road then followed the river for a mile, to turn right and cross a high bridge. Beginning in May, Cahaba lilies blossomed in incredible whiteness.

Thelma had seen the lilies and the great trees and everything. After crossing the river, you climbed up and up and around and up again, with trees, flowers, rocks, and red banks on either side, all the way to Piper.

"You see?" It was I now who had invented the road and Bibb County and Piper on those rolling hills above the river.

"Yes, I see why you love it here," Thelma said, and smiled that dreamy smile that came to all when the enchantment of our Camelot hit them. "I always thought you a little crazy. But if I ever lived here, I'd never want to leave, either."

Clarence came for a visit. Ambitious to be a newspaper man, he interviewed the Witcher brothers. They were hermits living between Piper and Coleanor. They drove a team of oxen and never shaved or took a bath. Through one of FDR's programs for polio victims, Clarence had a job with the *Birmingham Post* newspaper.

The lovely days passed, and summer wore its way into autumn. More and more new laws came from Washington. Piper men began to meet, to talk; the old call "United we stand, divided we fall" was on every tongue. "If we don't unite, the operators will have us over a barrel for the rest of our lives," they said. Somehow, the men and their wives managed to hate the company and yet love individuals. Mr. Randle, the superintendent, was affectionately known by his first name, Percy—but only behind his back. Times were more formal then. First-name basis for an employer was not practiced.

"What did Percy say?" was usually asked when a man had been called to the office. What he had said was usually known by anyone within a quarter of a mile. Mr. Randle had a tremendous voice. A favorite tale among the miners was that once, when trying to talk over the noisy telephone from the office to No. Two mine about a mile away, Mr. Randle, exasperated, finally stuck his head out the window and shouted the message.

There had been too much love for too long a time for the miners to hate Mr. Randle. You were supposed to hate anyone in authority, but we never did. Mrs. Randle was one of the most perfect ladies I have ever known, always kind and courteous, and she won my undying love by opening her

library to me and letting me read the stacks of magazines she had been saving for years. Though members of the "Royal Family," the Randle family was well-loved. Wilcox, their son, was "just like his mother," always friendly and courteous and kind. The girls, Rosalyn and Anne, too, were beautiful, but so sweet and friendly, we didn't feel jealousy or hatred for them.

SUMMER PASSED, AND I was not well. Not anything that I could put my finger on, just headaches, backaches, and never, never feeling well.

I took aspirin and diagnosed my own illness. One day it was tuberculosis, the next heart or kidney trouble. We were cut two dollars monthly for medical insurance, both local and hospital, so a complete examination would not have cost us anything, yet not once did it occur to me to have a medical checkup.

Well, David finally told our young, very good doctor, Bill Stinson, of my ailments, and he insisted that I be taken to the hospital that very day. My condition was complete retroversion of the uterus, and all of the ligaments were broken. I will spare you the details. Surgery was a must, and I could never, never again have a baby. For many years, when I saw a nursing child, I had a very special sadness and pain in my heart.

But the operation was successful, and life went on as usual—no, a new, different life began for us at Piper.

Jim Ledford, John Nash, Bryant Perry, Charlie Erwin, and others talked among the men, reminded them of past abuses. They brought out a petition to have a union, and soon every blue-collar worker in Piper and Coleanor had signed as well as all the men in Belle Ellen and those across the Cahaba field. The government had given the men the right to organize a union and to strike if they thought it necessary to obtain higher wages and better working conditions. United, coal miners became a growing power to be reckoned with through future years.

Christmas and the traditional tree again brought unity between the

company and the men for a short time. But after the holidays, little bits of hatred and hurts were dug from their rotting earth and polished. One man reminded another of the miseries of the past, and with that voice from Washington to encourage them, they were ready to fight.

All over the world, men were growing literate. Communication bounced from pole to pole, and workers everywhere were united. In Russia, communism seemed a bright example to many. In Germany, Hitler promised immortality, a thousand-year reign for the Third Reich. In Italy, the voice of Benito Mussolini was heard in the land.

In America, land of the free, in the country born of and for freedom, there were new thoughts and new ideas. Many trembled. Would America turn communist? Or fascist? Would she sell her soul for bread? Or had decades of freedom bred giants? Would men, could men throw off shackles of one kind without donning others?

It took us eight years to learn. It took that "Day of Infamy," December 7, 1941, for us to learn that we could fight and strike and demand our rights—that we could wrangle and cut ourselves until we bled, and yet that the seeds of freedom were deeply sown. We settled our battles among ourselves. No fascists, Nazis, or communists could tell freeborn Americans how to run their country.

BUT AT THIS TIME, our Armageddon was eight years ahead. We now searched the past and we feared, and our men, savage in their determination to stand united against whatever oppression the future might hold, stood as one man.

Demands were made.

They were refused.

The men laid down their tools and brought lunch buckets home; Piper, Coleanor, and Belle Ellen were on strike. All stood firm in their demands.

Rumors spread through February and into March. Strikebreaking can

be a bloody business. Armed guards were brought in to guard imported strike breakers—"scabs," we called them. Hunger could face miners again. Hunger was not easy to forget, but was there strength to see this through?

Mr. Ben Sherrod, general manager of Piper and Coleanor, spoke for the owner. Not one demand would be met. The men could return to work or else—.

One night as David and I listened to the radio, a car roared down the road, brakes squealed, and steps bounded across the porch and to our door. As the door opened, I heard the trample of feet and an angry murmur, low but growing.

O. C. Busby stood at the door. Then Raymond Jones and Hap Hendon followed. Raymond and O. C. had come to warn David and Hap. "If you have a gun, Dave, bring it," O. C. said. The men were white-faced. Hap's eyes were wild, and his hair was bushed high on his head. "The company has brought in a bus-load of guards. Mike Self is their chief!"

"Where are they?" David asked and kissed me hastily.

"In the Coleanor office."

Terror sent cold chills over my body. I fell on my knees beside the bed. Then I raised my head to listen to the tramp of feet as men took the road that led to Coleanor. I would have stopped David if I could, if I'd had time to think. Stunned, I opened the door to another knock, and Vic Hendon and her children came in. They were crying. We went to sit in the living room. Sharon and Davene joined in the tears; then we became strangely silent, numbed, just waiting, and I wondered, is this a deathwatch we are keeping?

All Men Brothers

Mike Self! Legends had made a demon of him. Half of them must have been purely legends. Possibly he was a good neighbor, a loving husband, and father. Possibly he went to church on Sunday and lived a good moral life. Coal miners across Alabama hated the very name of Mike Self, yet all had to admire his courage. He was not afraid of the Devil himself, and he was now in Coleanor with his henchmen. They had been brought in to guard men who would take the very bread from the mouths of our children.

Self was company deputy at Acmar—"shack rouster," he was called. Coal companies had been fighting for existence. The owners lived, as a rule, over the mountain in Birmingham. Cadillacs, furs, jewels, trips to Europe: these had been the accepted way of life for them.

Coal miners were mostly just figures on a ledger to them. At the top, they scarcely were aware of the turbulent base of the pyramid that held them aloft. The owners hired general managers. Under these were the superintendents. Next came the mine foremen and on down to the common workers.

Now, in Coleanor, one question was answered. The tramp of running feet had answered it. Miners were not afraid. Many had ancestors who had fought in the Revolution and all other wars. They, too, would fight if necessary.

This dread night, as feet thundered past our house, David joined the men who ran, some cursing, some weeping. A black man from Belle Ellen swam the river and climbed the hill to Coleanor. This man wept as he ran, afraid that someone would fire the shot and kill Mike Self, whom, he believed, it was his right to kill.

"I was sick," he wept, with what breath he could spare for weeping. "I wasn't able to work, and he made me—he had a gun—he'd a killed me. Made me hold to the tail of his horse. I had to run or he'd a dragged me to the mine—and he laughed at me as I run—and they made me work all day. I got the right to kill him."

We'd heard the story before, and we believed it. Yes, the man was black and did not have the rights of white men then. But in a coal mine, all faces are black, and all men brothers. Rights taken from one miner were considered taken from all, and each had a tale of bitterness.

Many stories had come from Acmar. One said that the village was ruled by armed thugs. And these men had come to bring the same rule to our peaceful, tree-surrounded area. Jim Ledford had prepared the miners for such a night as this. "Kill a man's spirit, and he is forever yours," Jim warned. If any could kill the spirits of these men, it would be such guards.

WISE IN EXPERIENCE, THE officials understood coal miners. They knew that regular trains and bus lines would be guarded as they came in and out of Coleanor and Piper.

Not too many years past, a train load of strikebreakers had been killed at Woodstock in Bibb County where the train had stopped at a siding to let another pass. The men who fired into the boxcars said they did not know the strikebreakers were there. They had fired to frighten the men, whom they said they believed to be in the regular passenger cars.

Possibly this was true. They had certainly been in the regular cars at first, then were hidden in the boxcars for their own safety. But more than

a score of them had been killed. Remembering this, the local officials had not brought the guards in openly by train or bus. Once entrenched in town, they knew they would be strong. The problem was getting them there. They chartered a bus, which took the long route through Boothton, a coal-mining town in Shelby County, then on to Marvel, in Bibb. From Marvel there was a back road to Coleanor which was seldom used. They had traveled this way, and now the men were in the company office in Coleanor.

The best-laid plans of men do fail. Self was recognized through a bus window by someone in Boothton. Miners throughout the Cahaba field had been expecting such a thing. The Piper-Coleanor-Belle Ellen strike was a proving ground for the future of miners. All miners in the Cahaba field were involved and deeply interested.

The men at Boothton were prepared, knew their work must be done quickly but silently. If the officials at Boothton learned what they knew, the news would be telephoned to Coleanor and the thugs would be on guard.

Trusted men were sent first to Piper, and they would warn Coleanor. On to Belle Ellen they went. Other men were sent to Dogwood, Marvel, Aldrich—all through the area, and men from these towns gathered with all speed to help their fellow miners. Every available car was soon loaded and rushed to Coleanor.

The men were wise, indeed. Cars and feet that had thundered with earth-shaking speed slowed as they neared their destination. Cars were parked out of hearing, a guard set to warn any who might approach, and silently the miners gathered in an armed ring about the office in Coleanor. In the darkness they stood, all around the lighted office.

The officials and the armed guards in this office must have been jubilant, making their plans, while unknown to them this army of men gathered with one intent: to fight—to kill! kill! kill! if necessary.

Word had spread that bloodhounds had been brought to the county seat in Centreville and held in reserve there. For what purpose? To track down our men as if they were criminals? We knew the pattern. When Self and his men were in control, then the strikebreakers would come. Our harvest would be hunger, despair, and finally giving in to the company, working under whatever conditions and pay they might wish to impose. It had happened once; it could happen again.

Washington was to help later. John L. Lewis would send all aid as soon as possible. But this night, our men stood alone against armed, trained gunmen. Who could believe they would rebel? That peaceful coal miners would stand against such men? As Israel of old quailed before Goliath, so miners would quail before the very name of Mike Self, officials must have thought.

Only they didn't.

Most of the local leaders—Jim Ledford, Bryant Perry, and George Nash—had gone to Birmingham for a meeting with the U.M.W. officials. Tension had grown during the strike. Trouble was expected. Black men and white guarded the homes of local officials day and night. Jim Ledford was busy at all hours, meeting with groups of men, strengthening, advising. Flossie and Jim had a prearranged signal. If he was needed, the porch light would be burning.

The light burned bright that night.

EVEN THOUGH THE LEADERS were gone, sanity reigned, although the miners, many of them armed now, had anger and bitter wounds to remember. Some wanted blood vengeance, wanted to kill, kill, kill—but sane men were able to stop them.

Percy Tillery lived at the top of the hill above the river in Coleanor. Men from Belle Ellen had come two ways: one, the long miles downriver by car to cross the bridge, then up the hills to Coleanor. Others, not

wasting time, swam the river and raced up the hill to Coleanor.

"They popped over that hill like rabbits," Tillery said later. "I collected their guns and stacked them as they came."

But sanity ruled by a very thin thread. Charlie Erwin was there. The men trusted him. "Let there be no bloodshed," he pleaded. "Don't let that be on our record."

Perhaps a thousand men now surrounded the office. Inside were the guards—heavily armed, trained men—and with them the company officials, carrying out the orders of their superiors. Mr. Sherrod was there; his reputed words, "Let them eat hickory nuts; let them eat mussels," still rankled in the bitter hearts of these men. Mr. Randle was there, and other officials. Piper and Coleanor men were their neighbors and friends. Many men would die. These guards were trained gunmen. They would pour volleys into the crowd. If one shot had been fired, a massacre would have resulted.

At the end, all inside the building would have died.

Mr. Sherrod came out to plead with the miners. Tears ran down his cheeks. "We will send these men back. We will do anything—only do not shed blood."

Here was balm for miners. Here was slight healing for old wounds. They, too, had begged once. For bread!

And for the first time in his life, perhaps, Mike Self begged—not for his own life, but for the lives of his men.

"He was not afraid," David said in awe, admiration, too, when he told me. "He was not afraid for himself. I stood just a few feet from him. His eyes were cold. I never saw such eyes. He didn't want his men to die. He stood before those hundreds who hated him, and he was not afraid. He lighted a cigarette. His hands were perfectly steady."

Jim Ledford, Bryant Perry, and George Nash had now arrived. "Kill them! Kill!" some of the men screamed. But the leaders were sane men

and proud. They talked in soft voices, calmly, talked reason to the miners. If one madman had fired one shot, blood would have colored the green hills of Coleanor. Miners, as a whole, were God-fearing men. They did not want bloodshed, though hired men had come to shed their blood, had brought bloodhounds and guns to overcome them; even so, they listened to their leaders, and these prevailed.

But as long as a man lives who was there that night, it will be remembered. Coal miners had been stripped naked, humiliated, but now the general manager of the company pleaded with the men, wept before them. Balm for old wounds. They stood tall now. Once again they could think of themselves as men.

All of the guns that Self and his men had brought with them were turned over to the miners. Some of them are used for hunting in Bibb County today. Mike Self was armed with three pistols, one between his shoulders. Self may have thought of shooting his way out, but there were his men to consider, so he consented to being disarmed. He and his men would leave peacefully.

A call went to Boothton. The chartered bus was stopped there and returned to them. When they left, it was by the same back route. Among thousands of men, there is always the chance that one will break. One might fire a shot at the sight of men entering the bus. To avoid this, the seventeen guards, with Self, were escorted one by one, Jim Ledford on one side, John Nash on the other, and Bryant Perry guarding his back. No miner in the Cahaba field would risk hitting one of their loved leaders.

SELF AND THE MINERS at Coleanor and Piper made headlines the next day. An era had ended; the little people were beginning to assert their rights. Oppression must end, and this was the beginning of the end. Self and his men had been glad to leave guns behind and escape with their lives. A giant had fallen.

The names of Piper, Coleanor, and Belle Ellen blazed across newspapers all over America. Men had stood as men. Taking heart from this success, miners throughout Alabama, then the whole South, came out on strike. They joined their Northern brothers and . . .

The rest is history.

When John L. Lewis shook his eyebrows, the whole nation listened. Bellwether of the unions, he led demands for better working conditions, hospitalization, pensions. Coal miners are well-to-do these days, using their power as ruthlessly, perhaps, as coal companies once used theirs. But Piper—my Piper does not profit. After World War II, natural gas and electricity began to erode the market for domestic coal. Commercial mining almost died. Boothton, Belle Ellen, Marvel, Piper, and Coleanor mines closed.

The faded houses in Piper were sold and moved. The great oaks were murdered, and pines were planted on those high hills. Strip-mining has left wounds on those beautiful hills. Yet the Cahaba still flows in its peace and beauty, and Piper and Coleanor still live in the hearts of all who ever lived there. From across America, hundreds come yearly to the Piper-Coleanor Reunion.

And suddenly—

America is now energy-conscious, and millions of tons of black diamonds still lie underground, enough in this field for more than a hundred years.

Someday, perhaps, Piper will live again.

Epilogue

During the Mike Self-U.M.W. incident at Coleanor, my sister Thelma Johnson, and her husband, George, afraid for the girls and me, came down and took us home with them to Dolomite. Three days later, David appeared with our furniture on a truck. A slow rain fell. We were moving to the extra house on Papa's farm and would farm that summer.

My usual reply: "David! We can't! You don't know how to farm!"

"All right, then, I'll unload the furniture here in the road and go to Detroit to look for work."

We went to the farm. In a week, David changed his mind. On a cold day in March, snow was falling, but that didn't faze David. He left, walking, to "bum" a ride to Birmingham—then on to Detroit. I followed, weeping, but he could outwalk me. So I returned to see about the girls.

David found a job. My cousin George Mosley was foreman at Budd Wheel. He and his darling wife, Linda, took us in, helped find an apartment, and we settled in.

In three months, we made a trip back home. Then Mr. Randle was, of course, happy to have David back. I was delirious with happiness.

One Wednesday night in 1935, David had an experience with God at a Baptist-Methodist Men's Prayer Meeting. A true "born again" experience. He came home radiant with happiness. From that day on, there was no more "drinkin'" and "cussin.'"

Otherwise, he was the same exciting, ambitious person. His father had taken him out of school at age sixteen and put him to work in the mine. Now, David studied mining books, took exams, received fireboss status, then mine foreman papers. When he was not given the next "bossing" job in Piper, he was hired by Tennessee Coal and Iron Company, a subsidiary of U.S. Steel.

Coal mining was growing across America. David, as section foreman, headed the monthly lists for safety and also production of coal. T.C.I. had a number of mines in the Birmingham area. Next David was made night mine foreman of Docena mine, then mine foreman at Edgewater mine.

T.C.I. OPERATED "CAPTIVE" MINES. U.S. Steel took all of the coal. Black Diamond of Birmingham was the largest commercial mining company in the South, operating seven mines in Alabama, Tennessee, and Kentucky. The company contacted David a week or so after Pearl Harbor and offered him a job as superintendent of their No. 9 mine in West Blocton in Bibb County (seven miles from my beloved Piper). David accepted, and we moved the last of January 1942.

Mr. Bissell, the owner of Black Diamond, was so proud of David— boasted that he was, at age thirty-four, the youngest mine superintendent in Alabama. He was also the best. Three hundred men worked at the West Blocton mine. David was over the whole shebang: production, renting company houses, the office, commissary, clothing, furniture stores, and the restaurant—all owned by Black Diamond. West Blocton was then thriving as a shopping center for many coal mines. There were also many other stores, privately owned.

No. 9 mine broke all records for coal mined in one day. And coal was desperately needed those war years. The record was painted on the office wall in large numbers. While David was there, his records were broken again and again, but his records were never broken afterwards.

We loved the old superintendent's house—the oldest and largest house in West Blocton—with its big rooms, high ceilings, French windows and doors. It was and still is the best place in the world for me. The night we moved in, I sat before a huge fire in the living room and felt not only "at home," but as if I had returned home.

Then Black Diamond transferred David to their Blue Creek mine, with a new, much smaller house. We were not happy.

David, offered a job as general manager for Garland Coal Company in the Smokies near LaFollette, Tennessee, accepted the job, and we moved to Lafollette. We loved it, but it was not Alabama.

David made a trip home, saw a man or so, and was hired as general manager for Little Gem Coal Company at Dogwood, near Montevallo. There were two mines, and in two months all records were broken. There was a nice salary, also house, telephone, water, a 20 percent discount at the company store, and other "goodies." Yet I was desperately homesick for West Blocton.

By now, the U.S. had given great power to coal miners. They could advise U.S. safety men, point out the dangers, and they did go into the Dogwood mines with the safety men. The result: both mines were closed. Actually, they were extremely safe mines. In twenty-eight years, there had been only two fatal accidents in them. The mines never reopened, and men were out of work.

David thought of buying a local, smaller mine, but Mr. Charles Blair, then president of Black Diamond Coal, offered him work as safety director over all of the Black Diamond mines, and David accepted. His reputation was such that the University of Alabama asked him to teach safety to coal miners at night, which he did.

We had built a small house on Pea Ridge on forty acres of land we owned. But I was still homesick for the big old house in West Blocton. It was for the superintendent who must live near the mine. The safety direc-

tor could live anywhere as he had to oversee all of the mines.

Mr. Cardwell's wife did not like the big old house and wished to move to a smaller house uptown. David saw Mr. Blair and bought the big house before he even told me. I could scarcely believe it until we drove up the hill from the Cahaba River on our first trip to see it again. Then I wept with joy.

David made a Garden of Eden of the place—so many flowers, shrubs, large lawns. But he still had the wandering mind his mother had warned me about those years ago. A nephew interested him in taking work in California, selling insurance for those famous cemeteries. David applied for the job and was accepted.

Oh, yes, by this time, he was safety director and assistant to the vice-president of Black Diamond Mine. "You'll never work for Black Diamond again!" Mr. Blair told him when he quit this time.

"David, I can't go!" I wept. We had made several trips to California and loved it, but I didn't wish to live there. "I am going," David said. I had three weeks to sell my furniture—antiques collected over twenty years. We moved to California, but we didn't sell our house. Later, I cried my way home also.

David hated the work. "My nose stinks all the time," he said one day after working in the smog. Another time he said, "I'd rather be in Alabama digging ditches than here."

We returned home, and I began hunting antiques once more. David bought a franchise for Standard Oil gasoline and opened in Montevallo—did quite well, too. But he was a coal miner. We were delighted when Mr. Blair sent for him to work as superintendent at Blocton No. 9 mine.

In the meantime, coal mining was dying across America. Today, where dozens of mines once operated in Alabama, now there are very few. Also, the steel mills have closed in Alabama. Bibb County, which has enough coal underground to last two hundred years, does not have even one underground mine.

David retired at age sixty-five. These were the very happiest years of our lives. We made a wonderful trip to England and many to California, Florida, and other places. We were together constantly—became almost literally one person.

You may not believe in miracles, but one is writing these words. In February 1987, it was discovered that I had colon cancer. The prediction: only one month to live without surgery, and I could die on the way to the hospital with another bleeding spell.

I didn't want to have the surgery, but David, a very strong man who never cried, wept constantly, his face wet with his tears, and pleaded with me to have the surgery. So, surgery was performed at Bessemer Medical Center. I was given one year to live by Dr. Edge. "I removed two cancers, each as large as my fist," he said. Fortunately, a colostomy was not necessary. Today, Dr. Edge admits that a higher power was involved.

I had been writing for the *Centreville Press* for years. The urge to write was always in the background. I began writing seriously at the age of forty. Very unsuccessful, I finally sold a short story to *Weird Tales*. Readers wrote the editor flattering letters. They bought everything I wrote after that. Soon, I was featured on the front page. I began writing books. Then I was offered work as reporter for the *Centreville Press*. When I became ill, readers across America who subscribed to their "home paper," had private prayers and also their churches praying for me. One church in Dallas, Texas, with two thousand members, had my name at the top of their "round the clock" prayer list. More than ten years later, I have finally retired from the *Press,* but there is no sign of a return of the cancer.

When the doctor told that I might have one year of life, David went up and down the hospital corridors saying, "I won't live without her." He didn't have to.

Three years after that, David and I had been in the yard; I ran into the

house for a minute, returned, and he was lying on the lawn, blood running from his mouth. "David!" I knelt. "Speak to me, darling!" But I knew. "You can't speak; you are dead!" I screamed. I tried to lift him, but couldn't.

This was September 15, 1990. Most of me died that day. Soon a crowd was here. Our children, grandchildren and greats, also friends and neighbors, did all that they could. David lacked a few weeks of being eighty-two years old, and we would have been married sixty-four years in a few days.

Daily I thank God for the wonderful years we had together—the last years were even better than the first. I am surrounded by beauty that he provided: the home, grounds, blooming shrubs. He is everywhere; I can still hear his beautiful voice, see his face, his laughing eyes. I am only half-alive without him. As I told him daily and he told me, "I love you," and, as Elizabeth Barrett Browning wrote, ". . . if God choose, I shall but love thee better after death."

Editor's Postscript: Sue Pickett lived on in the superintendent's house in West Blocton almost another decade after her beloved David died. She passed in 1999 at age 91.

❧

Terms and Expressions

Here are definitions or explanations for a few terms used by the author which many contemporary readers might not understand:

capboards — small slabs of softer wood driven between the top of an upright timber and the roof of the mine "room" being excavated; the downward pressure of the roof presses the timber into the capboard, distributing the pressure.

cotton house — on farmsteads, a small barn or outbuilding where the picked cotton is stored until time to take it to the gin.

dog-run — also called a "dog-trot"; a hallway or breezeway, open on both ends, running down the middle of a type of house commonly found on farms in the rural South in the slavery/sharecropping eras.

dolomite — a magnesia-rich limestone that has been used in iron and steel production since the nineteenth century.

"drawings" — see windlass.

"hide you" — whip or beat.

longwall — mining of a long, straight face of coal inside a mine, as opposed to exavating "rooms" of coal.

"maggaline" — dialect for magdalene, a "fallen woman," after Mary Magdalene of the Bible.

"over the mountain" — throughout south Jefferson and the adjacent counties of Alabama, including the author's Bibb County, this term is still used to refer to the wealthy areas on the other side of Red Mountain; i.e., where the bosses and owners lived.

"the Rooster" — the ballot symbol of the Democratic Party.

sorghum — a syrup made from juice pressed from sorghum cane stalks, then cooked until thickened.

"sunned his clothes" — a rural practice of spreading clothing and linens outdoors, often over bushes, hedges, or fences, to be freshened by the heat of the sun.

tow sacks — a type of sack made from coarse cloth such as burlap; most farms had an abundance of these sacks because livestock feed, seeds, and other commodities were packaged in them.

wallboss — the supervisor of a crew of miners.

windlass — a thick axle, often made of a section of log, suspended above a well, with a crank attached to one end. A length of rope would be secured to and wound around the windlass then through a pulley above; a bucket attached to the rope would be lowered into the well; the bucket's weight would submerge it into the water. The filled bucket would be retrieved by turning the crank on the windlass, thus rewinding the rope until the bucket reached the top. This action was "drawing" water. Most Southern homes got their water this way until electrification made mechanical pumps practical (and led to indoor plumbing).

❧